From the Golden Age to the Present Day

Two Centuries of Art and Craft in Denmark

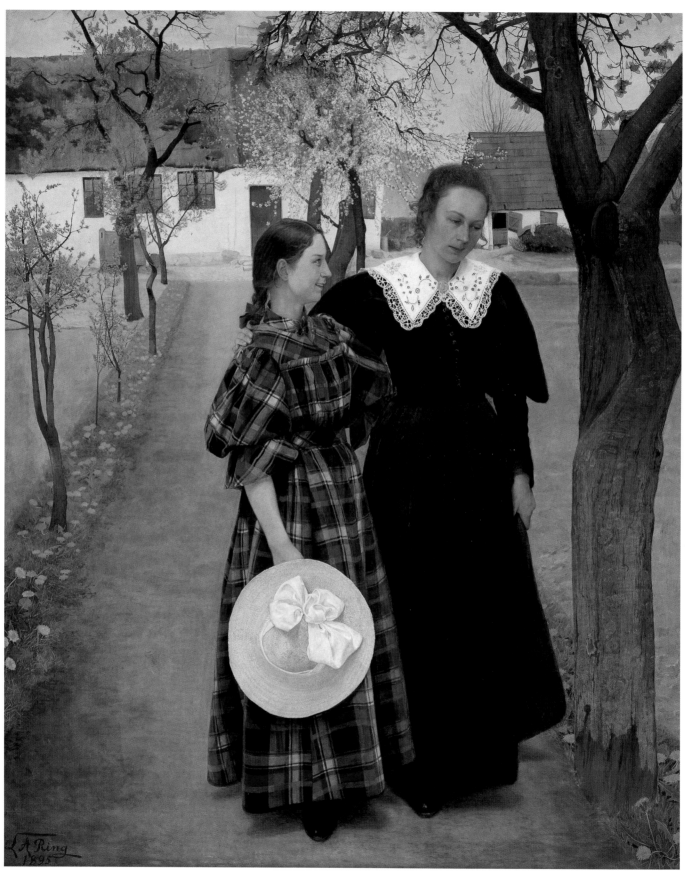

62 *Laurits Andersen Ring* *Spring* 1895

From the Golden Age to the Present Day

Two Centuries of Art and Craft in Denmark

CITY OF EDINBURGH MUSEUMS AND GALLERIES

DANISH CULTURAL INSTITUTE, EDINBURGH

City Art Centre, Edinburgh
12 August - 30 September, 1995

Editors: Finn Andersen & Ian O'Riordan

Design: Ewen Griffiths, Museums & Galleries Design Section

Translation: Vivien Andersen, David Hohnen

Published by City of Edinburgh Museums and Galleries
Danish Cultural Institute, Edinburgh

ISBN No: 0 905072 64 2
ISBN No: 0 9523869 1 7

The City Art Centre is an Edinburgh District Council Venue

Cover illustration *Michael Ancher* ***A Stroll on the Beach*** *1896 Skagens Museum*

Contents

Lenders to the Exhibition

Statens Museum for Kunst, Copenhagen

Aarhus Kunstmuseum

Skagens Museum

Nordjyllands Kunstmuseum, Aalborg

Louisiana Museum of Modern Art

Den Hirschsprungske Samling, Copenhagen

Holstebro Kunstmuseum

The J.F. Willumsen Museum

Bornholms Kunstmuseum

The Danish Museum of Decorative Art, Copenhagen

Georg Jensen Museum, Copenhagen

The Royal Library, Copenhagen

Royal Copenhagen

Hebsgaard Glass Studio

Galerie Mikael Andersen, Copenhagen

Galerie Jerome, Copenhagen

Galerie Faurschou, Copenhagen

Private Lenders

The Artists

Preface

From the Golden Age to the Present Day is the most significant exhibition of Danish arts and crafts ever to have been shown in Britain. It is also one of the most interesting exhibitions to have come out of Denmark in recent years, encompassing as it does such a wide range of media from the last two centuries.

It is appropriate that the exhibition is being shown in Edinburgh during this year's International Festival, for which the city is renowned throughout the world. Edinburgh is also known as one of Europe's most beautiful cities, and it gives us great pleasure to bring the exhibition to the City Art Centre which has hosted so many major exhibitions over the last few years.

Exhibitions in London in recent years have brought Danish art to a southern audience, and we are delighted that we can now redress the balance somewhat by showing *From the Golden Age to the Present Day* in Scotland. Visitors to the exhibition will discover that Danish art has its own distinctive cultural voice in the same way that Scottish art has. Both nations have been subjected to similar mainstream European influences that have helped form and shape their particular identities in fascinatingly parallel yet divergent ways.

Edinburgh also has the distinction of being the home of the Danish Cultural Institute for the United Kingdom. The Institute has been tireless in its efforts to promote Danish arts and craft in this country. Last year the impressive *Flora Danica* was shown at the Royal Botanic Garden and in 1993 the National Museums of Scotland displayed a major exhibition from the Danish Design Centre.

As a people, we Danes are often accused by foreigners of being too modest. I would like to set the record straight and say that the Danish Ministry of Culture is proud to be showing *From the Golden Age to the Present Day* in Edinburgh during the 1995 Festival. Neighbours as we are, separated only by the North Sea, I hope that the exhibition will further understanding between our two countries.

Jytte Hilden
Minister for Culture

Sponsors of the Exhibition

Adam Transport

Augustinus Fonden

British Midland

Beckett-Fonden

Copenhagen 96

The Danish Tourist Board

DFDS Transport/Scandinavian Seaways

Dunard Fund

Komsul George Jorck og Hustru Emma Jorck's Fond

Lothian Regional Council

Ministry of Culture, Denmark

Museums and Galleries Commission

Nimmos Colour Printers

Reiach & Hall Architects

Scandic Crown Hotel, Edinburgh

Visiting Arts

Foreword

The City of Edinburgh Museums and Galleries and the Danish Cultural Institute are delighted to be showing *From the Golden Age to the Present Day* in the City Art Centre during the 1995 Edinburgh Festival. Our two institutions have worked together in the past but this is the most substantial collaboration that we have ever undertaken. Danish art has been a comparatively well kept secret outside of Denmark until the recent Golden Age exhibitions shown in both Europe and America. As a result of these events, Danish painters of the early 19th century are now receiving the international recognition they deserve. But Denmark's contribution to world art was not confined to the Golden Age. A remarkable artists' colony at Skagen emerged in the 1880s, whose members were inspired by the extraordinary light and atmosphere of this small fishing community at the northern tip of the country. This century, Denmark has produced its share of internationally acclaimed figures, including Asger Jorn of the Cobra group and Per Kirkeby. The country is also renowned for its commitment to design, and decorative art and craft. To illustrate this, the exhibition includes a wide range of both historic and contemporary ceramics, glass, silver and textiles.

Of necessity an exhibition of this scale involves the support and collaboration of a large number of people and organisations, without whose expertise and knowledge it would be impossible to stage. The daunting task of making the selection has been tirelessly and perceptively undertaken by Bente Scavenius for the fine art and Mogens Bjørn Andersen for the decorative art and craft. This catalogue, a comprehensive survey of the last two hundred years of Danish art, has been enriched by the essays written by Kasper Monrad, Bente Scavenius, Ane Hejlskov Larsen, and Jonna Dwinger. Working to tight deadlines, they have provided the reader with a complete, but easily understood, introduction to Danish art and craft. As a complement to Danish scholarship, the Scottish art historian, Duncan Macmillan, has provided an illuminating comment on Danish art from this side of the North Sea.

Every exhibition is dependent on the goodwill of the lenders. In this case considerable help has been given by a number of institutions, whose directors, curators and conservators have not only agreed to the loans but also provided invaluable advice during the preparation. In particular we would like to thank the Statens Museum for Kunst, Copenhagen, home of Denmark's national collections, which has permitted over fifty key works from its collections to travel to Edinburgh. In addition we are extremely grateful to Aarhus Kunstmuseum, Skagens Museum, Nordjyllands Kunstmuseum in Aalborg, Louisiana Museum of Modern Art, the Danish Museum of Decorative Arts, the Georg Jensen Museum, the Royal Library, Royal Copenhagen, and to the other institutions lending to the exhibition. As well as lending works, a number of galleries in Copenhagen have provided invaluable guidance on contemporary artists; in this connection a particular word of thanks should go to the Galerie Mikael Andersen. We are also eager to thank those private lenders who have chosen to remain anonymous. Finally, we must not forget the most important people of all, the artists and craftspeople who have been generous in lending work to the exhibition, as well as offering their full co-operation in its preparation.

This exhibition has been a long time in the gestation and has proved to be a task of far greater complexity than was first envisaged. It has been a fascinating and educational process for the staff of both institutions. Particular appreciation of the thorough and painstaking work of Lise Kirkpatrick, secretary at the Danish Cultural Institute, and Vivien Andersen, translator, should be recorded. Ian O'Riordan and David Scarratt, Keepers of Fine and Applied Arts respectively, have co-ordinated the organisation in Edinburgh, and the design of this catalogue has been undertaken by Ewen Griffiths. As well as their efforts, the exhibition has made demands on the time and energy of many of our staff, and we would like to express our warm appreciation of their hard work. We also wish to thank Neil Gillespie of Reiach and Hall, who has conceived the splendid design of the exhibition. As ever, we are extremely grateful to all those sponsors and organisations who have helped us to make this exhibition possible. It goes without saying that without their generous contributions, this project could not have taken place. We wish to thank them for their continued support.

Finn Andersen, Director, Danish Cultural Institute, Edinburgh
Herbert Coutts, Head of Museums and Galleries, Edinburgh District Council

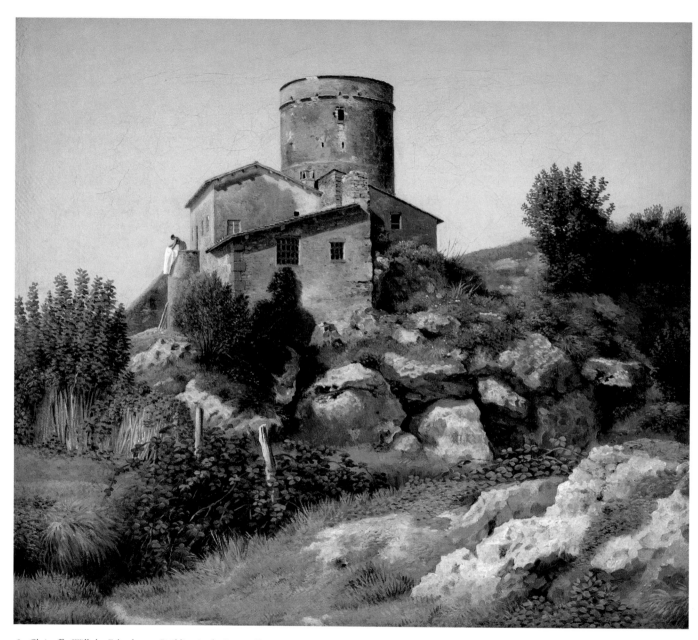

3 *Christoffer Wilhelm Eckersberg* **Building in the Roman Campagna** *1815*

Romanticism in Danish Art

BY KASPER MONRAD

The foundations of the Golden Age of Danish art were laid in Rome around 1815. The young Danish artist Christoffer Wilhelm Eckersberg had come to the city in 1813 to conclude his studies as a history painter, but became so fascinated by Rome's old buildings that he executed a series of paintings of ancient ruins and medieval churches. These pictures were to represent a turning-point in Danish art.

Eckersberg painted Rome's well-known buildings just as many other European painters had done before him. But he preferred to show them from new and unexpected angles, and also had an eye for apparently insignificant subjects that had never been painted by anyone else before.

Eckersberg painted scenes of contemporary reality, but he never chose them at random. His compositions were invariably strict and well-arranged. He was sober-minded and objective, and his pictures were devoid of romantic infatuation. Every detail was rendered with loving care.

Eckersberg allowed his subjects to be illuminated by clear, bright daylight, which was unusual. He was the first Danish painter in Rome to paint outdoors, in front of his subject, and thus paved the way for an intense, direct study of nature.

With his Roman pictures Eckersberg established the basis for more than three decades of Danish art – in the period usually known as the Golden Age. On his return to Denmark in 1816 he was appointed professor at the Royal Academy of Fine Arts in Copenhagen and thus given an opportunity to pass on his new artistic principles to the next generation of artists.

With Eckersberg as the magisterial teacher at the Royal Academy, the range and style of Danish painting from about 1820 to 1850 was clearly marked out. This says a great deal about how Danish art developed, but also about how it did *not* develop. The guiding principle was the artist's personal experience. Anything approaching extremes or the sublime had no appeal to the Danes – nor had the strange world of dreams. No Danish painter let himself be carried away like Delacroix by strong emotions, or tried like Géricault to explore the darker recesses of the human mind. No Danish painter imbued his landscapes with strong religious feeling like Caspar David Friedrich, or gave nature a visionary character like Turner. Not even romantic yearnings found expression in the pictures painted by Danish artists. Even though the Norwegian Johan Christian Dahl played a significant role in Denmark's Golden Age and influenced

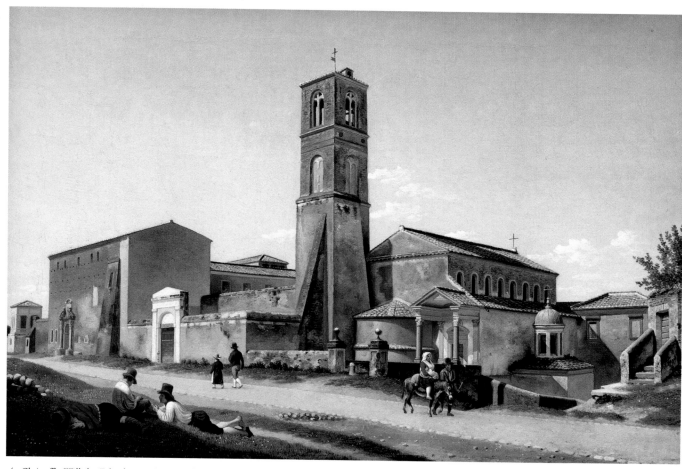

4 Christoffer Wilhelm Eckersberg **S. Agnese fuori le mura, Rome** *1815*

several of the younger painters, none of these was ever attracted as he was by violent volcanic eruptions or dramatic marine catastrophes. Danish painters had the opportunity to see Dahl's pictures, but seldom followed his example.

In one way, the very nature of the Danish countryside may have imposed these restrictions. Much of the scenery depicted by artists abroad did not – and does not – exist in Denmark. Conversely it may be said that the Danes could have sought out these subjects had they wished to do so. Nearly all Danish painters visited Rome and were therefore obliged to pass through the Alps. But none of them was inspired by natural phenomena the way Turner was in Switzerland. The few pictures that Danish artists painted of the Alps differed little in principle from Danish scenes. Eckersberg painted in clear daylight, and so

did his pupils and successors. All details were to be observed in detail – and lovingly. There was thus no infatuation with dark forest undergrowth or brooding twilight, and hardly any night scenes. Even the sharp light and cold of winter was largely avoided by the Danes – bleakness held no interest for them.

Eckersberg demanded faithfulness in depicting even the smallest detail. Although his pupils gradually permitted themselves to step back a few paces and take in a wider perspective than their teacher had done they never forgot the details. His approach to colour and painting technique also imposed restrictions; his pointed brushes and smooth brushstrokes were all adopted by the following generation of painters. No Dane ever cultivated the painterly brilliance or grand manner of Delacroix, and none of them could ever dream of using a spatula in the last phase

of their work the way Turner and Constable sometimes did. Even when the Danes painted oil sketches they were noticeably careful. Nothing was left to the whim of the hand or the moment.

If we are to look for an international parallel to Danish Golden Age art we must turn to contemporary North German painting, so-called Biedermeier art, where the same realistic approach and love of detail can be found in a number of painters.

Eckersberg soon attracted a great many pupils – never before had so many artists been active in Denmark. For the first time it was possible to speak of a distinct Danish school of art, or rather, a Copenhagen school of art, for at that time nearly all cultural life in Denmark was concentrated in Copenhagen.

Pupils at the Royal Academy were obliged to follow the same programme of studies as Eckersberg himself had done: first, copying prints by old masters, then drawing from plaster casts of antique sculptures, and finally drawing from a live model. But Eckersberg revised the curriculum and brought it up to date; naked models were removed from the elevated world of history painting and instead posed in more everyday attitudes. At the same time he saw to it that tuition was given in the actual technique of painting.

An innovative practice introduced by Eckersberg was to take young artists on study excursions into the environs of Copenhagen to give them a chance to paint and draw from nature. Such studies became a part of the academic curriculum – something quite unheard of at the time. There were admittedly many artists abroad who painted studies from nature, but the various academies of art throughout Europe still upheld the old classical ideals. Eckersberg may therefore be regarded as a pioneer in the art of the period, not only in Denmark but also on a European level.

On his return to Copenhagen in 1816, Eckersberg was Denmark's leading portrait painter for a few years, but lost ground in this

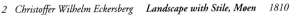

2 *Christoffer Wilhelm Eckersberg* **Landscape with Stile, Møen** *1810*

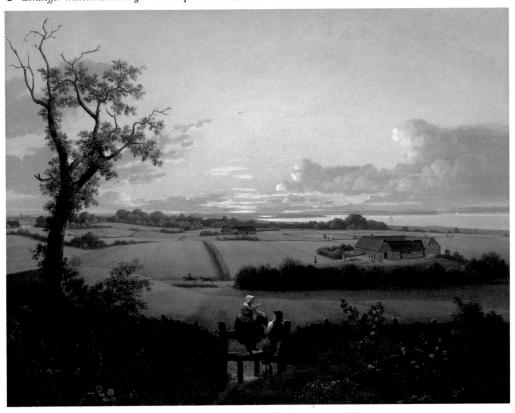

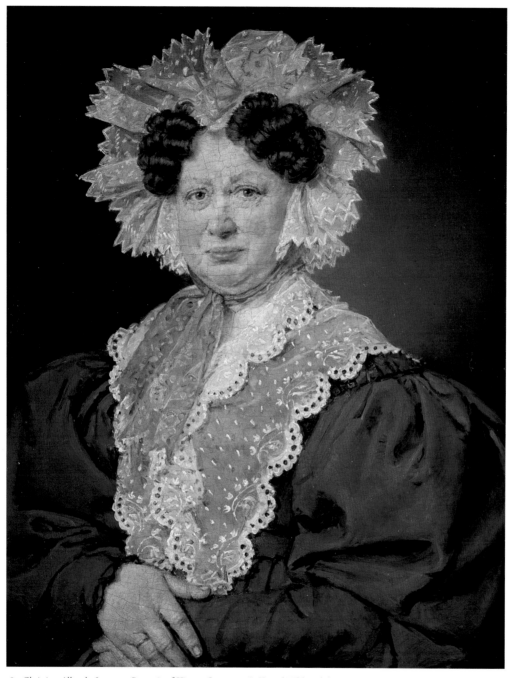

9 *Christian Albrecht Jensen* **Portrait of Kirsten Stampe, née Kaas (1766-1842)** *c. 1831*

area around 1826 to a slightly younger colleague, Christian Albrecht Jensen. Eckersberg's portraits reveal how much he had learned from French art. Compared with contemporary Danish portrait painting, his pictures are grandly conceived and furthermore characterized by clear outlines and an exquisite linear interplay. One notes that he had been inspired not only by his teacher, Jacques-Louis David, but also by David's French pupil, Jean-Auguste-Dominique Ingres, whom he must have met in Rome.

After 1820, landscapes and urban views came to be of less importance to Eckersberg. As a rule he painted pictures of this type only on the excursions he made with his pupils to the outskirts of Copenhagen in order to paint and draw from nature. Instead, marine

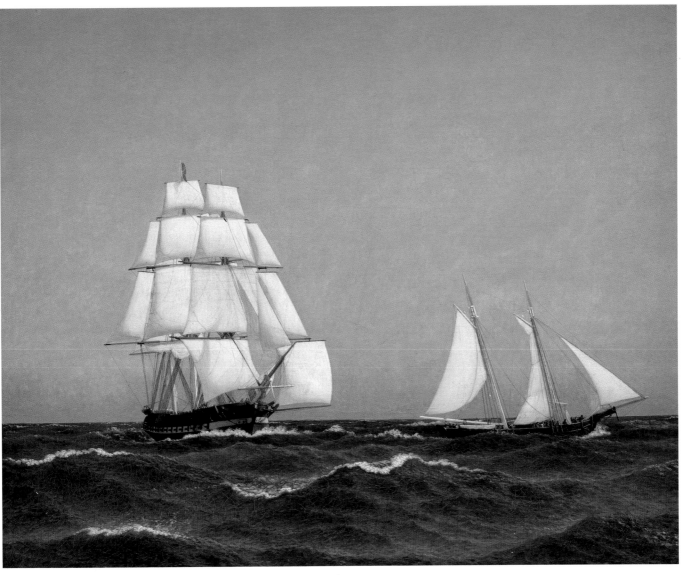

6 *Christoffer Wilhelm Eckersberg* **Privateer Outsailing a Pursuing Frigate** *1845*

painting gradually became his preferred genre. He depicted the various kinds of ships with great care, and tried to portray them with extreme accuracy in their natural setting on the basis of daily meteorological studies.

In his later years Eckersberg became increasingly interested in the theory of perspective, which began to play a very central role in his teaching. In due course he began to draw up a systematic list of rules for spatial construction and the effects of light and shade. This resulted in two treatises on the subject and also in a number of paintings and drawings in which he tried out his theories

in practice.

Especially during the 1820s and 30s Eckersberg was to influence a number of the most important painters of the period, such as Wilhelm Bendz (1804–32), Martinus Rørbye (1803–48), Constantin Hansen (1804–80), Jørgen Roed (1808–88), Wilhelm Marstrand (1810–73) and Christen Købke (1810–48), all of whom bore the stamp of his realistic outlook.

The great artistic flowering of the Danish Golden Age took place during one of the worst economic crises in Denmark's history. Already

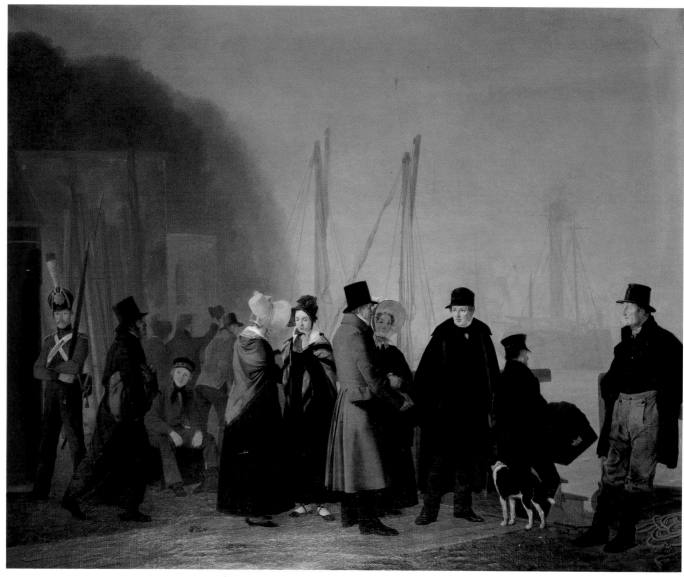

18 Jørgen Roed *Farewell Scene at the Customs House* 1834

during the last years of the Napoleonic Wars Denmark had lost her position as one of the foremost trading nations in Northern Europe. When the terms of the peace treaty, concluded in 1814, obliged the Danish king to hand over Norway to Sweden, Denmark's overseas trade was finally shattered and the country was plunged into an economic crisis of such severity that it affected every single Dane and lasted right up to the beginning of the 1830s.

It was when the economic crisis was at its most serious in the early 1820s that the pronounced upsurge of artistic activity in Copenhagen took place. But people's demands, reduced almost to the point of austerity, were clearly reflected in the subjects chosen by painters. The Danes of the period seemed hardly capable of even dreaming about a new and better form of existence. On the contrary, their limited possibilities of diversion taught them to seek out positive qualities in their everyday lives. Painters therefore cultivated whatever was close, familiar and modest, first and foremost subjects taken from their own – or their clients' – lives: everyday episodes of one kind and another, scenes of

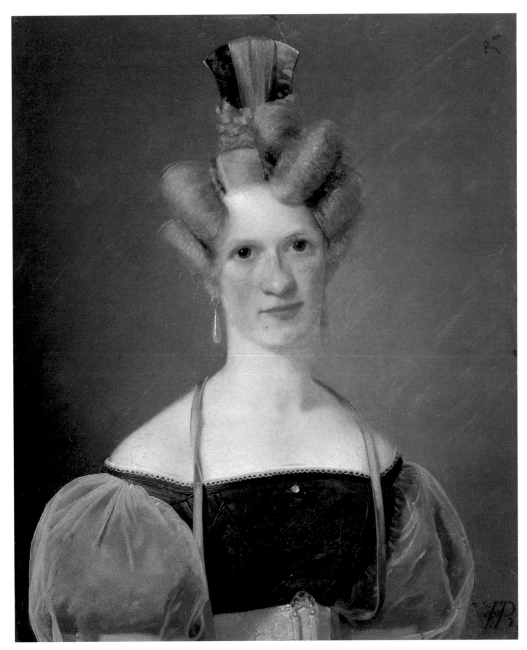

*13 Wilhelm Bendz **Portrait of Marie Raffenberg, the Artist's Fiancée** 1831*

family life in the homes of the bourgeoisie, pictures of familiar surroundings such as the streets, alleyways and squares of Copenhagen and of rural districts just outside the city's ramparts.

Family pictures won great popularity around 1830. For many Danes, undemanding pastimes in the bosom of the family represented highlights in an otherwise arduous existence. The family was one of the cornerstones in Danish society during the Golden Age. Painters were therefore kept busy painting pictures that reflected the cosiness of family life, such as activities with children or quiet moments spent knitting or reading the newspapers.

A great many family pictures were painted, but the Copenhagen bourgeoisie mainly wanted small portraits of the closest members of the family. Virtually all the

12 Martinus Rørbye **View of Copenhagen at Sunset** *c. 1847*

Golden Age painters accepted commissions to paint portraits, but only a few of them, such as Christian Albrecht Jensen (1792–1870), worked exclusively as portraitists.

The Danish painters were interested in depicting not only everyday scenes, but also their immediate surroundings. Eckersberg encouraged his pupils to practice by painting any subject that happened to take their fancy "no matter what". He wanted to teach them that even the most insignificant subjects could provide them with rich opportunities for training their powers of observation and their artistic skills.

His pupils followed his advice. They had no need to go very far to find a subject suitable for a painting exercise or for a finished painting. The subjects of these pictures were often

chosen more or less at random, but could be of far greater importance to the artists themselves than Eckersberg had intended. The painters often chose subjects that were directly connected with their own everyday lives.

Eckersberg was also to be of great importance to architectural painting, which was the field he had preferred in Rome. A great many of his pupils painted both studies and major pictures of historical Danish buildings such as Kronborg Castle, Frederiksborg Castle and several of the medieval churches in Denmark's market towns. This was undoubtedly bound up with the period's interest in national history. Behind these architectural pictures one can discern the strong influence of the art historian Niels Lauritz Høyen, who saw here a possibility of generating a greater understanding for Denmark's historical monuments.

There was one artist who, more than any other, was a child of the economic crisis and the resultant narrow horizon. This was

20 Christen Købke *Frederiksborg Castle Seen from the North-West. Study* 1835

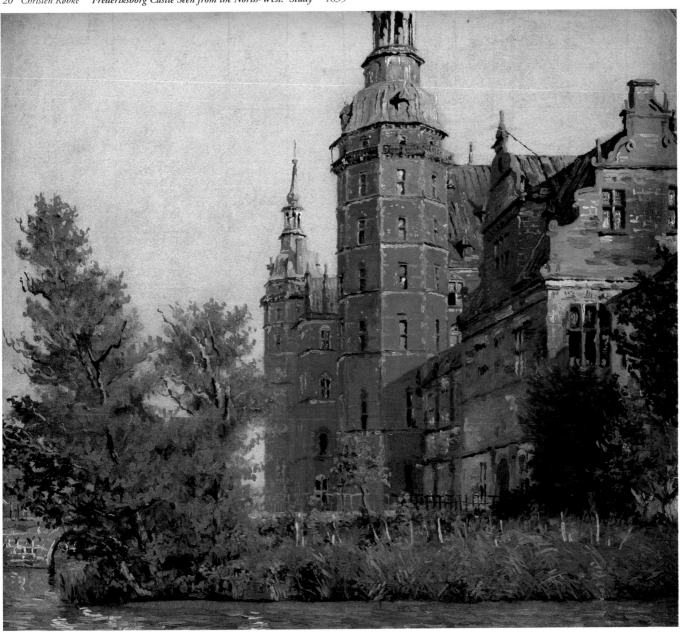

Christen Købke (1810–1848). He found most of his subjects in the immediate vicinity of his home, just outside Copenhagen, and there is nothing remarkable, let alone spectacular, about the subjects he chose, such as a view over a moat, a bascule bridge, or a view alongside a lake shore. But he created pictures whose originality is now appreciated far beyond Denmark's borders.

Christen Købke is without question the most important Danish painter of the first half of the nineteenth century and is now, with good reason, recognized all over the world. He had an intuitive sense of composition. In many cases both his angle of vision and the way he framed his subject were surprisingly

21 *Christen Købke* **Susanne Cecilie Købke, née Købke, the Artist's Wife** *1836*

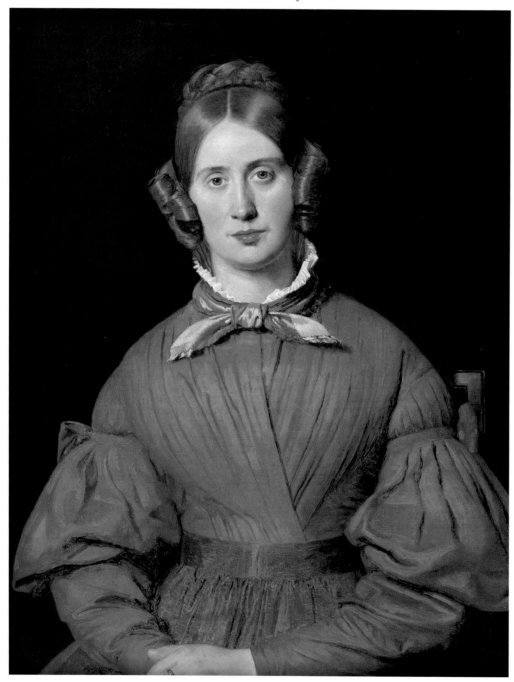

22 Christen Købke *A View towards Nørrebro from Dosseringen* *1841/45*

bold, with the result that a seemingly unimportant subject would take on significance. Købke is unsurpassed when it comes to detail, brushwork, a sense of colour and a feeling for composition. While possessing much of the sober-mindedness displayed by his teacher Eckersberg, Købke nevertheless interpreted his subjects in a much livelier way, and although he never departed from the classical principles of composition that Eckersberg had taught him, he used far more sophisticated colouring effects than his teacher had ever done. He used hues within a limited spectrum and set them off by means of a few contrasting colours.

Købke was far from being a bohemian. He lived in his parents' home, even after he married, and his range of subjects was strikingly limited. A very considerable number of his paintings are connected with the two places where he spent the greater part of his life, just outside Copenhagen's ramparts: until 1833 in Copenhagen's Citadel and from 1833 until 1845 at Blegdammen on Lake Sortedam. He felt no need to go far to look for a subject, and this has puzzled many later writers. But Købke simply saw no point in travelling any great distance when he could find suitable subjects outside his own door.

Købke exercised a certain passing influence on some of the slightly younger landscape painters, especially Johan Thomas Lundbye, Dankvart Dreyer and Thorald Læssøe. Købke's art attracted no particular attention in his day, and after his early death

19 *Frederik Sodring* **Summer Spire at the Cliffs of Møen** *1831*

in 1848 he was almost forgotten. It was not until the end of the nineteenth century that his qualities began to be seriously appreciated.

Throughout the first half of the nineteenth century, Rome continued to be the goal of Danish artists when they went abroad to further their studies. Rome was where they were supposed to complete their training, in an international artistic milieu surrounded by the art of Antiquity, and they often remained there for several years.

On their way south from Denmark these Danish artists often stayed for protracted periods in various German cities, especially Dresden and Munich, and in the 1820s and 30s there was a lively artistic exchange between Danish and German painters. It is even possible that Wilhelm Bendz, had he lived, would have settled in Munich for good after his stay in Italy; he died in Vicenza in 1832 at the age of only 28.

On the other hand, very few painters went to Paris. Apart from Eckersberg, no other Danish artist derived any positive inspiration from contemporary French art. His pupils showed little appreciation of the artistic endeavours made by French artists during the years after 1820, and certainly not of the innovation they represented. On the contrary, Martinus Rørbye in 1834 wrote home from Paris to Eckersberg that he had turned away "in revulsion" from one of Eugène Delacroix's paintings.

The one fixed point in Rome for young Danish artists was the sculptor Bertel

Thorvaldsen, around whom everybody in the Dano-German artist colony flocked. But although they admired him as a shining example of a Danish artist who had achieved international fame, they declined to follow his example. Hardly any of them shared his interest in the classical idiom and ancient mythology. Eckersberg was the one to provide inspiration for Denmark's young painters when they were in Italy during the 1820s and 30s. In practical terms, his Roman views determined to a pronounced degree the type of subjects the following generation chose to paint when they came to Italy. Admittedly these pictures had only been exhibited in Copenhagen to a limited extent, but

Eckersberg's pupils had been able to study them in his official residence at the Royal Academy in Charlottenborg Palace.

In Rome, Danish artists went in search of the same subjects that Eckersberg had painted, but only rarely did they also paint them. Instead, they chose subjects that were related, but were none the less their own. When Constantin Hansen in 1839 was in the Forum Romanum one day, the position he took up was not directly facing the Arch of Titus, but to one side of it. The façade is thus not seen frontally but greatly foreshortened, so that the viewer forms no clear impression of what the arch really looks like. The artist's aim was to experiment with some visual effects. Hansen

14 Constantin Hansen *Piazza della Bocca della Verità in Rome* 1837

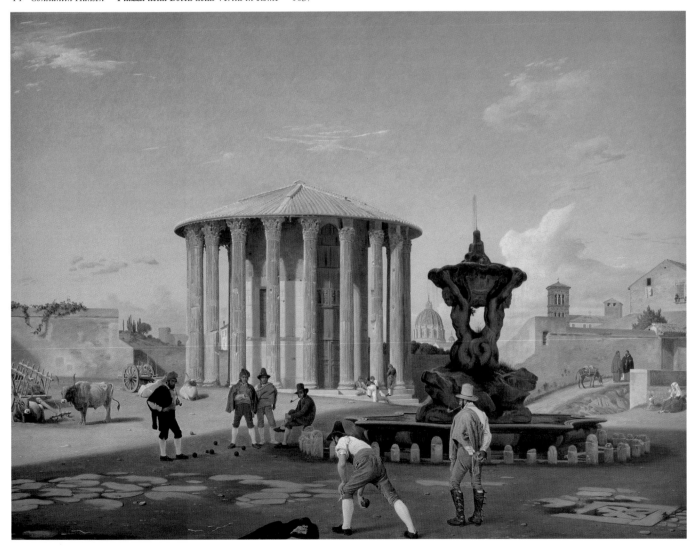

here furthermore displays a far more pronounced feeling for the delicate, changing nuances in the sunlight and in the shadows. But the picture of the Arch of Titus was not intended to be shown to a wide public; it was meant only as an exercise.

When Eckersberg's pupils were to start on a major work, however, they were not content with depicting ancient buildings. They were just as absorbed by the liveliness of Italian street life, and many of their paintings took on the character of reportage.

Wilhelm Marstrand, for example, specialized during his stay in Italy in depicting ordinary Italian people in a series of amusing and touching scenes. Like the other Danish artists, Marstrand closed his eyes to the seamier sides of Italian life and showed the Italians the way the public in Copenhagen would like to see them. However, in some of his paintings from Venice he focused on the social tensions prevailing in Italy at the time, for example by painting a gondola beside which beggars are trying to attract the attention and sympathy of

15 Constantin Hansen *The Arch of Titus in Rome* 1839

24 *Wilhelm Marstrand* **Landing at a Palace on the Grand Canal, in the Background the Church of S. Maria della Salute: the Woman in the Beggar's Gondola Receiving Alms** *1845*

some wealthy Venetians. In many of his paintings Marstrand displayed a painterly freedom that is otherwise extremely rare in Danish art of the period.

The year 1838 saw a striking new departure in Danish painting – artists took to depicting the Danish landscape. Until then, only a few of them had specialized in this genre. On his return from Rome in 1816, Eckersberg had painted landscapes only by way of exception. Admittedly he had regularly taken his pupils on study excursions into the environs of Copenhagen, where they painted and drew from nature, and this had helped to sharpen their powers of observation. But virtually

none of Eckersberg's pupils had taken up landscape painting exclusively. For most of them, painting a proper landscape picture was a rare occurrence.

The new political situation had paved the way for this development. During the 1830s, conflicts of national interest had arisen in the Danish king's two German duchies, Slesvig and Holsten, and towards the end of the decade violent nationalistic feelings flared up on both sides, resulting in a marked mood of mutual intransigence. A number of prominent people in Copenhagen did everything in their power to promote Danish nationalism, not only in the duchies but also in Denmark itself. The new political situation also made a strong

impact on the art world. Sharp conflicts arose between German and Danish artists, and the former close cultural bonds were severed. Like everybody else in the duchies, artists from Slesvig-Holsten were split into two groups. Several Holsten painters left Copenhagen and drifted away from the artistic life of Denmark.

Landscape painting was rapidly drawn into the national struggle, especially because of a widespread feeling that Danish national character was formed by the country's natural geographical characteristics. During the 1840s

8 *Johan Christian Dahl* **View in the Park at Wörlitz** *1838*

32 Johan Thomas Lundbye *View of Frederiksborg from Hestehaven* *1841*

landscape painting therefore acquired a central position in the public debate, and it was here that the most striking development in Danish art now took place. Some of the very young artists began to devote themselves to the Danish countryside; first and foremost Johan Thomas Lundbye (1818–48), Peter Christian Skovgaard (1817–75), Dankvart Dreyer (1816–52) and Vilhelm Kyhn (1819-1903) came to represent the new national Romanticism of the 1840s in their landscape painting. They all reacted against Eckersberg's objectivity and instead preferred to be guided by his colleague, Professor Johan Ludvig Lund, who had a more romantic concept of nature; they also received significant inspiration from the Norwegian landscapist Johan Christian Dahl, who was closely associated with the artistic life of Copenhagen.

The young painters felt no wish to dwell on the special character of a particular subject, but strove instead to emphasize the general and typical aspects of nature in Denmark. Nor did they see anything wrong in including in their compositions details taken from various other sources – something Eckersberg would never have done. Painters set out from the capital into the countryside, where they found, not unspoilt nature, but cultivated farmland – and with good reason, for even in those days there was little unspoilt nature left in Denmark. But instead of cultivated fields they could always paint the commons, where the vegetation was more natural. They always depicted regions where people could be seen going about their daily work. These painters imbued their pictures with a feeling for nature and atmosphere, but never with fervent religious animation or violent drama.

National landscape painting expressed to a high degree the sentiments prevailing at the time, and it is significant that on the whole the

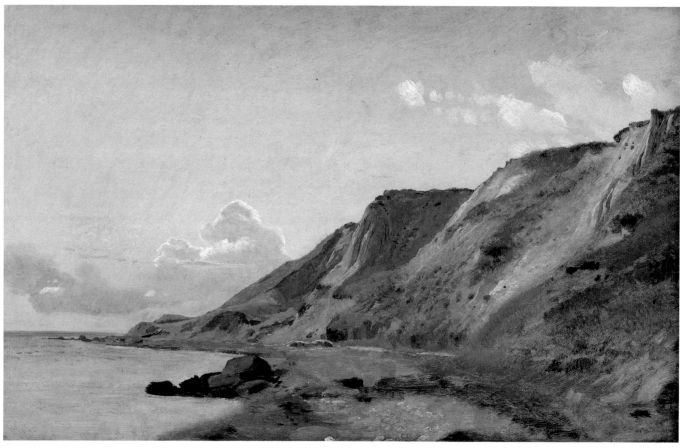

34 *Johan Thomas Lundbye* **Study of the Cliffs at Refsnæs in North Zealand** *1847*

young landscape painters evoked a much more enthusiastic response to their work than Eckersberg's pupils had done.

The most prominent of the young landscapists was Lundbye. He wanted to show that the Danish countryside was comparable to that of other countries, including even their mountains. In his art he clung to meticulous observation of nature, but at the same time he tried to depict the general and typical aspects of Danish scenery. Being a Romantic, urban life appealed less to him than the countryside, but he always painted rural scenes where human beings led their daily lives. Although the genuine feeling for nature reflected in his pictures contrasts sharply with the realistic approach of the Eckersberg school, his work possesses a classical serenity when compared with the Romantic artists of both France and Germany.

As a change from their purposeful work on large compositions, the landscape painters regularly made excursions into the countryside during the summer in order to draw and paint less demanding sketches. These provided them with inspiration for their studio work during the winter. Lundbye often set out on study excursions with Skovgaard. Whereas Lundbye preferred to paint the open landscape of Zealand, Skovgaard specialized in depicting the typical Danish beech forest. His large, monumental forest landscapes reveal his true conception of nature. His forests are never dense and impenetrable – on the contrary, he liked to show a clear, wide view through the trees. The trees are straight, and only seldom windblown or storm damaged. Skovgaard always grouped them in a gentle rhythm. The weather hardly ever disturbs the harmony – at most there may be a single shower threatening. His beech wood is just as peaceful as a park. Like the other landscape painters, Skovgaard

depicted nature the way well-to-do Copenhageners preferred to see it on their excursions into the countryside; parents would feel no anxiety about letting their children venture into these woods.

Throughout the Golden Age, painters depicted first and foremost the countryside of Zealand. Copenhagen was to such a pronounced degree the centre of their world of ideas that even those who sought their subjects out in the country still preferred to stay within comfortable distance of the capital. Jutland thus remained undiscovered by artists for a long time, despite the fact that several of the landscape painters came from Denmark's German duchies. In 1830 Rørbye travelled through Jutland on his way to Norway – diligently making drawings on the way – and in 1833 the Holsten landscape painter Louis Gurlitt painted the first Jutland landscapes. But Dankvart Dreyer was the first to start depicting the Jutland scenery systematically. He had been born in Funen and found it hard to settle in the Copenhagen art world. He therefore left the capital and returned to the region of his birth, and from here he made excursions to find subjects for his paintings.

Dreyer came to Jutland for the first time in 1838 and painted a great many pictures there during the ensuing years. He depicted a bleak, barren and windswept landscape, considerably different from that of Zealand; man's activities and intervention are far less noticeable here, and the countryside therefore seems more primitive. In 1845 Vilhelm Kyhn came to Jutland as well, and he continued to paint Jutland subjects for the rest of his long

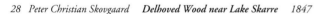

28 *Peter Christian Skovgaard* **Delhoved Wood near Lake Skarre** *1847*

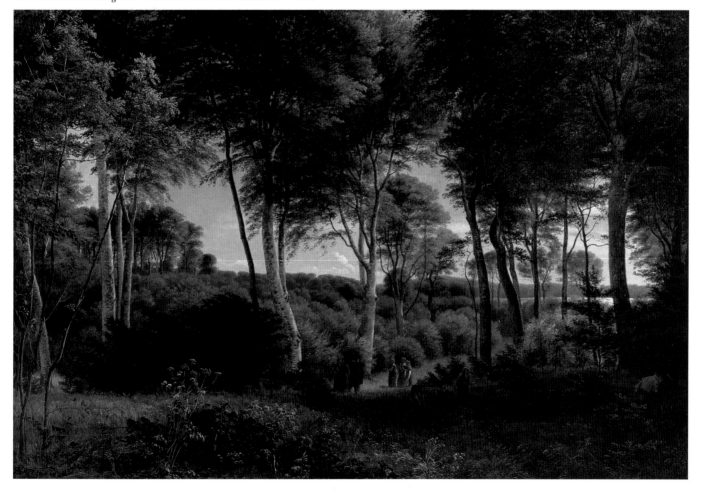

26 *Dankvart Dreyer* **View from Mølleknap Hills towards the Little Belt** *late 1840s*

life. His landscapes are sustained by lyrical moods and are wholly devoid of dramatic effects. His compositions were far more complicated that Lundbye's and avoided the latter's simplifying and unifying linear interplay. His landscapes consist of a wealth of details, all of which are given equal prominence in the composition as a whole.

Several of the painters evoked through their paintings a picture of Jutland that is reminiscent of the lowlands of Scotland. There was a good reason for this. Since 1821 they had derived inspiration from Sir Walter Scott's novels, which were carefully translated into Danish and just as carefully read.

In 1844 the art historian Høyen gave a lecture that was to have great significance for Danish art. He contended that it was a country's history rather than its geography that determined the national character of its people, and that painters should therefore try to depict scenes from their country's mythology and history. In preparation for this task he suggested that they should seek out and study rural people and fisherfolk living in distant parts of the country as they were likely to have upheld old customs and traditions. Høyen's encouragement failed to generate a new and vigorous class of history painting (Constantin Hansen made one attempt that was not a success), but instead it initiated a wave of scenes from Danish folk life imbued with the spirit of national Romanticism that was to continue through the 1850s and 60s. In this way the focus in Danish art switched from landscape painting to genre painting and a new era dawned. But it was also due to the

fact that towards the middle of the century the ranks of Denmark's artists were considerably thinned. Several of the most prominent artists died in 1848 (Rørbye, Købke and Lundbye) while others stopped creating art completely – or almost completely (Eckersberg, Jensen and Dreyer). During these years links with several of the Holsten painters were virtually severed. A few painters – Hansen, Roed, Marstrand and Skovgaard – remained, but they nearly all changed their mode of expression. The artistic milieu in Copenhagen was radically changed – the Golden Age of Danish painting was over.

The taste for national Romanticism in genre painting served to widen the range of subjects for Danish painters considerably, and ordinary farm people and fishermen made their appearance in Danish art. Painters such as Christen Dalsgaard (1824–1907), Julius Exner (1825–1910) and Frederik Vermehren (1823–1910) set about depicting the way these people lived. The result, however, was not a new form of realism, but to a pronounced degree a romanticization and idealization of rural life. Painters concentrated not so much on poor farmhands but rather on prosperous farmers, and although several pictures were painted that gave a sympathetic and detailed picture of everyday life, it was scenes of a happy and carefree existence that came to dominate. One can also note a pronounced lack of personal engagement in the treatment of these subjects; characterization was often excessively stereotyped. To begin with, Dalsgaard chose serious subjects and in 1857 painted a scene in which a village carpenter is

35 Vilhelm Kyhn *Landscape in the North of Zealand, Afternoon* 1849

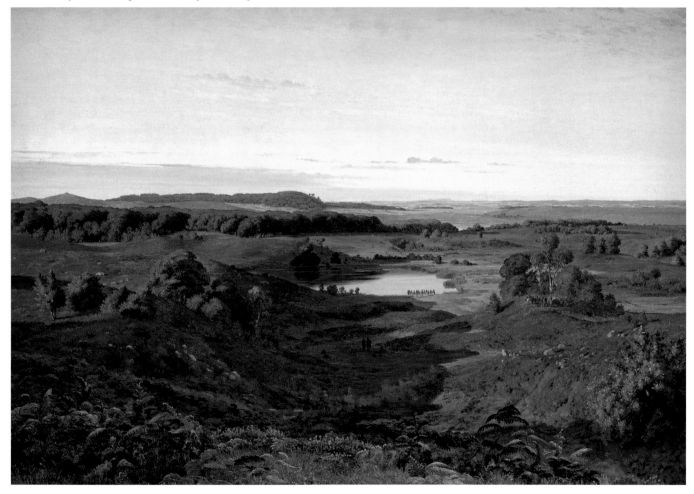

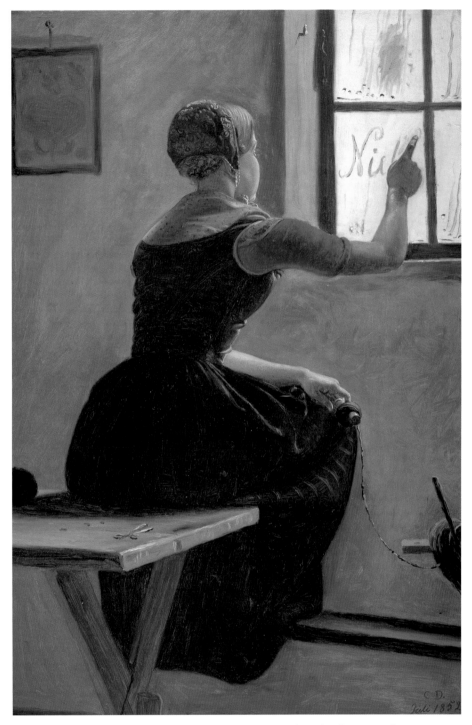

40 Christen Dalsgaard *A Young Peasant Girl from Jutland Writing her Beloved's Name on the Misty Window Pane* 1852

bringing a coffin to a young couple who have just lost their child (Statens Museum for Kunst, Copenhagen). But he soon concentrated almost exclusively on more romantic pictures, for example of a young farm girl peering longingly in the hope of seeing her lover. In 1855 Vermehren painted a serious and sympathetic picture of a shepherd on the Jutland moors. But at the same time he was deeply upset by the fact that the models he was able to find in the country failed to live up to his ideals of beauty. However, the most

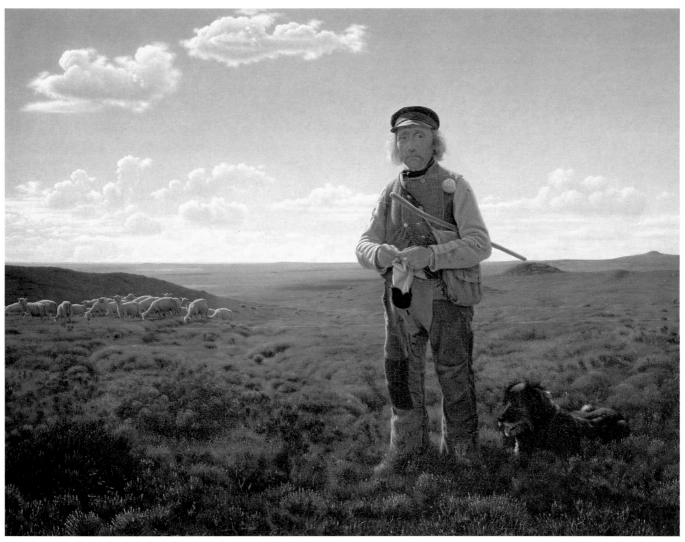

39 Frederik Vermehren *A Jutland Shepherd on the Moors* 1855

pronounced form of idealization was demon-
strated by Exner, who depicted rural life as an
endless form of celebration.

Høyen's nationalistic ideas were to
dominate the artistic life of Denmark, and
several artists whose orientation was more
international had difficulty in gaining recogni-
tion. The result was an artistic isolation that
deprived Danish art of vital contact with the
art of other countries and lasted from the
1850s until the close of the 1870s. Even the
obligatory study tour to Rome was unable to
change this. For many painters the encounter
with Italy now became a continuation of well
established artistic patterns rather than a
broadening of their artistic horizons. Not

until Danish painters once again turned their
attention abroad, towards Paris in the years
leading up to 1880, was the trail blazed for
artistic innovation. This came with the
naturalism of the following decade, when
personal experience and authenticity once
again became central in Danish art.

Translated by David Hohnen

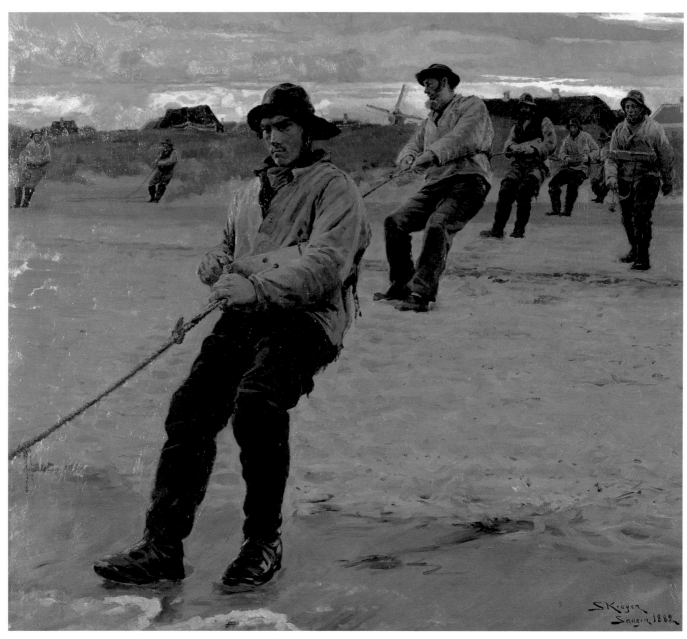

50 Peder Severin Krøyer **Fishermen Hauling in their Nets** 1882

Approaching the Turn of the Century

BY BENTE SCAVENIUS

The 1878 World Exhibition in Paris brought nothing but painful humiliation to Danish art. Great expectations were held of this event, so in all good faith the selection committee had chosen those works which it considered to be the most outstanding. But the committee obviously had little faith in the viability of the new generation of artists, since it had only chosen artists representative of the national romantic movement. And this was despite the fact that the conditions stipulated by the Jury of the World Exhibition excluded works produced before 1866. The Danish pictures were cleverly postdated, so that they could fulfil the formal requirements of the exhibition.

This embarrassing episode was to have catastrophic consequences for the Danish participants, for they were publicly ridiculed for their antiquated art. Both the technique and subject matter of the Danish painters lagged far behind that of the Realist and Impressionist painters in France. The French critic Victor Cherbuliez, who had noted in his review that the Danish painters were conscientious and industrious, wrote:

That which particularly characterises the Danish painters is that their brush is always clean, yes, far too clean, it is sleek, and nature is never sleek; to remove the dust, the scars and warts, to remove the spots, is to murder its beauty.

The repercussions of the World Exhibition in Paris created a heated debate in Denmark on whether the artists could develop in line with the new stylistic tendencies. Should art become French or should it retain its national character? This was the essence of the debate.

The younger painters had already made up their minds and had gone off to France, where they were inspired by naturalist painting *en plein air*. The first to go was Carl Locher, who started studying at Léon Bonnat's art school in 1876. He was followed by Laurits Tuxen and P.S. Krøyer and with their influence a new era in Danish art began. So from 1880 the French influence and Naturalism was

a reality, which became apparent to the Copenhagen art circle at the annual Spring Exhibition at Charlottenborg.

At Bonnat's school the young artists were taught to strive for an overall unity in their work using light and shade to create harmony. His most talented student was clearly P.S.Krøyer, who had an innate, magical talent. His technique and use of colour were superior to many of his colleagues. He effortlessly captured the image of his model and the moods of nature. Light played freely over his picture surface. No wonder that he attracted such a large audience from the very beginning.

Together with other members of the rising generation of painters *en plein air*, Krøyer

visited Skagen, the most northerly tip of Denmark. They were all enchanted by the unique light of the sea and the sky in Skagen. Krøyer's first visit was in 1882, and thereafter he went there every summer, becoming a natural focal point for all the other visiting artists, including those from Norway and Sweden.

It was not only the northern light which attracted the young painters to Skagen, but also the milieu of the fishermen, and the daily, dramatic struggle with the sea, the wind and the weather. Anna Ancher was more familiar with local conditions than anyone else, for she was a native of Skagen. Her parents were the owners of the famous Brøndum's Hotel, where

52 Peder Severin Krøyer *The Light Summer Nights at Skagen* 1885

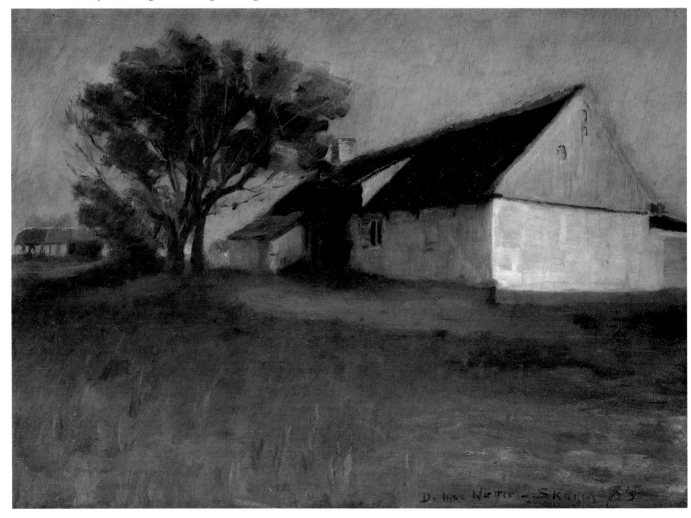

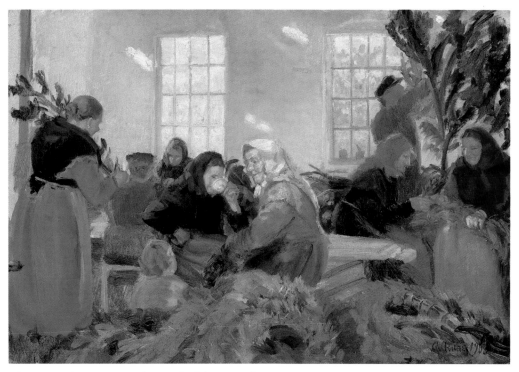

67 Anna Ancher **Women Making Garlands for a Festival** 1906

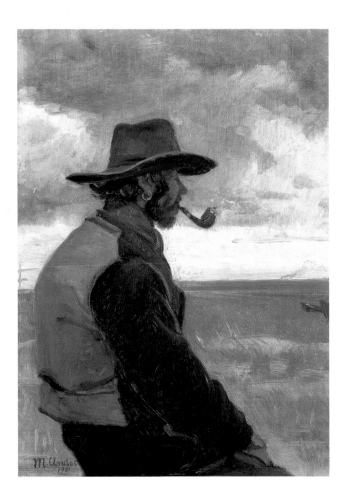

49 Michael Ancher
A Fisherman
1901

she was born on 17th August 1859 (incidentally the very day that the fairy-tale writer Hans Christian Andersen came to Skagen for the first time and stayed in the hotel).

Anna Brøndum was greatly inspired by the young painters who started visiting Skagen every year. She had always wanted to be an artist and had already painted her first picture when she met Michael Ancher in 1874. That summer proved to be mutually inspirational. The magnificent scenery at Skagen and the bluff, weatherbeaten fishermen were to become Michael Ancher's favourite subjects. His numerous heroic pictures of the fishermen demonstrate his deep and genuine understanding of the working conditions of these people. His social concern for the local population was completely in the spirit of Naturalism. Anna's acquaintance with Michael Ancher provided her first introduction to a career as a professional painter.

Anna and Michael Ancher were married in 1880 and set up home in Skagen, but they exhibited in Copenhagen every year. As the

55 Carl Locher *Stormy Weather. Højen* 1895

years passed, Anna developed into an exceptional colourist in the Naturalist vein. Since she had not been able to study at the Academy of Fine Arts, as women were not admitted until 1888, she had taken private lessons with Vilhelm Kyhn, the highly orthodox landscape painter. When she married, he suggested that she put aside her brushes in order to be a good wife to her artist husband. Fortunately she did not follow this advice. Instead she progressed quietly and steadily into one of the most significant painters of the period. She achieved recognition in her own lifetime, and in contrast to many of her female colleagues, she succeeded in being acknowledged by the male critics.

Anna Ancher clearly had an innate artistic instinct, for she was not noticeably influenced by foreign art movements. She was tempted to travel abroad only twice. The first time was to Vienna in 1882, when she accompanied Michael Ancher, who was participating in the World Exhibition with his painting *Vil han klare pynten?* (Will he Clear the Point?). The second time was when the couple travelled to Paris together in 1888. In this inspiring city she immediately felt attracted to the circle around Puvis de Chavannes, studying at his school for half a year. She was also fascinated by Manet's pictures. But she did not really enjoy being away from Denmark; short trips were enough for her. She preferred to stay at

home and paint her immediate, familiar surroundings. Her favourite motifs were life in Skagen and the women and children of the family pictured in the rooms of the house. Few of her contemporaries managed to capture everyday life with such authenticity and brilliance.

The Anchers met P.S.Krøyer for the first time on the trip to Vienna and invited him to Skagen the following summer. This was the start of a long and faithful friendship. It is claimed that Michael Ancher sometimes felt that Krøyer stole his motifs, but looking back it is clear that the two artists had little common ground in terms of temperament. Ancher was the true realist, involved in the social conditions of the local people, whilst Krøyer was the painter of moods and the passing moment. Krøyer was also the one who immortalised the festive and carefree times in Skagen, when all the artists enjoyed themselves together. The most famous example of these gatherings is *Hip,Hip, Hurra*, 1888, a large picture depicting a luncheon in Anna and Michael Ancher's garden. "It was a happy time", as it is written in one of the many accounts of the period. The painter Viggo Johansen also came to Skagen at that time,

45 *Michael Ancher* **Children and Young Girls Picking Flowers in a Field North of Skagen** *1887*

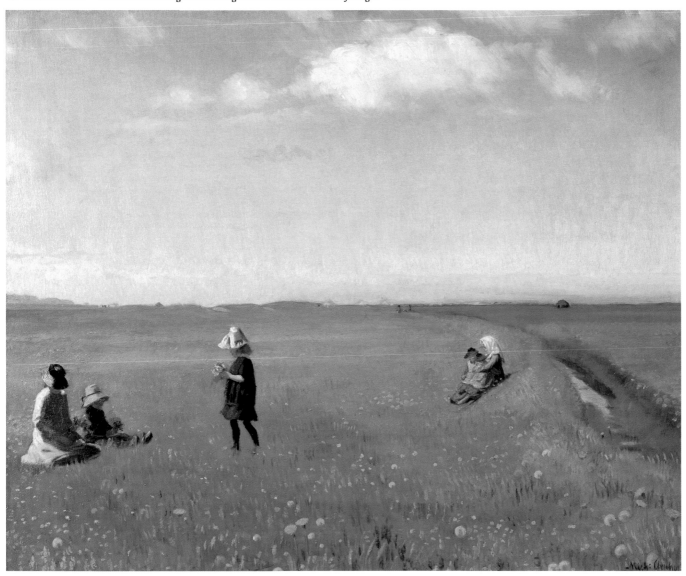

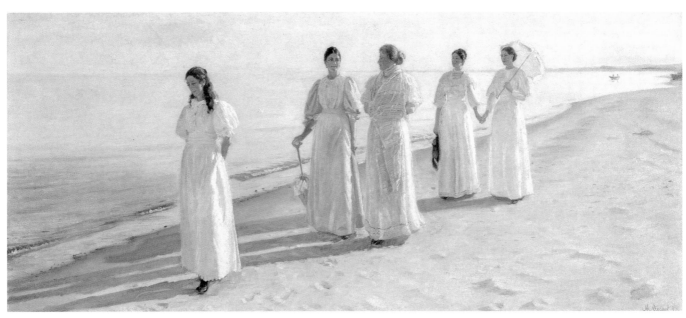

48 Michael Ancher *A Stroll on the Beach* 1896

61 Laurits Tuxen *Rhododendrons in the Artist's Garden* 1917

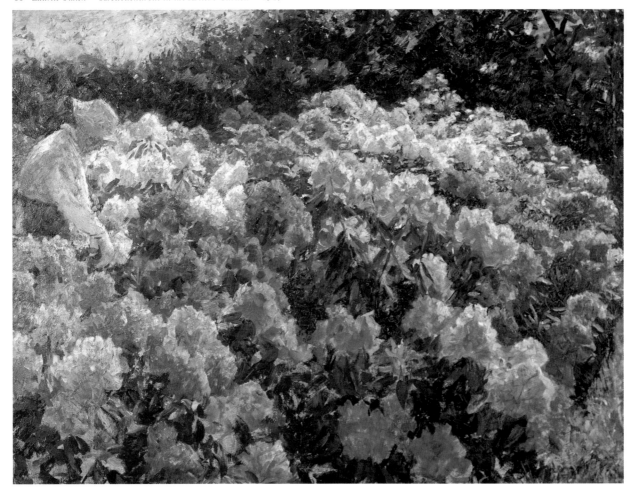

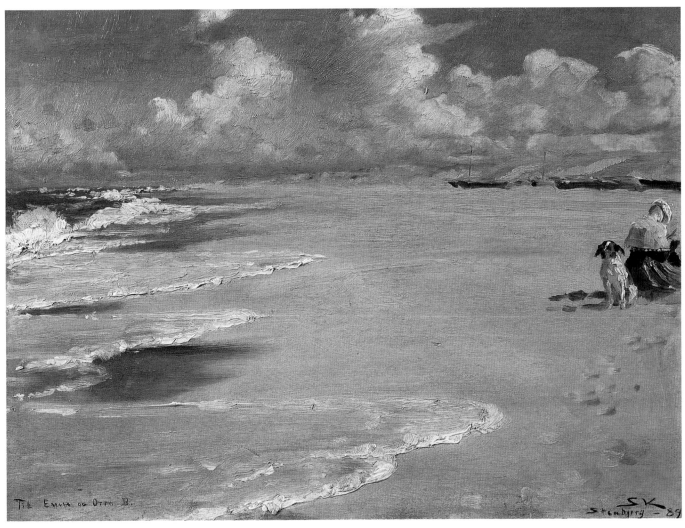

53 *Peder Severin Krøyer* **Marie Krøyer, the Artist's Wife, Painting at Stenbjerg Beach** *1889*

marrying a local girl, Anna Ancher's cousin, and so acquiring a natural link with Skagen and the Ancher family.

The carefree days in Skagen did not last. In 1890 Krøyer married the very beautiful young painter Marie Triepcke. The marriage was to plunge from the peaks of happiness to the depths of misery. When they married, Krøyer was a fêted celebrity while Marie was unknown as an artist. This disparity, coupled with her frail health and his progressive mental disorder was to have dire consequences. But before this tragic end, Krøyer managed to create a lasting memorial to Marie in his numerous pictures of her. He painted her lovingly and with great feeling for her beauty,

at home, by the sea and on frequent occasions, walking along the beach in the inspirational hour before sunset. For Krøyer this "blue hour" was the best time of day, because at this time the chromatic range of light was at its narrowest. Nobody could have surmised from all these pictures of Marie that the marriage was to end so sadly. The happy years in Skagen came to an abrupt end for the couple when P.S. Krøyer was hospitalised with manic depression in 1903. A couple of years later Marie left him for a Swedish composer, and she returned only once to Skagen, to attend Krøyer's funeral in November 1909. After that the Skagen period was nothing but memories. But in terms of art history, rich

59 *Viggo Johansen* **A September Evening. Skagen** *1889*

memories of a fruitful period.

The annual Spring Exhibition in Copenhagen was the place to follow the development of the Skagen painters, led by P.S. Krøyer, Viggo Johansen and Michael and Anna Ancher. Throughout the 1880s they exhibited frequently and were well received by the Copenhagen press. Anna Ancher often got the best reviews, and Krøyer had to suffer being criticised for his light, virtuoso brush-work, But they were all, without doubt, extremely popular.

But not all the young artists experienced the success of the Skagen painters. The 1880s was a revolutionary period in Danish art. At the Academy of Fine Arts the professors were still adhering to the national romantic tradition with their roots in the Danish Golden Age, and their reactionary attitude towards the new tendencies was evident in both their teaching and at the annual Spring Exhibition, which was censored. The first reaction to the professorial power of the Academy of Fine Arts was the establishment of the Artists' Study School, where students were able to take lessons from artists such as Laurits Tuxen, P.S. Krøyer and later on the painter Kristian Zahrtmann, who proved to be such a significant teacher that the influence of many of his students permeated Danish art well into the 20th century.

Amongst the other exhibitors at the

Spring Exhibition along with the Skagen painters were L.A. Ring and Hans Smidth. These two were true Naturalists, with a profound empathy for the conditions under which the poor rural population lived. Their favourite subjects were old people who had suffered a lifetime of hardship. Later in life L.A. Ring was to develop a more positive attitude, expressed in a long series of enchanting landscapes, following in the footsteps of the Danish Golden Age tradition. Like Krøyer, L.A. Ring often included his wife as a charming motif in his evocative scenes of the Danish countryside.

Vilhelm Hammershøi first exhibited at almost the same time as Ring. It was a debut which attracted considerable attention, since Hammershøi's aesthetic and lyrical pictures did not resemble anything seen in Denmark before. The critics felt that Hammershøi had more in common with Whistler's soft, evocative lyricism than with the plain and simple Danish Naturalism.

In the years following Hammershøi's debut, opinions about his painting remained divided. He even had to suffer the humiliation of having his pictures rejected by the selectors of the Spring Exhibition, including the brilliant picture of a young girl sewing. This painting was exhibited the following year at

42 *Hans Smidth* **A Storm Brewing behind Nørre Vium Church. Jutland** *mid 1890s*

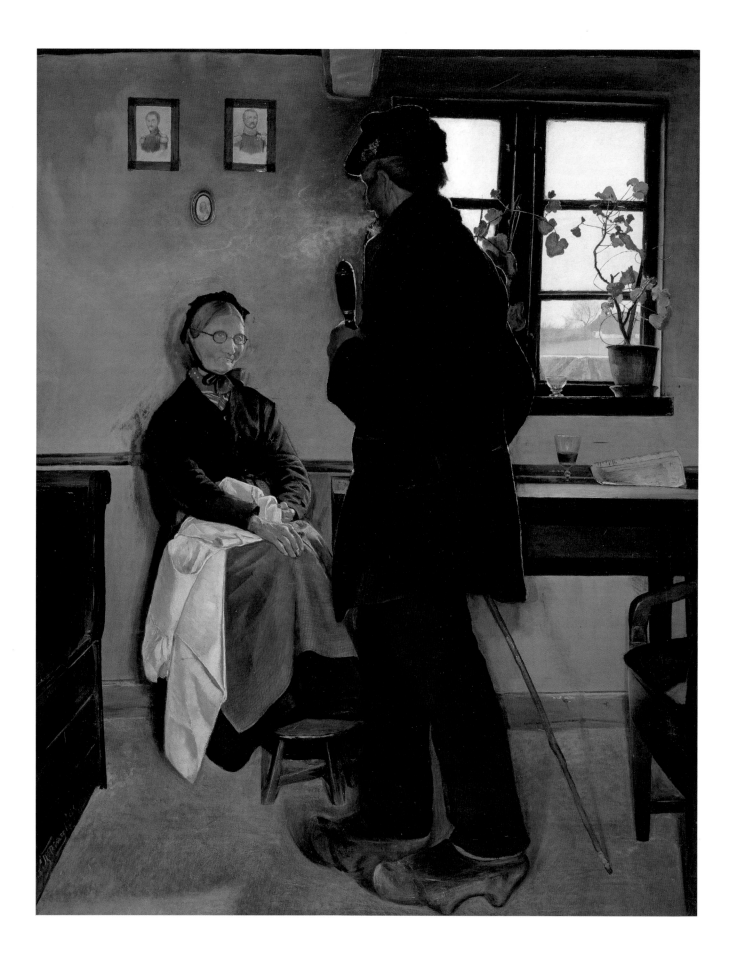

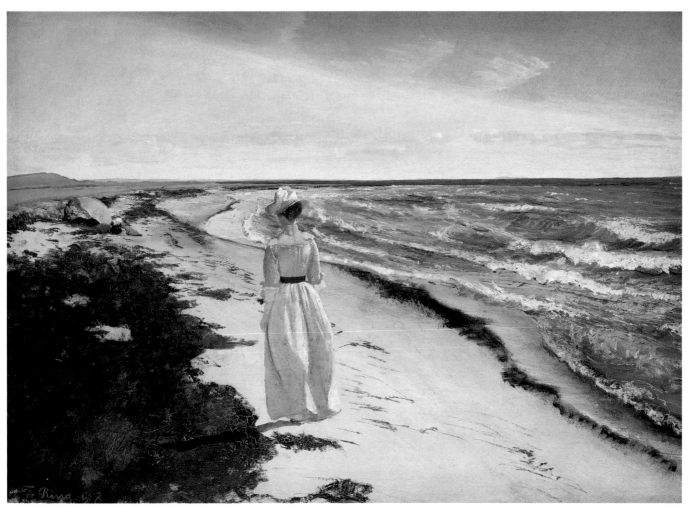

64 *Laurits Andersen Ring* **Lady at the Beach of Karrebæksminde. Zealand** *1898*

the Art Society in Copenhagen, where the French critic Théodore Duret saw it. He admired it more than any other work of Danish art he had seen during his stay.

More and more of the new generation of artists were, like Hammershøi, unjustly suffering the reactionary selection of the Spring Exhibition. This annual exhibition in Copenhagen was virtually the only venue for a young artist to make his debut. If one failed to win the approval of the selectors there were no other outlets, and so the need for an alternative exhibition venue arose. For several years the rejected artists tried a *Salon des Refusées* along the French lines. But as these were not exhibitions which aroused interest, more forceful measures became necessary. The time was

ripe to challenge the official selection committee at the Spring Exhibition. Just as the younger artists had disassociated themselves from the orthodoxy of the Academy of Fine Arts several years earlier, they now demonstrated their dissatisfaction with the tyranny of the Spring Exhibition. This led to the creation of *Den frie Udstilling* (The Independent Exhibition) in 1891.

For many years to come The Independent Exhibition was the most significant event in the Copenhagen art calendar. An exhibition of high artistic quality was successfully mounted every year. The artists responsible for the exhibition were not only those who had been excluded from the Spring Exhibition, but also established artists such as P.S.Krøyer.

73 *Vilhelm Hammershøi* **A Wing of Christiansborg Castle. Copenhagen** *1907*

However it was painters like Vilhelm Hammershøi, J.F. Willumsen, Johan Rohde, Agnes and Harald Slott-Møller, who were the most active participants and whose work consistently provoked debate. The Independent Exhibition included both the Naturalists and the Symbolists. It was this breadth which was the main reason for the vigorous debate on the true nature of art. Should art be truthful or should it be profound?

This eternal question was taken up by the Symbolists in the literary art journal *Taarnet* (The Tower), which appeared in the early 1890s and was edited by the author and critic Johannes Jørgensen. This important journal included articles about the French Symbolists, and texts by Baudelaire, Mallarmé and Verlaine stood side by side with texts by Danish authors of the period. The literary and theoretical debate in *Taarnet* as well as the debates provoked by The Independent Exhibition contributed to the artistic richness of Denmark during the last decade of the 19th century.

The Independent Exhibition, just like the Secessionist exhibitions in Vienna and Munich, became a focal point not only for painters and sculptors, but also for artist

75 Harald Slott-Møller **Primavera** 1901

153 Thorvald Bindersbøll **Dish** 1896

craftsmen. It also gained significance with the occasional exhibitions of works by contemporary foreign artists. One year the exhibition committee invited the Glasgow School of painters. In 1893 it caused a sensation by mounting an exhibition of works by Paul Gauguin (who had links with Denmark though his wife Mette Gad), as well as by the recently deceased Vincent van Gogh. This exhibition provided enormous inspiration for the younger Danish artists with subsequent reverberations throughout the Danish art world.

In the years prior to this sensational event, which took place in a little wooden building on Rådhuspladsen (the Town Hall Square) designed by Thorvald Bindesbøll, it was J.F. Willumsen's works which consistently attracted attention, because they broke with the traditional view of what could be considered good art. In the early 1890s Willumsen was inspired by Gauguin's Synthetist pictures

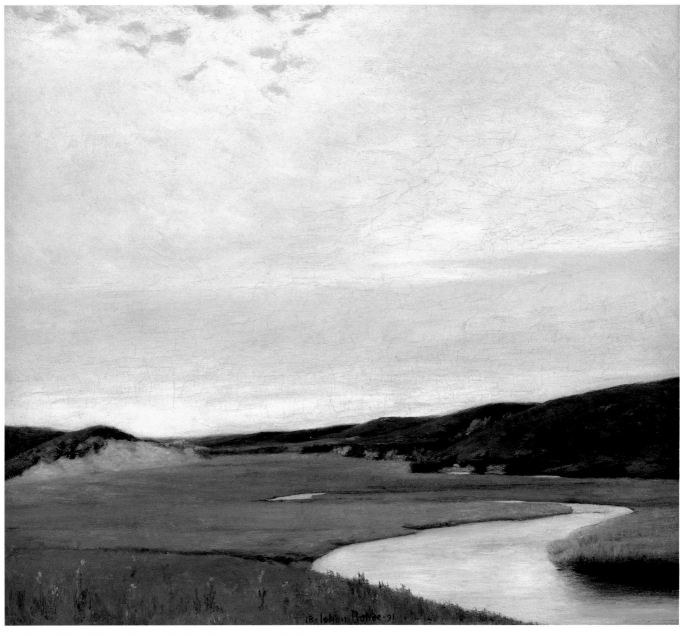

66 Johan Rohde *A Summer's Day at the Karup River. Jutland* *1891*

of Britanny, where the planes, contours and colours form a decorative whole. Willumsen spent a whole summer in Britanny, staying in Pont-Aven, which was to leave its mark on his painting both with regard to his style and his choice of motif. Like many of his contemporaries, Willumsen did not restrict himself to painting, but also worked as a sculptor and an architect. He was therefore a natural choice for the design of The Independent Exhibition building, constructed in 1897. This typical Secessionist building is one of the finest examples of the architecture of the 1890s.

The Danish art scene of the 1890s was characterised by very dissimilar interests. At The Independent Exhibition painters as different as Willumsen and Hammershøi would be hung side by side. Both represent the 1890s in Denmark in the same way as Gauguin and Whistler abroad. Hammershøi's intimate motifs portray a mood of absence in a calm and muted range of colours. These are empty

69 *Jens Ferdinand Willumsen*
The Green Girl Lying in the Woods *1922*

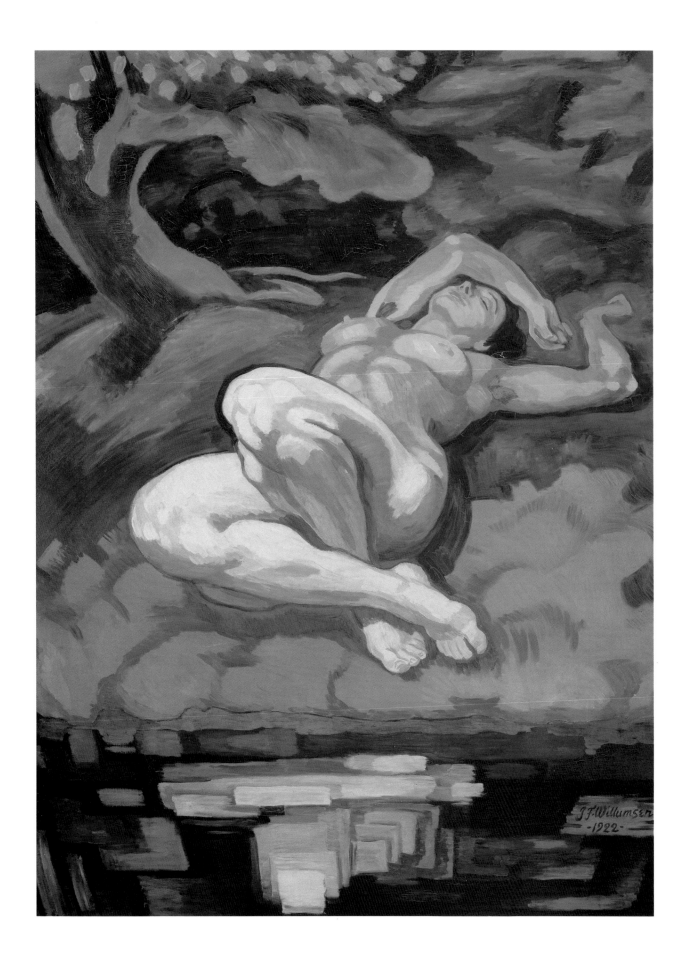

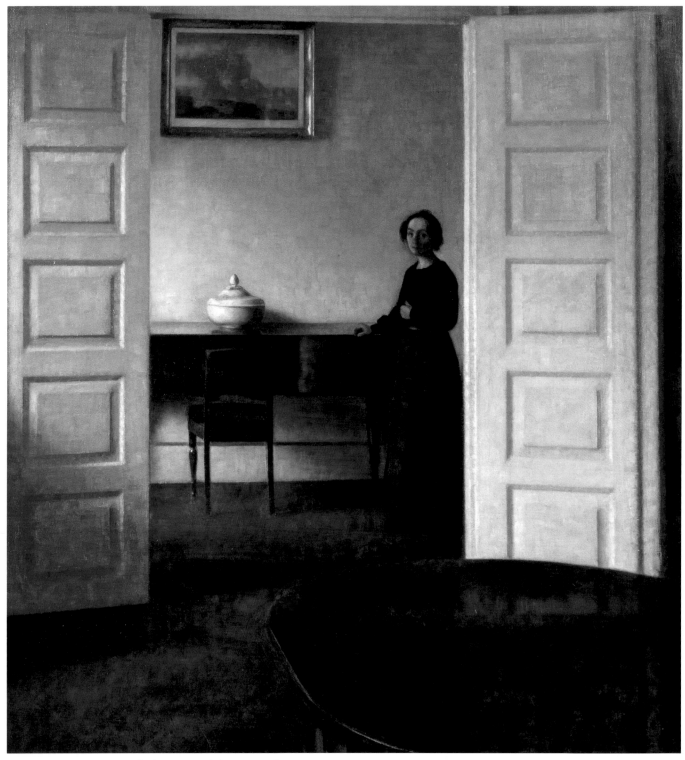

74 *Vilhelm Hammershøi* **Bredgade Interior with the Artist's Wife** *1911*

rooms, defined by open doors and closed
windows, sometimes with the odd piece of
furniture. The room is often occupied by a
woman half turning, dressed in black,
completely lost in her own thoughts. This lack
of animation permeates Hammershøi's
pictures, even when they contain people. His
many female figures reflect the fate of women,

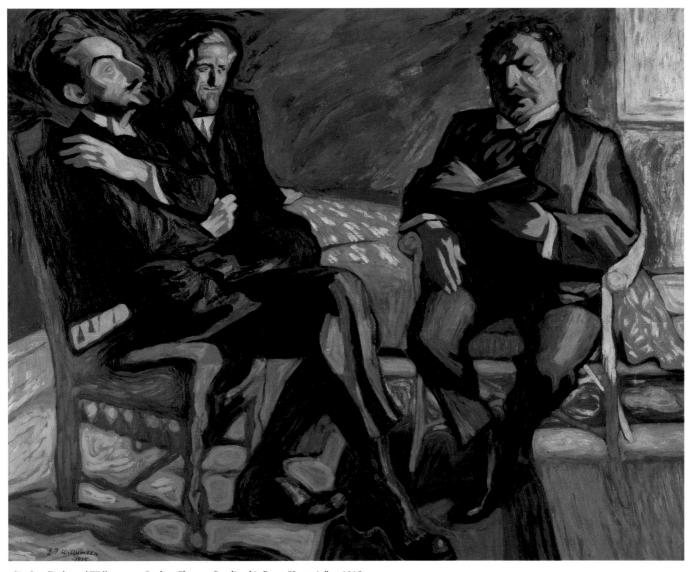

68 *Jens Ferdinand Willumsen* **Sophus Claussen Reading his Poem "Imperia"** *1915*

lonely and tied to the home. But in the midst of all this melancholy, Hammershøi manages to express a rich inner spirituality, which reaches far beyond the familiar and commonplace.

In the 1890s many of the young painters were still inspired by ordinary everyday life in their selection of motifs. This was especially true of the group of painters who were known collectively as *Fynboerne* (The Funen Group). They had all been students of Zahrtmann and exhibited at The Independent Exhibition in the final decade of the century. These young Naturalists, whose background was the small

agrarian society on Funen, were often held up as a healthy, down to earth contrast to the more decadent and intellectual art which followed the literary theories of Symbolism. This was bound to create a conflict in such a small artistic milieu as Copenhagen at the end of the 19th century. The confrontation finally came during the first years of the 20th century, thus sowing the first seeds of the breakthrough of modernism in Denmark.

Translated by Vivien Andersen

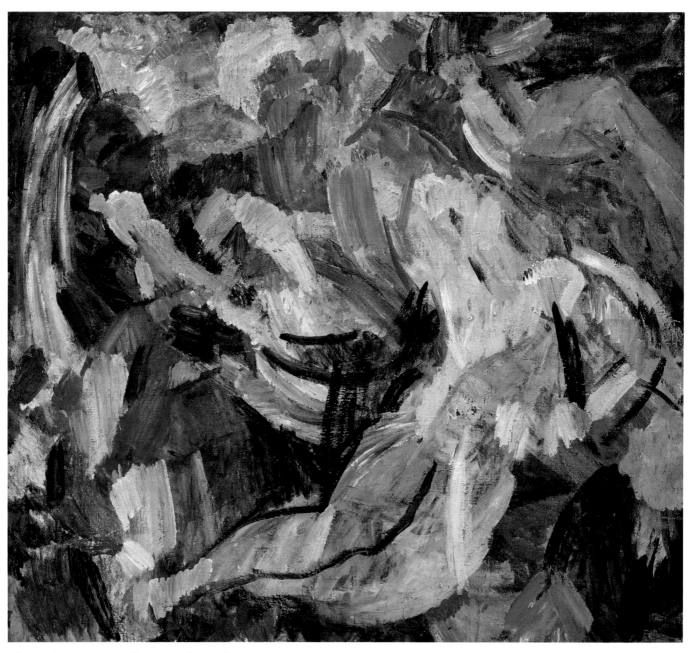

79 Edvard Weie *Romantic Fantasy. Sketch* 1922

Internationalism and National Identity

A Brief Overview of the Key Figures and Movements in 20th Century Danish Art

ANE HEJLSKOV LARSEN

In an age of mass tourism, the old maxim "to travel is to live" has become a somewhat jaded cliché. But when it was first uttered by the Danish fairy-tale writer Hans Christian Andersen in the 19th century, it sounded almost like a mission statement for the artists of the period. The motivation for travel was quite simple: to educate oneself and seek inspiration abroad. And in that sense travel is still important for Danish artists. It has always been necessary for artists from a country as small as Denmark to venture forth to absorb new impressions.

The favourite destination for the painters of the Danish Golden Age was Italy, and Rome in particular. In the ruins of the Forum Romanum and the countryside around Rome they discovered the remains of a former glory, which they depicted in small, bright and harmonious pictures – dreams of Arcadia and Elysian Fields.

Half a century later Italy was still the place for art – for the painter Kristian Zahrtmann

(1843-1917) – but he swopped classical Rome for the small simple mountain village of Civita d'Antonio, which was his own personal discovery. There was more than a change of subject matter – Zahrtmann's work was very different to that of the Golden Age painters, especially his treatment of light.

Zahrtmann played an important role teaching generations of young artists attending the Artists' Study School in Copenhagen, and from 1883 he often spent the summer months in Civita d'Antonio, together with his young students as part of the curriculum. Some of these students were to become the key figures in Danish art at the beginning of the 20th century: the Swedish-Danish painter Karl Isakson (1878-1922), Edvard Weie (1879-1943), Harald Giersing (1881-1927) and Olaf Rude (1886-1957).

Zahrtmann's teaching was less orthodox than that of the Royal Danish Academy of Fine Arts. He tolerated experimentation and encouraged his students towards radicalism

and to disdain easy solutions.

He did however adhere to his admiration for the Old Masters of the Italian Renaissance and classical Greek art, even when the younger generation was being influenced by French art through prints, exhibitions and trips to France.

The young generation of modern artists around the turn of the century preferred Paris and France to Rome and Italy. For instance, Harald Giersing lived in Paris from 1906 to 1907, Olaf Rude was there in 1911, and Edvard Weie's first visit took place in 1912. The young Vilhelm Lundstrøm (1893-1950) was not satisfied with numerous visits to Paris in the early 1920s; he actually lived in Cagnes-sur-Mer on the Riviera from 1923 to 1932.

The ensuing generations of abstract, Surrealist and Expressionist artists maintained the interest in France. Richard Mortensen (1910-1993) and Robert Jacobsen (1912-1993) both left for Paris in 1947 and did not return home until the 1960s. Asger Jorn (1914-73) received his training there, studying under Fernand Léger.

But typical of the trend after 1945 was the attempt by Asger Jorn and the other Cobra artists to shake the dominant position of Paris. The name Cobra itself was formed from the first letters of the three capital cities of Copenhagen, Brussels and Amsterdam, and the Cobra artists attempted to create new formative centres of art. Their success was shortlived, only lasting until 1951, when the Cobra group split up.

Nevertheless the Cobra initiative was an expression of the trend which was already apparent on the international art scene. The European centres of art were losing ground to new centres on the other side of the Atlantic, first New York and then Los Angeles.

But European destinations were still most popular throughout the 1950s and well into the 1960s. In addition to Paris, Danish artists affiliated to the Fluxus movement, such as Arthur Køpcke (1928-77), visited Berlin, Wiesbaden and Düsseldorf.

In the 1960s the new generation of Danish artists started turning towards the USA. Per Kirkeby (born 1938) and Peter Louis-Jensen (born 1941) went to New York in 1966. But the extensive media coverage of the art world allowed most Danish artists to follow developments through the journals and exhibitions in Europe. It was expensive to visit the United States, and moreover there was a great difference in mentality. The Danes did not take to the United States in the way that earlier generations had taken to France, and so no colony of Danish artists was ever established in the United States.

In the early 1980s, the impact of developments in Berlin, Cologne and Hamburg was very strong, but as the decade progressed, destinations beyond Europe and the United States were also being explored.

The trend in the 1990s is for each artist to select a destination which suits his own needs - and not necessarily to seek out a specific artistic circle. Each individual artist finds the place which will answer his personal quest. For instance Per Kirkeby has even made a lifestyle out of tackling a new place every year. It was Bali in 1987, Polynesia in 1988 and Morocco in 1989. Some of the younger generation such as Claus Carstensen (born 1957) and Peter Bonde (born 1958) are taking after him in this respect. The volume of information about art has become so great that artists almost seem to need to distance themselves from the centres and to choose destinations which have no associations with contemporary art and culture. The destinations chosen have become a subjective and intellectual statement.

Form and Colour - The First Danish Modernists

Immediately prior to the First World War, a rapid succession of radical works appeared on the international art scene. There was, for instance, Pablo Picasso's *Les Demoiselles D'Avignon* in 1907, followed by his collages in 1911. There were Wassily Kandinsky's Abstract Expressionist compositions, first appearing in 1910, Kasimir Malevich's *Black Square on White Square* in 1913 and Piet Mondrian's first Plus/Minus series in 1914.

However Danish Modernists of the period were not very receptive to the ideas contained in these avant-garde works, nor fully appreciated the radical nature of these artists. Instead the Danes made a broad study of French art in order to identify arguments for the liberation of art from the shackles of Naturalism. The aim was to introduce new "painterly" qualities and thus new content to Danish art, in opposition to the establishment Academy of Fine Arts and *Den Frie* (The Independent Exhibition).

The leading Danish Modernists can be divided into roughly three generations: Karl Isakson and Edvard Weie, born in the 1870s: Harald Giersing and Olaf Rude, born in the 1880s: and Vilhelm Lundstrøm, born in the 1890s. Each generation created the foundations for new artistic insights and interpretations of reality.

Edvard Weie (1879-1943) was very influenced by Symbolism, which was not only apparent in his painting technique and selection of motifs in his early years, but ran as an undercurrent throughout his artistic oeuvre and philosophy. In the essay *Poetry and Culture*, which was not published until after his death, he wrote that form should not originate in external reality, but in the mind, and he understood the "painterly" as a state of mind.

He regarded Impressionism and Expressionism merely as steps towards the creation of a spiritual perception of Nature and Neo-Romantic dramatic art, leading to the supernatural. In his opinion, Karl Isakson was the artist who had paved the way for this new art with his experiments with colour and complementarity.

For Weie the essence of the painterly in other words was "colourist plasticity": the construction of the picture in planes of colour whose mutual contrasts produce life. He drew parallels between the picture and a piece of dramatic music, where each colour plays a part within the whole. In one still life after another he worked on building up the picture in these complementary fields of colour without the use of outline or shading.

The still lifes were only preparations and exercises for the large figure compositions, which were closest to his heart. The 1922 picture *Romantic Fantasy* of a young man under a tree in a lyrical abstracted landscape with naked figures dancing in the background is the product of Weie's ideas about a dramatic, natural and romantic narrative of a mental impression. Weie was however never completely satisfied with his pictures, and he often used the same motifs over and over again in order to reach the essence of the subject – the underlying spiritual idea. There are therefore a number of different versions of the *Romantic Fantasy*.

Harald Giersing (1881-1927) had a different view of the painterly principle from Weie. Influenced by Paul Gauguin and Henri Matisse, he had a purely aesthetic view of art and believed that the content of a picture was confined solely to the beauty which could be expressed in colour, line and form. The picture had its own rules, and these were purely formal: "By composition I mean not only the ability to create figures in a picture, but the ability to make a picture perfect in its formal existence, in perfect arabesques." (Harald Giersing, 1909)

The Judgement of Paris, 1908-09, is a beautiful example of Giersing's conception of the picture as a perfect arabesque. Three figures, actually using one model in various positions, stand in a semi-circle around a male figure in rear view. The title refers to the mythological story of Paris choosing one of the three goddesses Athene, Hera and Aphrodite, but the picture is concentrated around a simple colour range, white, black, ochre and blue-green, the ornamental tracing of the outlines across the picture surface, and the arrangement of the figures in the small, anonymous space. The subject is only an excuse to paint – the vehicle for the more important aesthetic form.

Even though Weie and Giersing did not express a common goal for their art, they could work together. They both liked the picturesque island of Christiansø, which from 1911 onwards became the favourite summer gathering place and source of subject matter for the painters following trends in French art. The clarity of the light, the luxuriant and almost exotic vegetation and especially the temperamental activity of the waves against the

Harald Giersing ***The Judgement of Paris*** *1908-09*

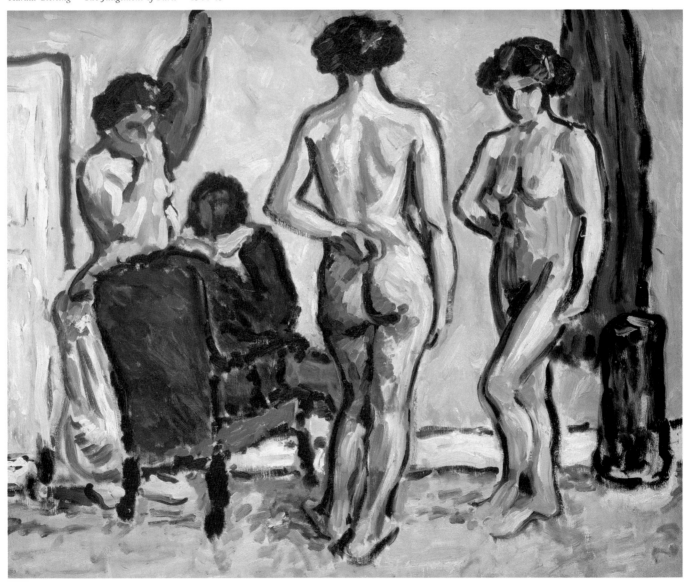

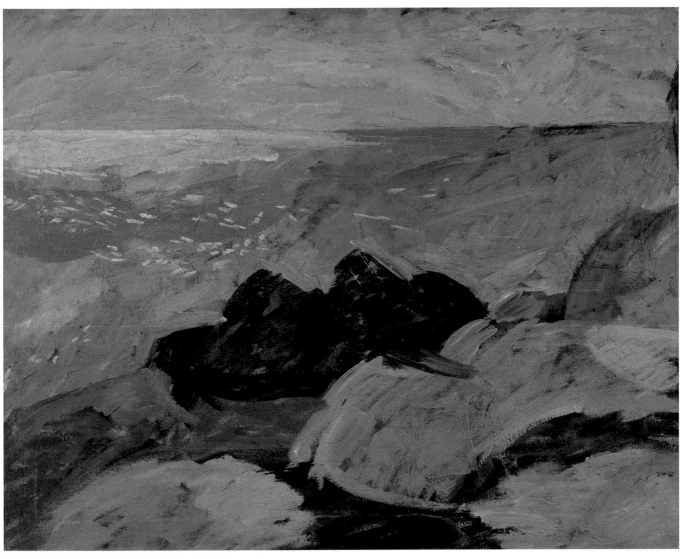

77 *Edvard Weie* **Reflections of the Sun on the Sea. Christiansø** *1913*

rocks defined Christiansø as the most picturesque place for them in Denmark.

In many ways Harald Giersing was the most influential figure of his generation. In 1915 he was one of the co-founders of a new association of artists, *Grønningen*, which was initiated partly following a split in *Den Frie*. And in 1917 Giersing wrote some of his famous aphorisms, such as "Nature is nothing, the picture is everything" and "The edge of the frame is the most powerful effect of the picture" in the newly established journal *Klingen*, which was to become the mouthpiece of the Modernists.

It was not until the publication of *Klingen* in 1917 that Danish Modernists began to perceive themselves as a real movement and part of an international front. And that was despite the early exhibition of Futurist, Expressionist and Cubist art in Copenhagen. For instance Herwaldt Sturm, the German editor of the journal *Sturm*, had organised several avant-garde exhibitions in Denmark, and people were collecting international art, which they made accessible to interested parties.

However, during the last year of the war, Futurism and Cubism became the height of fashion, and amongst those hopping enthusiastically on the bandwagon were Olaf Rude (1886-1957), Jais Nielsen (1885-1961),

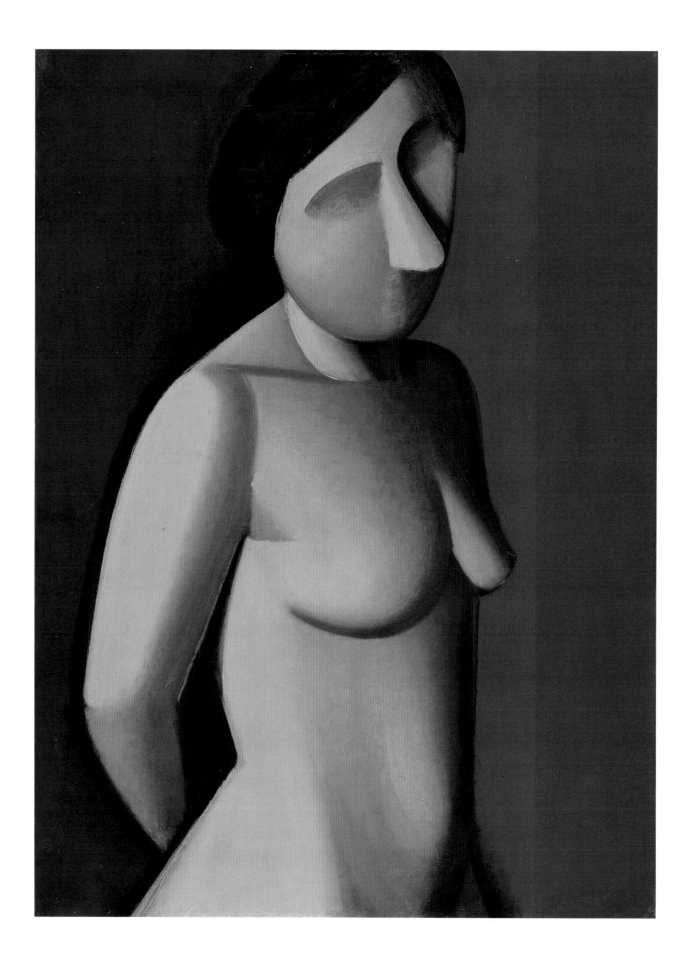

William Scharff (1886-1959) and Harald Giersing. They turned to sport and café life for the subject matter of their pictures; they fragmented the picture space and arranged motifs in colour fields and geometric forms. Common to them all was a strictly flat style and an emphasis on decoration.

The products of the radical new direction were shown at the Artists' Autumn Show in 1917 and 1918. At both exhibitions it was the young painter Vilhelm Lundstrøm (1893-1950) who was the centre of attraction, or rather scandal. He was the first Dane to introduce the element of collage in the form of prefabricated materials into a painting. In 1918 he exhibited his so-called cardboard box pictures, which were more radical than any of the works of other modern Danish painters. He had mounted pieces of wood directly onto the canvas as part of an aesthetic composition of colours and lines. The pictures were entitled *The First Commandment, The Second Commandment* and *The Third Commandment.*

Professor Salomonsen's pamphlet *Infectious Mental Disorders* was published in 1919 in reaction to this Modern Art. Here he postulated a hypothesis about a mental disorder "Dysmorphism", which had spread amongst the new generation of artists. The disorder caused a deliberately ugly distortion of the beautiful products of nature. It was obvious that Salomonsen did not sympathise with the rejection of Naturalism by the Modern movement, and there were plenty of articles by supporters, some of whom tried to explain that the goal of modern art was to work with form and the images of the mind, and not with direct impressions of the senses.

But the Dysmorphism debate and the radicalism in Danish art was shortlived. In the course of 1919 the abstract trend was overtaken by figuration. Several Modernists returned to Naturalism in one form or the other, whilst others strove towards a new classicism.

Vilhelm Lundstrøm took leave of Cubism

with a little pictorial trilogy in 1919, and by 1923 he was developing a monumental classical figurative style. He gradually warmed to purist ideas and constructed his compositions with simplified, anonymous forms and colours, placed in neutral surrroundings. Lundstrøm wanted colour, form and composition to fuse into a "painterly harmony". An example of this style is his 1930 *Female Model.* His paintings were to have a profound influence on the subsequent generations of abstract painters.

Modernism brought about the autonomy of painting, where beauty and emotions could be expressed freely. The artists became preoccupied by "painterly qualities", working with the composition of still lifes and models. But the new conception of reality in art could never fully liberate itself from Naturalism. The Danish Modernists left the final showdown with representation to later artists.

The World of Dreams - Abstract Surrealists

Wilhelm Freddie (born 1909) introduced Surrealism in 1930 with his painting *Freedom, Equality and Fraternity,* but it was Vilhelm Bjerke-Petersen (1909-1957) who wrote the manifestos and created a theoretical basis for the movement in Denmark.

After a period at the Bauhaus in Dessau from 1930 to 1931, Bjerke-Petersen committed his thoughts on the latest European ideas to paper in his 1933 book *Symbols in Abstract Art.* He had been particularly influenced by the theories of Wassily Kandinsky and Paul Klee. In the book he deals both with abstract art, whose means of expression are line and colour and their effects, and which challenges illusionism or Naturalism, as well as with a kind of art which held the symbol as its Alpha

85 Vilhelm Lundstrøm
***Female Model** 1930*

and Omega. "In abstract art we will find expressed all forms of life that lie within our knowledge. We will find nature which surrounds us, killed and robbed of its conditions for existence. We will find a new world, symbolising nature, but created in a new material and instilled with the characteristics which are necessary for its existence in this new world. The symbol is man's own production - the symbol is the highest form of artistic expression."

In 1934 the artists' group *Linien* (The Line) was formed, including Vilhelm Bjerke-Petersen, Ejler Bille (born 1910) and Richard Mortensen (1910-1993). The journal *Linien*, edited by Bjerke-Petersen, was also published that year.

The *Linien* group associated itself with the ideas about Abstract Surrealism which Bjerke-Petersen had outlined in *Abstract Symbols*. But agreement on the interpretation of the significance of Surrealism was only shortlived. While Richard Mortensen and Ejler Bille continued to adhere to Vilhelm Bjerke-Petsersen's theories, he himself abandoned them for a form of art where Surrealist symbols were more directly linked with the world of dreams and the subconscious. Bjerke-Petersen had to resign as editor of the journal *Linien* and he was replaced by Ejler Bille.

After his break with *Linien*, Bjerke-Petersen started a new journal, *Konkretion*, totally dedicated to Surrealism. The manifesto was written by Wilhelm Freddie: "We believe that the exposition of the subconscious (our dreams, drives and impulses) will lead to a sounder and more universal art than hitherto..." The stage was thus set for a split of the Danish Surrealists into two groups: one included Wilhelm Freddie and Bjerke-Petersen, representing symbolic narrative painting, aimed at making sexuality and the subsconscious the driving force for art; the other including Richard Mortensen and Ejler Bille, which preferred a poetic interpretation of Surrealism, where there was a place for imagination and reason.

Max Ernst, Salvador Dali, and Yves Tanguy were Freddie's sources of inspiration. But he was a complete individual. His overtly taboo subjects caused one scandal after another on the Danish art scene right up to the 1960s, linked as they were to the powerful aesthetic force of his pictures. Artistically he was the most prominent of the narrative symbolic Surrealists.

His first paintings were blatantly aggressive and contained violent outbursts against the sexual hypocrisy of the bourgeoisie. In 1937 he called an exhibition *Pull the fork out of the Eye of the Butterfly. Sex-surreal.* The police confiscated 6 of the exhibited works because of their overtly sexual content. Three of them were later transferred to the Museum of Crime and not released until 1963 after numerous court cases.

At another exhibition in 1937, Freddie attacked the spread of Nazism in Germany. The German Embassy in Copenhagen applied to the Danish Foreign Ministry demanding to have a picture entitled *Meditation on anti-Nazi painting* confiscated. It was instantly removed from the exhibition and Freddie was banned from travelling to Germany.

The classification of Freddie as a "degenerate" artist meant that he had to flee to Sweden during the occupation of Denmark, staying there until 1950. During the war years his paintings underwent tremendous changes. His former mischievous eroticism was replaced by dark and horrible motifs which evoked associations of war and destruction. Man was portrayed as a fearful being, who is crippled by his own actions. In the 1947 painting *Solitude*, man is thus portrayed as a robotic machine, frozen in desperate loneliness and unarticulated movements.

Whilst Freddie was challenging morality, society and the powers that be, Richard Mortensen and Ejler Bille were working towards new conceptions of the picture.

Only a year after the split with Bjerke-

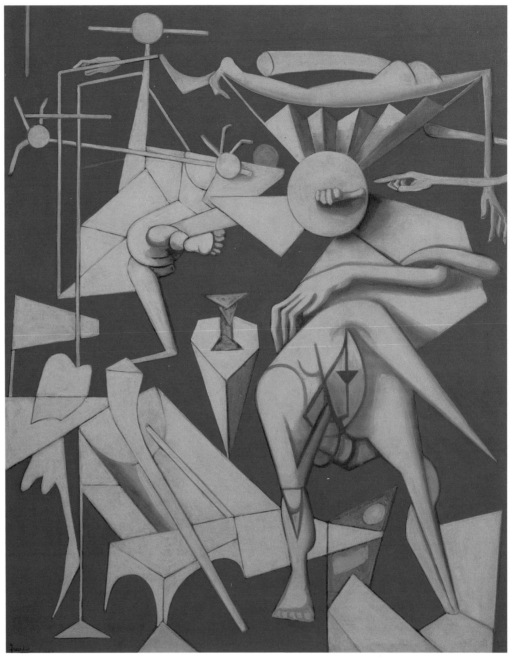

86 *Wilhelm Freddie* **Solitude** *1947*

Petersen in 1934, the journal *Linien* folded due to economic difficulties. But the group *Linien* survived and two years later, strengthened by new members including the sculptor Sonja Ferlov Mancoba (1911-1984) and the painter Egill Jacobsen (born 1910), it was in a position to present a comprehensive exhibition of works by members of the group together with works by Kandinsky, Miro, Hans Arp,

Max Ernst, Piet Mondrian and Paul Klee. It was their response to a corresponding exhibition which Bjerke-Petersen had organised in 1935, and from which the Abstract Surrealists had been excluded.

The philosphy of *Linien* was continued by the *Linien II* group, established in 1946/47 to strengthen abstract art, whose role models included Richard Mortensen.

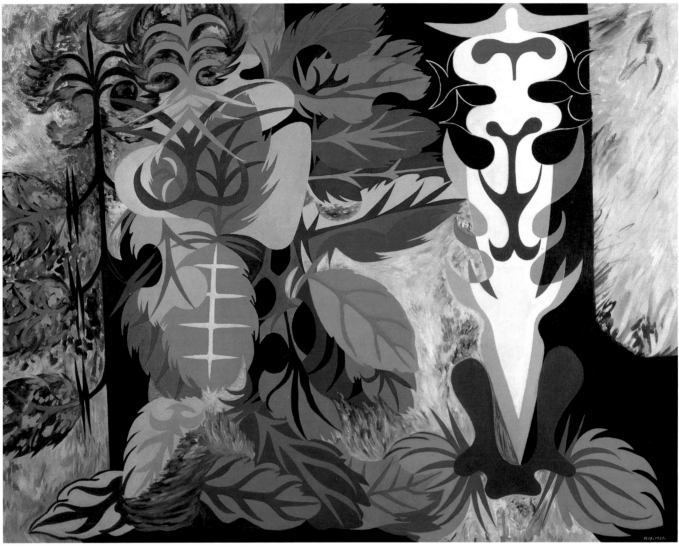

91 Richard Mortensen **Botanical Portrait** 1937

Throughout the 1930s Richard Mortensen had developed a form of abstract organic painting, with associations of natural forms. Using "automatic" writing as his tool, the picture surface was broken up into colour fields which move in and out of each other and form images of fish. The 1937 picture *Botanical Portrait/Confrontation/Metamorphosis* is one of the main works from this phase in Richard Mortensen's production. Natural growth is presented in sprouting organic forms. However, as the events of the war around Europe accelerated, Mortensen's painting became wild and desperate. The soft sprouting shapes of *Botanical Portrait* are replaced by destructive whirling brushstrokes. In a remarkable series of pictures, the classical mother and child motif is shown in a disintegrated state – the mother resembles the god Moloch, to whom children were sacrificed, and the child resembles a slaughtered animal.

When the war came to an end in 1945 these scenes of horror were superseded by a new vision.

Concrete and Kinetic - The Abstracts

The Second World War and the German occupation of Denmark had meant isolation for the artists and had prevented access to new information and insights. When it came to an end in 1945 several of them felt the need to travel abroad. The old links with France were restored. Here a kind of purification process was happening. The lessons of the Nazi cultural propaganda and its misuse of naturalistic imagery led to an attempt to liberate painting from any trace of representation; and the Denise René Gallery in Paris became the focal point for a large number of international

*93 Richard Mortensen **Bolléne** 1954*

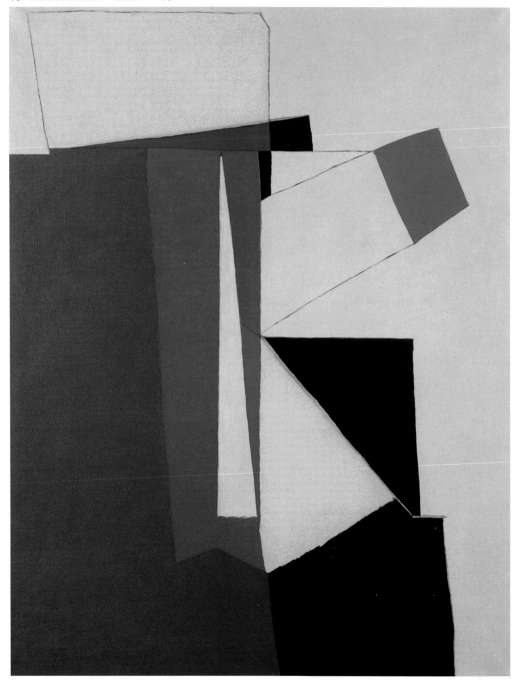

artists, including the Russian Serge Poliakoff, the Frenchmen Jean Deyrolle and Jean Dewasne and the Hungarian Victor Vasarely.

Richard Mortensen (1910-1993) and Robert Jacobsen (1912-1993) set off for Paris in 1947 and joined the group. "What they were working on was the elimination of all recognisable elements from the picture – to remove the perspective and align the picture with the plane. This also applied to sculpture. It was very fascinating. We actually created an art which had not really existed before", Robert Jacobsen recalled in an interview in 1991. Perhaps this does not sound too original. Back in 1910, Wassily Kandinsky had written his book *Concerning the Spiritual in Art,* arguing for pure abstraction in painting. But it was the Denise René group which pursued his ideas with a hitherto unseen radicalism.

The artists systematically explored both form and colour and regarded the painting as a movable and undelineated surface. Even individuality and traces of the brushstroke were prohibited by some of them. A new Concrete art was to be created – universal and democratic – for everyone could understand lines, colours, space and movement without prior knowledge.

As part of this international circle of Concrete artists in Paris, Robert Jacobsen and Richard Mortensen became well-known throughout Europe.

Richard Mortensen did not find it difficult to change to yet another form of expression. He had already paved the way for flat surface painting in his botanical pictures from Bornholm painted in the late 1930s, and he now used these experiences to develop further.

From the late 1940s he energetically began to paint his pictures in the Concrete style, and he never changed again, although at times some more or less recognisable motifs did crop up in his pictures, and the picture titles refer to world political events and the places where he had stayed. It is this style that he is internationally famous for.

From 1947 until his death in 1993 his work can be conceived as a long sequence of series, following each other at intervals. From the mid 1950s onwards they deal with the creation of an egg-shaped and optically multi-dimensional space, with the colour fields tipping in and out of each other in rhythmic movement – contracting and expanding again like some eternal heartbeat. Using his knowledge of the latest findings of the psychology of perception, he replaced the relationship between figure and ground with a splintered dynamic view of space.

Robert Jacobsen's sculptures were also to change character after he went to Paris with Richard Mortensen in 1947. Until then he had worked in wood and stone and with a mythical fantastic content, but now started working in iron. He used this material to create a scaffolding of lines and spaces which seem to move in relation to one another. From 1948 to 1953 he developed a series of iron constructions painted in black and concentrated on the form – every recognisable and narrative feature was eliminated. It was almost as though he was drawing in space with the iron, which is why he called one of his 1948 sculptures *The Limits of Space.* He wanted to create a plastic idiom which was equivalent to the objectives of contemporary painting.

Neither Richard Mortensen nor Robert Jacobsen ever became dogmatic in their view of Constructivism. Jacobsen always worked spontaneously with his material, and it is therefore typical of him that in the 1950s his playful approach led to the production of *The Dolls.* These figures resemble people, and are reminiscent of primitive art, but use very sophisticated material effects; cycle chains, nuts, pipes, etc. are transformed into symbols and signs.

In 1951 Richard Mortensen and Robert Jacobsen were amongst the organisers of the exhibition *Klar form* (Clear Form) with their own works as well as those of Jean Arp, Victor

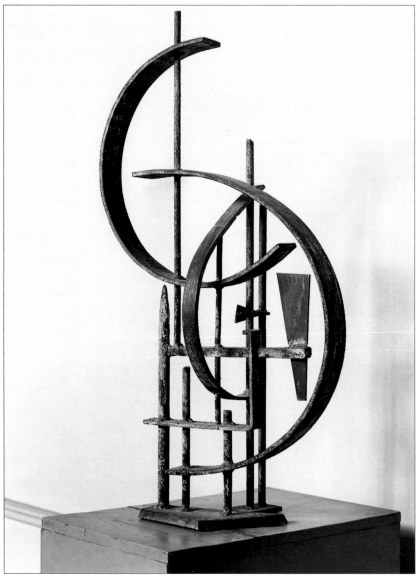

101 *Robert Jacobsen* **Statique II. Construction** *1959*

Vasarely, Auguste Herbin, Fernand Léger. The Exhibition toured to Copenhagen, Stockholm, Oslo, Helsinki and Liège. It had a profound impact on the Danish and Scandinavian circle of abstract painters. Richard Mortensen and Robert Jacobsen also brought a number of the Gallery Denise René artists to Denmark and exhibited their works in *Tokanten*, the *Linien II* gallery, as well as in Børge Birch's *Kunsthandel*.

New protagonists of Concrete art emerged from the artistic circle around *Linien II*, for instance Paul Gadegaard (born 1920), Preben Hornung (1919-1989), Ole Schwalbe (1929-1990) and Aagaard Andersen (1919-1982). Several of them went to Paris. Gunnar Aagaard Andersen went in 1946 and stayed until 1950; he saw all the exhibitions at Galerie Denise René and wrote home about them.

One of the characteristics of the Danish Concrete art movement was the degree of experimentation in many art forms: film, photography, music, painting, design and architecture. It wanted to create an up-to-date art for the people. Ib Geertsen wrote as follows about their efforts: "The idea of a collaboration between painters, sculptors, and architecture on spatial design is not only dictated by the desire for commissions, but more to create a richer existence for the individual person in an industrialised society" (Ib Geertsen, *K.E.-kataloget*, 1954). Particularly exciting results emerged from decoration commissions, and here the industrialist Mads Åge Damgaard in Herning, Jutland, played a significant role. He invited Danish and foreign artists to decorate his factory.

Despite the idealism and the social commitment which was fundamental to Concrete art, the Danish public never really embraced this form of expression. On the contrary, abstract and Concrete pictures caused indignation and protests well into the 1960s. It was only with the establishment of numerous new art museums in the 1980s, especially in the provinces, the new attempts to disseminate art and a greater prioritisation of the subject of art in schools that a better basis for a broader understanding – or at least silent acceptance, has been created.

The Magic of the Mask - Cobra and Expressionism

Cobra was formed in 1948 in Paris, and the last joint exhibition took place in Liège in 1951. Asger Jorn (1914-1973) was the initiator in the formation of Cobra. He created the contacts abroad, with Karel Appel, Corneille, Pierre Alechinsky, Christian Dotremont etc, and he was the focal point for the Danish circle, which included such disparate

characters as Egill Jacobsen (born 1910), Carl-Henning Pedersen (born 1913), Sonja Ferlov Mancoba (1911-1984), Ejler Bille (born 1910) and Erik Thommesen (born 1916).

Cobra was not a peculiarly Danish, Belgian or Dutch phenomenon. More than 50 artists had a stronger or weaker connection to the group and its centres in Brussels and then Paris. Cobra was held together by the collaboration of individuals and by the spirit of community across the frontiers, despite strong national ties and backgrounds.

The formative developments for the

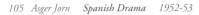

*105 Asger Jorn **Spanish Drama** 1952-53*

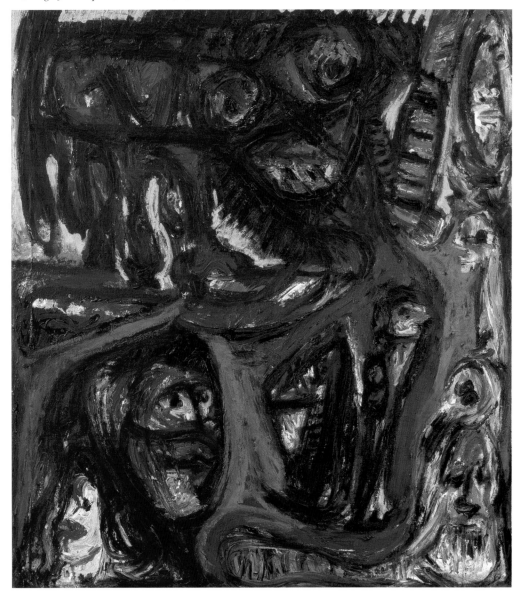

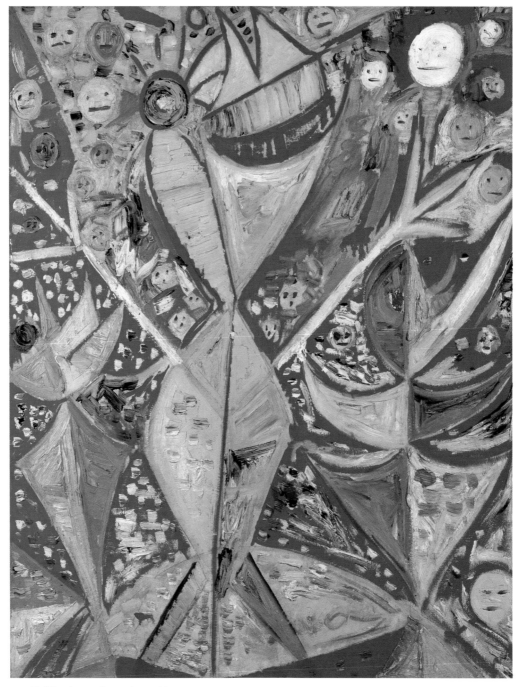

89 Egill Jacobsen **Carnival** 1944

artistic expression which is characteristic of the Danish Cobra artists were made on the home front in the 1930s and 1940s.

Egill Jacobsen painted his most significant early picture *Ophobning* (Accumulation) in 1937/38 in reaction to the German annexation of the Sudetenland in Czechoslovakia. The picture was painted with broad brushstrokes and brutal colour combinations in black, yellow and red. Paint literally poured down over the canvas. This protest was however untypical for him – his basic attitude was a natural lyricism and in *Orange Object* of 1940 he introduced the mask to the circle of abstract artists in Denmark.

In 1945 the Danish abstract painters

98 *Sonja Ferlov Mancoba* **Mask** *1977*

published a manifesto in the catalogue of the *Høst* Exhibition, which dealt with the subject of the mask. Using the Surrealist "automatic" method they sought a spontaneous abstract form of painting, their point of departure being the mask, which was to be perceived as a structure, a latticework on which the picture could be built up. The mask was of such signifance for them, that they even called their art "mask pictures."

Much later Egill Jacobsen wrote the following about the mask motif: "The mask has existed for thousands of years as an expression in many totally different cultures. It can be primitive or supremely sophisticated. It can be used to express any mood. It is related to pantomime and to theatre, and in my interpretation also to music, ballet, and from Africa to

111 *Erik Thommesen* **Caryatid** *1991*

104 Carl-Henning Pedersen *Tower, Trees and Fantastic Animals* *1951-52*

Carnival and children's drawings. Since Freud it cannot conceal, but through it the artist uncovers the human expression. It combines realism and fantasy. Everything that official culture has let down in favour of technology as the god of our times..." (Egill Jacobsen, 1979).

The mask became the expression of everything with which the Cobra artists wanted to be associated: the art of primitive people, the nordic folk art in the church fresco paintings and in the art of the Viking period, Eskimo art, African and Mexican sculptures and children's drawings. It could almost be said that the Danish Cobra artists replaced the still life with the mask. The mask was a symbol of the imaginative mind which exists in every human being, of the direct and spontaneous expression of the mind.

Whilst Egill Jacobsen introduced the mask to Danish art, Carl-Henning Pedersen introduced the fairy-tale. He constructed a fantastic painterly universe with winged horses, castles, fish, ships and gods. The pictures were fantastic and dream-like and dealt with the emotions of joy, happiness and sorrow. They can be interpreted as spontaneous pictorial manifestations of a mythology which Carl-Henning Pedersen perceives as having a collective existence.

But the process and spontaneity was not of supreme significance for all the artists. In 1938 Ejler Bille painted a number of pictures which were spontaneous and freely constructed – just like those of his fellow artists. But gradually it became of supreme importance to him to control the accidental through the artistic process, which increasingly concentrated on the encapsulation of a tiny world of small creepy-crawly movements in a bright microcosm.

88 *Ejler Bille* **Ornamental Figures** *1955*

Cobra challenged preceding formulations on aesthetic norms such as harmony, beauty, balance and painterly colourism. Asger Jorn was the spearhead. For him a picture could only be a picture of the process by which the picture arose. The process was the artistic doctrine. He used this to formulate a kind of anti-aesthetic: "... the truth about aesthetics is really nothing more than the naturalness of the unnatural, the humanity of the inhuman, the health of the abnormal and sick, the clarity of darkness, the fortune of misfortune, the power and authority of the powerless without authority, the meaning of the meaningless, the traces of the traceless, and the reality of the unreal..." (Asger Jorn, *Held og Hasard*, 1963).

Art history has identified Jorn as the key figure of the Danish Cobra. It was he who drew up the battle plans for the Danish group and took the lead with his experimental methods, expressive paintings and theoretical essays.

With time Jorn acquired a stronger and bolder expression, and in particular his colour contrasts became more violent and his figuration increasingly sketchy; the masks had almost disintegrated. The pictures became

gestural emotional discharges. When he could not make any progress on his painting, he wrote, made collages, sculptures, fired ceramics or collected material for his proposed 32 books about Northern art, a project he finally had to abandon. Jorn surpassed most of the Danish artists in artistic vitality as well as in productivity.

Only one of his Danish contemporaries could match Jorn in productivity and expressiveness. That was Svend Wiig Hansen (born 1922), who was an isolated figure in the Danish art scene of the 1950s. He was neither a Concrete nor abstract artist – just

Expressionist. His principal motif consisted of large monumental and deformed human beings, standing waiting in desolate and infinite landscapes. His basic theme is the nature of human relations, towards each other and towards their surroundings – their loneliness, inner desperation and suffering.

Because of his isolated position in Danish art, Wiig Hansen never gained the international recognition which he deserved. It was the key figures of Danish Concrete and Abstract Expressionist art – Asger Jorn, Richard Mortensen and Robert Jacobsen – who became international names.

115 *Svend Wiig Hansen* **Sitting Figure** 1965

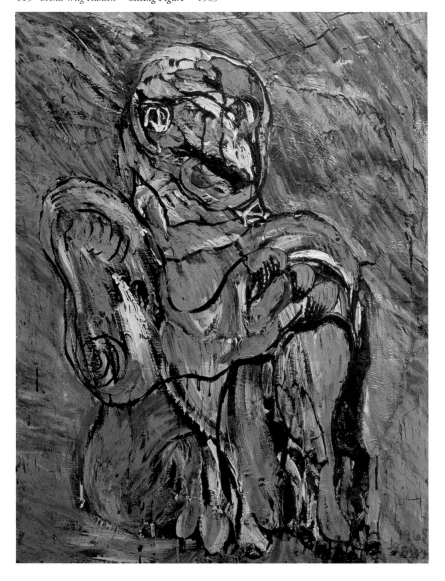

Junk. Pop and Conceptual Art - Fluxus and the Experimemtal Art

In the United States, the Abstract Expressionist art of Jackson Pollock, Willem de Kooning and Helen Frankenthaler gave way to a cool, monochrome style of painting. Traditional principles of composition and any trace of the artist and his brush-marks were totally rejected. An almost puritanical form of painting was the goal. The artists worked in very long series, where the smallest variations were accorded a crucial significance. This serial work was designed to elucidate the true nature of the painting – its quality as an object. Several American artists therefore opted to drop painting in the 1960s and turn completely to sculpture.

Serial work also spread to Pop art, which featured everyday objects and the images of the mass media. Andy Warhol's series of Marilyn Monroe is one of the most famous of these. In contrast to abstract art, which focused exclusively on itself, Warhol's art bears references to imagery outside the painting and to techniques alien to painting.

The experimental American artists were influenced by Fluxus, which originated in John Cage's lectures at the New York School for Social Research in the 1950s. *Experimental Composition* was the course he taught, and experimentation with all kinds of sounds and instruments was encouraged. The Lithuanian Georges Maciunas played an important role for the spread of Fluxus and its manifestions in New York. The first European Fluxus Festival was held in Wiesbaden in 1962.

It is in the light of this background that the Danish art scene in the early 1960s must be viewed. Several Danish artists were influential in channelling the current foreign movements and converting them to the Danish environment. One of these was Arthur Køpcke (1928-1977), a German who had settled in Copenhagen in 1953, where he ran a gallery. Another was Paul Gernes (born 1925), who was the driving force behind the establishment of The Experimental Art School in Copenhagen in 1961.

Fluxus attempted to remove the divide between the artist and the spectator, between art and life. To this end the artists staged surprising and paradoxical Happenings and Actions. A Fluxus piece could involve a mixture of sculpture, music, literature and performance and be the catalyst for a wide variety of expressions.

Arthur Køpcke was clearly the most prominent exponent of the Danish Fluxus. In his *Galerie Køpcke* he showed the latest of the avant-garde such as Dieter Roth, Piero Manzoni, Robert Filliou and Daniel Spoerri, and he threw himself into one experiment after the other. He is best known for his junk sculptures, which were made from cast-off everyday objects and junk he had collected.

The Experimental Art School was established as a night school. At first it offered actual classes, but the formal teacher/pupil relationships soon dissolved, and the school then functioned as a kind of working and workshop collective. The artists who were

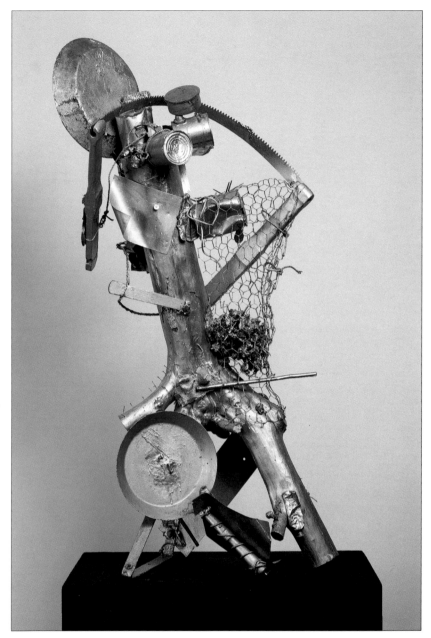

Arthur Køpcke **Sculpture** *1961*

affiliated to the school were interested in materials, and they applied these to all genres. Prevailing values were challenged and replaced with concepts such as *folkelighed* (popular culture), political and social awareness and democracy. The collective form of expression was preferred to the individual. Per Kirkeby (born 1938), Bjørn Nørgaard (born 1947) and Peter Louis-Jensen (born 1951) were active at the school, but many other young artists

moved within the circle without becoming actively involved in the school's projects.

ta, the journal which appeared from 1967 to 68, became a voice for Danish art in the Sixties, and in it several different movements were identified through a number of headings: "Depersonalisation, anonymity, mechanism, rules of the game alien to materials, form templates, flatness, monotony, juxtaposition instead of ranking: A large number of the artistic phenomena, which have became important in recent years, from Pop art and Hard-Edge painting to certain new kinds of music, concrete poetry and similar literary expressions, share an affinity with terms of this sort." (*ta*, Hans Jørgens Nielsen, 1967).

Per Kirkeby started at the Experimental Art School in 1962, working with graphic art, films, collages, painting and Happenings. In his 1965 painting *Women of Our Time* we find contemporary features such as the use of hardboard instead of canvas, synthetic lacquers instead of oil paints and anonymous templates instead of mythological motifs. And he used words such as "stage wings", "system, entropy" and "style pastiche". In his brick sculptures and environments he was concerned with juxtaposing "pure" and "impure" elements, that is to say "pure" association-free expressions against "impure" symbols, filled with associations – Kirkeby's personal response to Minimalism and Pop art.

But it was not long before the development of his own mythology and form of expression became more important to him than the collective spirit of the Experimental School. In a kind of manifesto he wrote: "I take other people's things – in the broadest sense. I use the myriad of materials, I make my own system, I have my own models." (Per Kirkeby, *Billedforklaringer*, 1968). Kirkeby insisted on being his own man, and he was. During the 1970s he developed towards a classical, naturalist and lyrical style of figure

Per Kirkeby Women of OurTime 1964

painting and in the early 1980s he won international recognition. His giant painting of transparent picture spaces were interpreted as an expression of a Neo-Romantic landscape style, a flat painting with no horizon, but with depth of colour and disruptive emblematic traces of areas of water, trees, fungi, stones and earth. Using geology as an interpretational model, the paintings can be read as sedimentations of memories and moods.

In contrast to Per Kirkeby, Bjørn Nørgaard consistently maintained his interest in the collective process: "We made objects, Happenings, Actions, Environments; we stole pictures, texts, ideas left, right and centre, turned them inside out and recycled them. We printed on small, fast off-set machines, quick turnover of ideas and pictures ... we made collective 8 mm films,... we set up *The Naked Christ* at *Børsen* (The Stock Exchange), *Hesteofringen* (Horse Sacrifice), we organised the Dumping Festival for Cultural Goods in the *Fælledpark, K.E.68, Festival 200* at Charlottenborg..." (Bjørn Nørgaard, *Statens Museum for Kunsts Lommebog nr.17, 1981*). Bjørn Nørgaard was always interested in the social relevance of art and he pursued his ideas in his own sculptures, which he later characterised as "popular recycled classicism". Throughout the 1980s and 1990s he has continued his wholesale theft from different cultures. His method could be called a kind of positive eclecticism.

Other artists such as Peter Louis-Jensen, Hein Heinsen (born 1935), Stig Brøgger (born 1941) and Mogens Møller (born 1934) created an independent style of sculpture which had no external associations but was objective in its expression. Stig Brøgger, Hein Heinsen and Mogens Møller founded *Instituttet for Skalakunst* (Scale Art) in 1974, which was based on the principles of Minimal art and developed a sculptural practice that explored and exposed the context in which the individual sculpture was located.

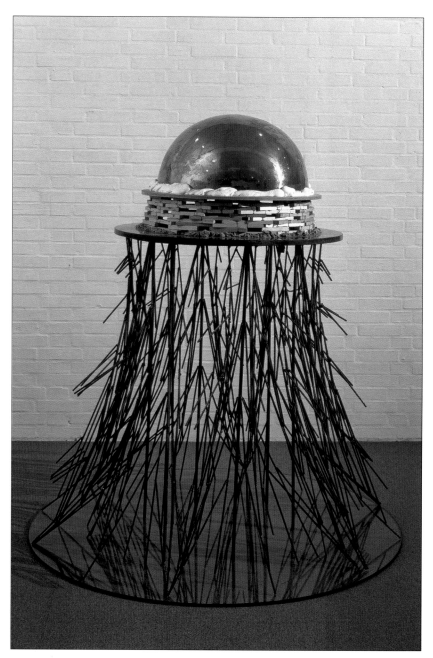

Bjørn Nørgaard Dome 1978

The Værkstedet Værst and New Sculpture - The Trans-Avant-Garde

143 *Peter Bonde* **Hell** *1990*

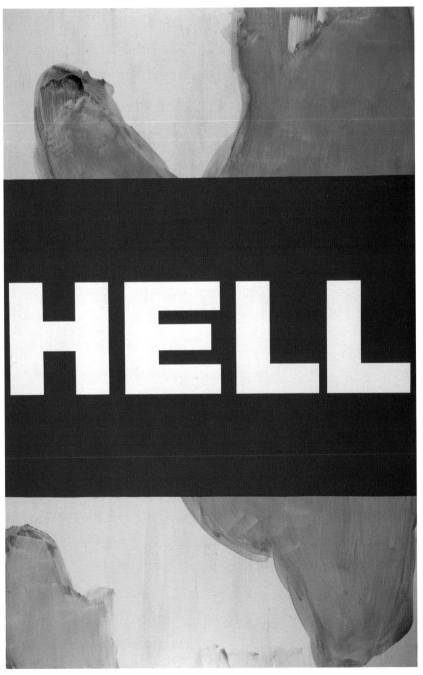

At the end of the 1970s and in the early 1980s there was a European reaction to the dominating American movements which were more or less Minimalist. In Germany there was the emergence of Neo-Expressionism, and in Italy of the trans-avant-garde. In Denmark the *New* and the *Savage* painting and the *New* sculpture were launched.

The Italian theoretician Bonito Oliva was the father of the trans-avant-garde, conjuring up a group of artists with common traits and writing their "manifesto".

The trans-avant-garde artist regarded himself, according to Oliva, as a nomad in the artistic process, in other words he was able to move freely in relation to art, history and society. The past and the present comprised a storehouse of motifs and forms of expression from which the artist could borrow at will. Stylistic eclecticism, stage setting and irony were some of the art terms which typified them. To a Dane this is somewhat reminiscient of the programme of the Experimental Art School. And it was also the new German *Wild Painting* which met with a more positive response in Denmark.

In the early 1980s, a group of students at the Sculpture School of the Academy of Fine Arts who were following the latest developments in art in their classes and through international journals, decided to swop sculpture for painting. They filled the exhibition venue *Tranegården* in Gentofte from floor to ceiling with rapidly painted pictures. Figuration, narration and spontaneity became the focus for the likes of Peter Bonde (born 1958), Claus Carstensen (born 1957) and Berit Jensen (born 1956). This was simulated Neo-Expressionism, an example of a style to which they did not feel committed.

These young students were not however the first to exhibit violently gesticulating painting. The collective gallery *Værst* was started in 1981 by Christian Lemmerz (born 1959), Erik August Frandsen (born 1957) and Lars Nørgård (born 1956). Michael Kvium (born

1955) joined them later. The *Værkstedet Værst* (worst workshop) explained what it stood for thus: "It is a group which has existed for 2 years. There is no programme, more a method of work, which has crystalised through our collaboration. We are not original, rather influenced... We have not found a specific form of expression, rather a method. ... We tend to work on specific projects, perhaps a joke, a concept, or money. We are neither Americans nor Chinese... Our work is driven by desire..." (*Værkstedet Værst, tidsskriftet Cras,* 1983).

This description of itself by *Værkstedet Værst* contains many of the views also put forward in the programme declarations of the Academy students. The Neo-Expressionist style was to be regarded as a deliberately calculated form of expression, which could be manipulated, played with, and subjected to irony. The views of the two groups thus shared the same foundations. Differing positions did not emerge until the artists gradually matured during the 1980s.

Claus Carstensen, Peter Bonde, Erik A. Frandsen, Lars Nørgård, Michael Kvium and Christian Lemmerz have now distinguished themselves and established individual profiles. So far Claus Carstensen has been in the public spotlight most. His lyrical and emblematic landscapes, his experiments with new methods of reproduction, his collage-styled technique of quotations in poems and pictures, his numerous essays and statements, and most recently, his appointment as professor at the Academy of Fine Arts, have all contributed to his unofficial position as the spokesperson for his generation.

Erik A. Frandsen on the other hand is above all a good painter, working within the Modernist tradition of motifs. His highly Expressionist paintings display a preoccupation with the human figure and its body language, but his aesthetic is an anti-aesthetic. His figures are distorted and deformed, and he ensnares them in a network of dashes and lines and elements of collage such as rubber rings,

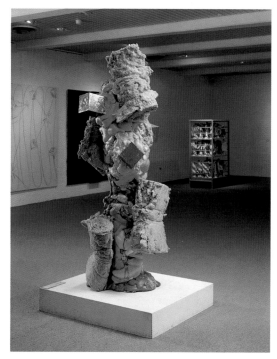

Christian Lemmerz **Aphasia** 1986

Claus Carstensen **Cancellation Proof III** 1994

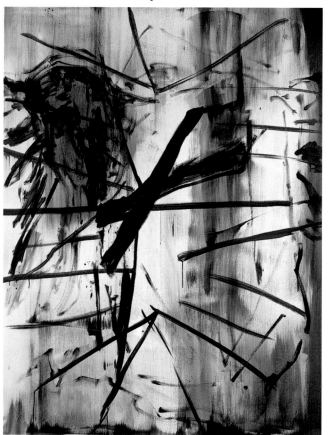

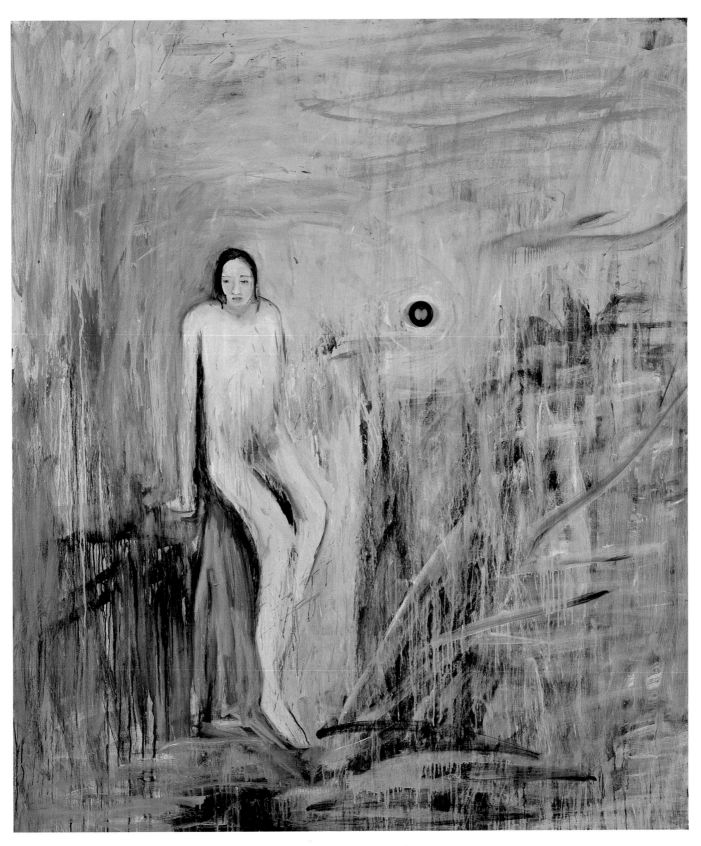

138 Erik A. Frandsen *Jalta Series IX* 1989

photo-boxes and steel wire.

Michael Kvium and Christian Lemmerz take the description of the mental and physical condition of mankind a step further, and they both demonstrate a grotesque and macabre vision based on current fears about deformities and death. In horrific scenes with science-fiction overtones, Kvium bares man's fear of natural catastrophes, destruction, genetic engineering and pollution, whilst Lemmerz involves the spectator in the very process of decay, constructing his sculptures from entrails, dead animals and human fæces.

Far removed from the moral debate harboured in the works of Kvium and Lemmerz, there is a group of sculptors including Søren Jensen (born 1957), Elisabeth Toubro (born 1956) and Morten Stræde (born

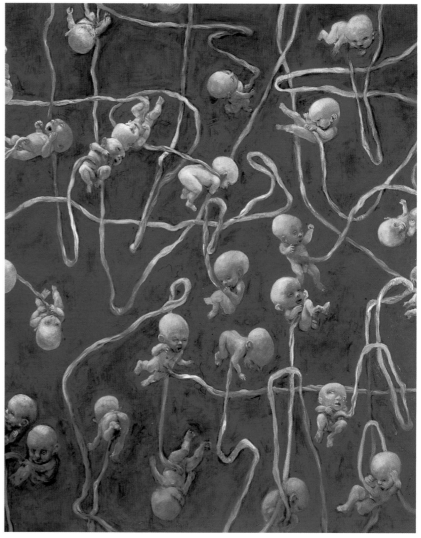

128 Michael Kvium *Future Jam* 1995

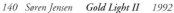

140 *Søren Jensen* **Gold Light II** *1992*

1956), working with sculpture as an independent form of expression. Collectively they have been preoccupied by the new evocative potential of Deconstructivism. They have thus carried out a deconstruction of the forms of the sculpture in order to find new sculptural forms and construction. Morten Stræde's and Søren Jensen's purposeful products appear to be the most interesting at the present time.

There are thus considerable differences between the artists and the artists' groups, and at present there is no sign of any specific common artistic denominator for the period.

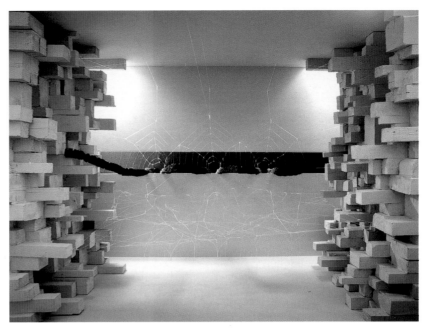

131 Elisabeth Toubro *A Construction of Spaces in Between* 1995

129 Morten Stræde, **Winterreise/Torum** 1990

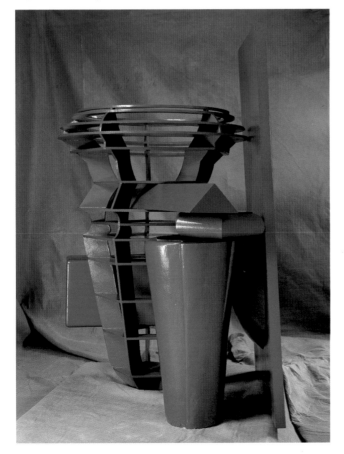

Danish Art: View from the end of the Century

Looking back at the century about to close it seems that the international orientation which Danish artists consistently sought so energetically has always produced a distinctive Danish art. Weie, Jorn and Kirkeby, as different as they may seem, are good examples of how in their maturity, their work is influenced by the nordic light and the figurations in Danish religious and national history.

And there are other examples. Even with the ironic and simulating artists such as Carstensen and Kvium there is an accepted bond with national localities (Carstensen's notion of a borderland) and a national mentality (Kvium's pessimism and melancholy). Above all it is the tension between the awareness of national identity and absorbing external influences that has defined the specific nature of Danish art in this century.

Translated by Vivien Andersen

A View from across the Water

DUNCAN MACMILLAN

The North Sea is like a garden fence and good neighbours like Denmark and Scotland have talked to each other across it for millennia. To give just one witness of this, the only altarpiece made for a Scottish congregation that survives from before the Reformation is preserved in the National Museum in Copenhagen. Not by accident, but because at the end of the fifteenth century it was commissioned by the Scottish community in Helsingør.

As we look over the history of art in Denmark from a Scottish point of view, even though much of the art may be new to us, there are often things that seem familiar because they reflect shared experiences stemming from this closeness. They reflect direct links between the two countries, but also similar links to the rest of Europe. The idea that you must travel to learn has long been an axiom in both. So artists would meet in a common destination, whether it was Rome or Paris, and share experiences there.

The Danish state is very old, but it seems to be true that the modern sense of Danish identity as something cultural and not merely political, dates from the period of the Napoleonic wars. But if this sentiment was born in politics, it was nurtured and focused in Denmark as in so many other parts of Europe by the writing of Sir Walter Scott, and in the sculptor Thorvaldsen, the Danes found a cultural hero whose role in Denmark, like that of Scott in Scotland, was to act as a symbol of this identity.

Scott was important for literary figures of the Golden Age like Hans Christian Andersen, or the historical novelist B.S. Ingemann, even for Søren Kierkegaard. But he also played a part in the inspiration of the painters. Led by Eckersberg, they turned to paint the world around them with wonderful freshness and clarity of vision. Their inspiration was the importance of the local and immediate. They saw that these were the things that made Danishness, just as for Scott they made Scottishness.

In sentiment though, perhaps they were closer to Wilkie than to Scott. Wilkie had aspired to realise Burns's vision of "a rustic bard", and Burns's lines, "Yet all beneath th'unrivalled Rose, The lowly Daisy sweetly blows" fit perfectly the quiet ambition of Eckersberg's or Købke's pellucid painting.

Later, another disciple of Scott, the art critic and historian N.L. Høyen encouraged painters like Lundbye to go out to find the authentic Danish landscape in Jutland and to study and record the life of the people. This too paralleled what had happened in Scotland with David Allan, Wilkie, or John Galt and Høyen set the agenda for much of the painting of the later century in Denmark.

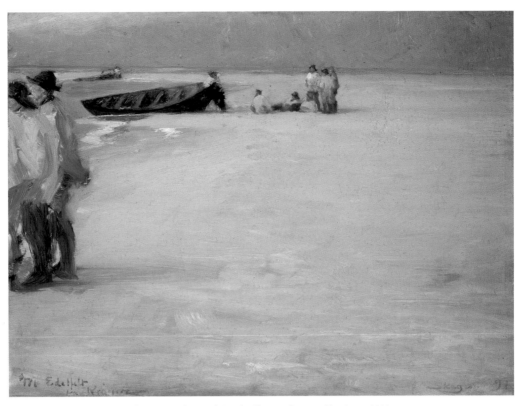

54 *Peder Severin Krøyer* **Fishermen on the North Beach. Skagen. Summer Evening** *1891*

As Paris replaced Rome, artists nurtured in the idea that art was local and personal had no difficulty in understanding what Courbet and the Impressionists were doing. They responded energetically in Denmark as in Scotland and you could compare P.S. Krøyer to James Guthrie, or the artists' colony at Skagen to the Glasgow Boys working at Cockburnspath or Kirkcudbright. The stress on national, indigenous traditions made Danish artists especially receptive to the ideas of William Morris and the Arts and Crafts movement which valued just these things. They raised craft to a level with art and so began the flowering of Danish design which has continued to this day.

In both Denmark and Scotland art was rooted locally and nurtured internationally. In the twentieth century, this has maintained the high level of creativity among Danish painters, but there are still both parallels and links with Scotland. Though each is individual, you could compare figures like Harald Giersing,

Vilhelm Lundstrøm and Richard Mortensen to J.D. Fergusson and William Johnstone. They brought in new ideas to act as a leaven in the development of art at home. Like Johnstone too, Mortensen represented a link between the generations across the watershed of the war and in the war's immediate aftermath, it was the Dane, Asger Jorn, who was central to the vivid development of Cobra painting. It is notable that one of the only British painters closely associated with Cobra was the Scot William Gear, and in some ways, not only Gear, but even more Alan Davie is a parallel figure to Jorn.

In the younger generation, artists in Denmark have maintained this open-minded tradition, looking for inspiration to America, and like so many of their Scottish contemporaries recently to Germany. But when they go to such places to learn, they do not go empty-handed. They have the self-confidence that derives from their own strong tradition as this exhibition so amply demonstrates.

Hebsgaard Glass Studio

Since its establishment in 1986, the Hebsgaard Glass Studio, Vanløse, has become one of the leading decorative glass studios in Europe. Per Steen Hebsgaard (b. 1948) trained as a glass maker and received the Guild's Bronze Medal in 1967 and their Silver Medal in 1975. In 1970 he joined *Frese og Sønner*, one of the major Danish glass workshops, becoming a partner five years later. In 1986 he established his own studio, *Atelier for Internationale Glasudmykninger*, and this move underlined his increasing focus on the exploration of glass as an artistic medium.

Over the years the Hebsgaard Glass Studio has become an important centre for both Danish and international painters and sculptors, working on public art commissions as well as their own work, ofter experimental in nature. The products of the studio range from stained glass windows in cathedrals, the decoration of public buildings, swimming

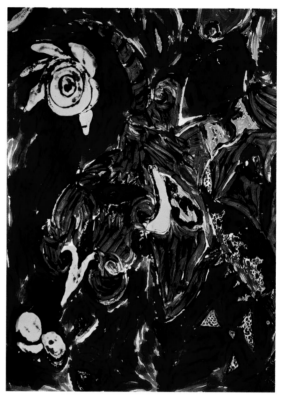

144 Carl Henning Pedersen **Glass Painting** 1994

145 Jørn Larsen **Concrete Glass** 1993

146 Arne Haugen Sørensen **Angel's Wings** 1991

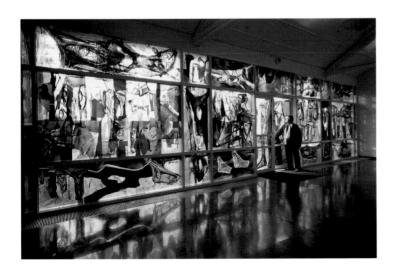

pools and offices, glass sculpture installations in town centres, to the creation of decorated panels and dishes for private houses.

Hebsgaard always regards his role as the executor of the artist's ideas, extending the technical limitations of the medium to meet the artist's vision. Hebsgaard's work has been shown in several exhibitions, both in Denmark and further afield, including at Chatres in 1988 and at FIAC in Paris in 1989. He has been awarded Prins Henrik's Prize, Ole Haslund's Award for Artists and the Velux Fonden's Prize.

Bjørn Nørgaard's Tower for Fredericia Bryggeri, 1989. Standing over 7.5 metres high and 3 metres in diameter, it is made of approximately 5000 pieces of glasss. Nørgaard intended it to be a place for meditation after working hours.

Peter Brandes with his stained glass wall in the TV2 Building in Odense. Glass painting and collage, it is 15 metres long and 3 metres high.

Artists' Biographies

ANNA ANCHER (1859-1935) was born in Skagen and became one of the group of artists living and working in Skagen, the most northerly fishing village in Denmark, at the end of the 19th century. As a female artist she was denied access to the Academy of Fine Arts, so she took private lessons from Vilhelm * Kyhn. She also learned a lot from her artist colleagues. She was married to Michael *Ancher. Anna Ancher was a fine colourist whose mild interiors depicted the everyday life of the ordinary Skagen folk. It was said of her that she was the first in Danish art to "capture a ray of sunshine properly."

MICHAEL ANCHER (1849-1927) was born on Bornholm, but spent his entire career as an artist at the other end of the country in Skagen. His formal training was limited, but in Skagen he was influenced by French Realism, particularly as interpreted by P.S. *Kroyer. Under this influence, coupled with that of his wife Anna *Ancher, the heroic style of his early pictures of the local fishermen gave way to a greater simplicity and more elegant colouration.

WILHELM BENDZ (1804-32) was a student of C.W.*Eckersberg. He was particularly interested in interiors in artificial light. However, many of his fine pictures are portraits and groups in rooms lit by daylight with an emphasis on the depiction of the room and its reflections etc, painted in light and fresh colours.

EJLER BILLE (born 1910) founded the group linien (The Line) in 1933 together with Richard *Mortensen and others who were inspired by the abstract, Cubist and Surrealist movements. By 1940 Ejler Bille had found his definitive form of expression in small, densely coloured forms which lean towards one another in a lyrical microcosm, intensely vibrant both in detail as well as the whole.

THORVALD BINDESBØLL (1846-1908) was one of Denmark's most profilic applied art designers. He trained as an architect at the Academy of Fine Arts but used most of his creative powers on designing anything from embroidery patterns, furniture, silverware, the covers and inside pages of books, to ceramics. He created the Dragon fountain on the Town Hall Square in Copenhagen, and is remembered daily by many people for his labels on the Carlsberg beer bottles. His patterns often consist of stylised, intertwining tendrils which swell powerfully and tensely into billowing shapes.

CARL BLOCH (1834-90) covered a broad range of motifs as well as techniques, from paintings of national folk life, genre paintings, historical motifs and ecclesiastical works to portraits in oils and etchings. He was much admired during his lifetime. His pictures often appeal to the emotions and even sometimes to sentimentality and are carefully composed and finished. His confident handling of light and shade is clearly evident in his graphic works.

PETER BONDE (born 1958) participated in the much publicised seminal exhibition Kniven på hovedet (Upside-down Knife) where the artists called De vilde (The Savages), inspired by contemporary German and Italian work, achieved a major breakthrough with their figurative style satirizing Expressionism. Peter Bonde has experimented with all forms of painting, from Minimalism to landscapes.

PETER BRANDES (born 1944) is a self-taught painter and ceramicist. He employs a largely Abstract Expressionist idiom. The point of departure for his pictures - either on canvas or glass - may for instance be a photograph, which he reworks with vigorous colours until the motif appears blurred with an inner luminosity of its own. His recent ceramic works are decorated pottery vases of gigantic proportions.

CLAUS CARSTENSEN (born 1957) is an artist whose media include painting, sculpture and poetry. He first attracted attention in 1982 at the Kniven på hovedet (Upside-down Knife) exhibition together with Peter *Bonde and others, and for a time he belonged to De vilde (the Savages). Claus Carstensen regularly changes medium and often chooses poetry, music, videos and installations; if possible he will mix all these together, adding painting and sculpture, the latter often in untraditional materials such as foam rubber.

J.C. DAHL (1788-1857) was born in Norway, which shared a dual monarchy with Denmark until 1814. He studied at the Academy of Fine Arts in Copenhagen. Dahl found his expression as a romantic painter inspired by Dutch 16th century art, as well as the painters Jens Juel (1745-1802) and C.W.*Eckersberg. Dahl was a prolific painter of landscapes and he influenced younger colleagues, including C.*Købke and J.Th.*Lundbye. Dahl owes his position in European art history to his friendship with the German Romantic painter Caspar David Friedrich and their reciprocal inspiration.

CHRISTEN DALSGAARD (1824-1907) was a loyal follower of the national romantic movement from his youth, depicting favourite motifs such as the interiors of farmhouses and rural folk life. His pictures are narrative and anecdotal and full of closely observed details which point towards Realism. He frequently used complicated lighting effects to give his pictures vitality.

DANKVART DREYER (1816-52) was one of the most significant early landscape painters, along with J.Th.*Lundbye and P.C.*Skovgaard. Dreyer's work is characterised by a particularly vigorous and spirited depiction of moods in nature and by his use of colours, quite outstanding for that period. Dreyer's drawings demonstrate an extremely lively stroke and superb rendition of light.

C.W. ECKERSBERG (1783-1853) On completion of his studies at the Academy of Fine Arts in Copenhagen, Eckersberg lived in Paris from 1810-13, where he studied under J.L.David, who held him in high regard and taught him to paint nature as it presented itself, in each and every detail. His time in Rome from 1813 to 1816 was also very influential. He returned to Denmark in 1816 and he became a professor at the Academy of Fine Arts. His superlative teaching ability enabled him to unleash the talents of his students, whom he imbued with the spirit of Naturalism. Eckersberg can claim much of the credit for the Golden Age of Danish Art in the first half of the 19th century.

SANJA FERLOV MANCOBA (1911-84) began her career as a painter and her principal influences were her contemporaries Richard *Mortensen and *Bille, and thereby the Abstract Surrealism of *linien* (The Line). However, in the mid 1930s she stopped painting and turned to sculpture, working first with *objets trouvés*, later with modelled figures. Her constructive abstract works were much inspired by Giacometti as well as by African masks. Mancoba belonged to the Cobra group.

ERIK A. FRANDSEN (born 1957) is a self-taught painter. He was influenced by the imagery of German and Italian art in the 1980s. He participated in the 1982 exhibition *Kniven på hovedet* (Upside-down knife) together with Peter *Bonde and others, and has since belonged to *De vilde* (The Savages). His first works displayed an ironic distance, but recently he has sought new forms of expression, frequently using layered pictures with elements of love and sex at the bottom and refuse such as bits of tyres and tin cans at the top.

WILLIAM FREDDIE (born 1909) introduced Surrealism to Denmark in 1930 and for 35 years thereafter he was a controversial and prominent representative of the movement with numerous scandals, confiscated pictures and sentences for pornography. Like Dali, Max Ernst and de Chirico, Freddie paints intellectual surrealist pictures of dream sequences, the subconscious and the mildly erotic. His idiom has become simpler since the mid 1970s.

HARALD GIERSING (1881-1927) studied under Kristian Zahrtmann, one of the greatest Danish art teachers, who taught him to have the courage to express himself freely in his painting. His encounter with the work of Paul Gauguin and his visit to Paris where he studied the work of Signac, the Fauvists and Cézanne, were crucial influences on his work, with paintings sometimes characterised by strong, often cold colours, and sometimes dark and melancholy figures.

VILHELM HAMMERSHØI (1864-1916) had several teachers, including V.*Kyhn, F.*Vermehren and P.S.*Krøyer. His very refined work is characterised by an extremely muted chromatic range and an equally limited choice of motifs, usually confined to his own quiet rooms, either empty or very sparsely furnished with no more than a single figure in black as a contrast to the white walls. Hammershøi was also an excellent portrait painter.

CONSTANTIN HANSEN (1804-80) started as a portrait painter, but a visit to Italy changed both his use of colour and his choice of motifs when he started painting the everyday life and scenery of Italy. On his return to Denmark he painted a series of monumental patriotic historical pictures whose composition demonstrated great confidence. He also regained favour as a portrait painter

ARNE HAUGEN SØRENSEN (born 1932) is a self-taught artist. He has lived abroad for almost 40 years. A recurring theme in both his paintings and his graphic works is a mixture of the idyllic and the catastrophic in a hidden world populated by bestial figures in crude and sinister colours to underline the theme.

EGILL JACOBSEN (born 1910) visited Paris in 1934 where he was inspired by Picasso and Matisse. Back in Denmark he became one of the lead figures in Danish modern art together with Ejler *Bille and Richard *Mortensen. The mask is a recurring theme in Egill Jacobsen's work, variations of which he has used prolifically for 60 years with great vitality.

ROBERT JACOBSEN (1912-93) had no formal training. His first works were in wood and stone, but after 1947 he worked almost exclusively in iron. Whilst his Danish contemporaries largely followed spontaneous Expressionism, Robert Jacobsen retained his pure Constructivist idiom without any inhibiting theoretical ballast. He achieved widespread popularity in 1950 with the small humourous iron figures called "the dolls". He spent much of his life in France and was a professor in Munich for many years.

C.A. JENSEN (1792-1870) is a unique figure in Danish art due to the fact that he only painted portraits. He painted anything from small intimate studies to large official pictures, working in Denmark, England, Germany and Russia. His confident brushwork and psychological insight are evident in his paintings, where the subjects are frequently illuminated against a dark background.

SØREN JENSEN (born 1957) studied at the Academy of Fine Arts in Copenhagen. He produces sculptures, whose forms are determined by the rhythms and irregularities of their drapery. It is impossible to distinguish the figure from the drapery, the body from the veil, the core from the ornamentation. They are staged incarnations, all external and veiled.

VIGGO JOHANSEN (1851-1935) studied at the Academy of Fine Arts under Jørgen *Roed and others. Viggo Johansen lived in Skagen, where he was influenced by the Skagen group of painters. He married one of Anna *Ancher's cousins. He became famous for his intimate depictions of his home with figures and interiors dimly illuminated by candlelight or oil lamps. He was also a fine portraitist.

ASGER JORN (1914-73) received his first formal training in Paris when he attended Léger's painting school whilst he was also immersing himself in the Surrealist movement and the work of Kandinsky, Klee and Miró. He was one of the co-founders of the artists' group Cobra in 1948. He developed an Abstract Expressionist idiom, with small figures, grotesque mythical animals and weird humans emerging from apparently accidental brushstrokes. All these tumble together forming a huge flickering vitality. Jorn's work encompassed paintings in oils and acrylics, graphic works, drawings, ceramics and sculpture.

PER KIRKEBY (born 1938) was a product of The Experimental Art School (EKS-skolen) which was started in 1961 in protest against the stultified Academy of Fine Arts. His very carefully planned and executed pictures combine modern, expressive painting with the colours and light of romantic landscape painting. He takes his point of departure in nature, for instance a piece of wood or a stone, onto which layer after layer is piled, all the while retaining the original motif.

P.S. KRØYER (1851-1909) studied at the Academy of Fine Arts under W.*Marstrand and others, thus affiliating him to the *Eckersberg tradition. Krøyer started his career by painting portraits and social genre pictures. In 1877 he became a student of Léon Bonnat in Paris, where he learned to add a dramatic element to his pictures. Light and bold colours were added to his palette during his visits to Spain and Italy. In 1881 he started spending part of the year in Skagen, where his atmospheric landscapes earned him his reputation as the most fêted of the Skagen painters. He spent the rest of the year in Copenhagen as a popular portrait painter and highly respected teacher at *Kunstnernes Studieskole* (the Artists' Study School).

MICHAEL KVIUM (born 1955) studied at the Academy of Fine Arts in Copenhagen. The first impression of his pictures is one of fantastic visions. He must however be regarded as a baroque realist. Even though his point of departure is the everyday situation, he inserts powerful elements of macabre surrealism which appeal to the subconscious mind. The aesthetic nature of the pictures is highlighted by his perfect technical skills and sophisticated use of colour.

VILHELM KYHN (1819-1903) painted landscapes almost exclusively, and usually soft, wistful scenes of the Jutland countryside in strong colours. Spiritually he was close to the *Eckersberg school with its attention to detail and its romantic nationalism. He thus continued the tradition of *Købke, *Lundbye, *Skovgaard and in particular *Dreyer. Anna *Ancher was one of Kyhn's students. During the artistic upheaval of the late 19th century Kyhn came to represent conservatism in Danish art.

CHRISTEN KØBKE (1810-48) is one of the greatest names of the Danish Golden Age. He was perfectly suited to the *Eckersberg school of thought, which encouraged nature studies on location. He become the most talented and famous follower of this tradition, managing to transfer the freshness of his sketches to the finished painting, to which he applied a tighter composition. He used a sophisticated palette and clear lighting. Købke's subjects, places and people, are largely taken from the immediate surroundings of his home.

EMANUEL LARSEN (1823-59) was artistically influenced by C.W.*Eckersberg. Emanuel Larsen's pictures, typically of the sea and coastlines, are dominated by a clear and cool tone, where the emphasis is on the composition rather than the colours. The extremely romantic nature of his pictures stems from the liberal use of atmospheric effects. His graphic works display a fresh, bold expression.

JØRN LARSEN (born 1926) is a painter and sculptor. Since he started working in 1955 he has consistently produced non-figurative, concrete paintings, which over time have become simplified into a stictly geometric idiom in black and white. His sculptures demonstrate the same simplicity; they are made in steel or granite and consist of cubes standing on one of the corners.

CARL LOCHER (1851-1915). Léon Bonnat was one of the artists who taught and inspired Locher, whose favourite subjects, both for etchings and paintings, were seascapes and ships. He settled in Skagen in 1872 and was thus one of the first of the Skagen painters. His pictures demonstrate a bold realism, broad brushwork and overall confidence. He ran etching classes, and his students included P.S.*Krøyer, Anna and Michael*Ancher.

VILHELM LUNDSTRØM (1893-1950) In 1918 Lundstrøm's packing-case pictures introduced Modernism to Denmark provoking a storm of indignation. A few years later he changed his style, with muted colours, thickly painted with bold sweeping brushstrokes. By 1923 he had changed again, to cool, purist pictures with tight geometric forms in a limited chromatic range. After 1940 he unleashed the whole colour spectrum in his still lifes, models and portraits.

J.TH. LUNDBYE (1818-48) is one of the most convinced Romantics in Danish art. He painted charming, atmospherically charged and beautifully hued landscapes and views, mostly from Zealand, which he sorely missed when he was abroad, as for instance, during his trip to Italy in 1846. Lundbye was also an extremely talented draughtsman, with a superlative feeling for lighting.

WILHELM MARSTRAND (1810-73) was a student of *Eckersberg, whom he succeeded as professor at the Academy of Fine Arts. He was a frequent traveller, both home and abroad, and was extremely industrious. His pictures display an imagination which could extend beyond any strict artistic control, frequently in dry, hard colours. He painted genre pictures, portraits, ecclesiastical works and large decorative commissions.

RICHARD MORTENSEN (1910-93) began as a painter in a personalised abstract surrealist style partly influenced by psychoanalysis. During the isolation of the 2nd World War he developed an expressionist style with strong colours and energetic lines. When the war ended he went to France, and from then on his work was completely abstract with a precise, simplified imagery devoid of any recognisable elements, harmoniously balanced, and in clear colours.

BJØRN NØRGAARD (born 1947) trained as a sculptor at the EKS-school (Experimental Art School) at the same time as Per *Kirkeby. It is difficult to categorise Nørgaard, since he has also produced graphic works, made films, organised collective experiments, happenings and actions. He has produced some very large sculptures in mixed materials, has designed street pavings, as well as tapestries based on themes from Danish history as a gift for Queen Margrethe II. Nørgaard has been a professor at the Academy of Fine Arts.

CARL-HENNING PEDERSEN (born 1913) was self-taught and very early in his career established his characteristic style of fables in strong colours. His pictures are populated by a universe of fantastic figures, mystical birds and strange heavenly bodies, which recall to mind the primitive elements of life. He has also executed extremely large decorative commissions, consisting of ceramics and mosaics as well as paintings.

FRITZ PETZHOLDT (1805-38) was one of *Eckersberg's students, who dedicated himself largely to landscape painting, usually unpopulated. He recognised early that the soft, flat Danish landscape did not offer his romantic nature sufficient challenges, so he moved to southern Italy and Sicily. His composition is meticulous, his brushwork lively and his colours flow freely.

L.A. RING (1854-1933) and Hans *Smidth are the two painters who elevated Realism in Danish art beyond pure period pieces to a greater universality. Ring wished his art to contribute to progress, so he depicted socially relevant rural environments on Zealand. His meticulously executed landscapes with sharp outlines, frequently painted in light, muted colours, demonstrate great depth of perspective.

JØRGEN ROED (1808-88) studied under *Eckersberg, whose teaching he remained loyal to throughout his life, retaining the tradition of composition and colour. He achieved beautiful results with his refined colours and gentle interpretation of the subjects of his portraits. He also produced a series of architectural pictures and altarpieces and he conformed to the nationalist requirement of the period with pictures of farmers and fishermen.

JOHAN ROHDE (1856-1935) was a Naturalist with Symbolist overtones, incorporating elements from old Dutch

landscape painting as well as contemporary French art. His colours became increasingly subdued over the years. Rohde's work as a painter has often been underrated in comparison with his other work, for instance as a designer for the silversmith Georg Jensen. He was also a co-founder of the *Kunstnernes Studieskole* (the Artists' Study School), where P.S.*Krøyer was a teacher; and also co-founder of *Den frie Udstilling* (The Independent Exhibition) together with *Willumsen, *Slott-Møller and *Hammershøi. Rohde collected French graphic art, and was an important disseminator of contemporary art from abroad.

MARTINUS RØRBYE (1803-48) studied under *Eckersberg at the same time as *Bendz, who, like J.C.*Dahl, came to have a profound influence on him. Rørbye undertook many long trips to Norway via Jutland (once together with the writer Hans Christian Andersen), and also to the south as far as Greece and Turkey. This provided a wealth of motifs as a relief from the portrait painting of his youth, which he found boring. Numerous impressions from his travels are captured in fresh and vibrant water colour sketches.

P.C. SKOVGAARD (1817-75) was a friend of J.Th. *Lundbye and Dankvart *Dreyer, and together they formed a trinity in Danish landscape painting. Skovgaard first painted sombre, rugged landscapes under the influence of J.C. *Dahl. Then he became inspired by *Købke to adopt a milder expression, demonstrating a greater interest in colour, light and atmosphere in his panoramic and idealised landscapes revealing a simple love of nature. His use of colours became richer and more vibrant after a visit to Italy.

HARALD SLOTT-MØLLER (1864-1937) studied under P.S.*Krøyer. He was an early representative of Realism, starting his career with a series of bitter and pessimistic pictures. He travelled abroad for long periods, and influenced by early Italian art, his style changed in the 1890s to national romantic Symbolism. Slott-Møller was an active participant in the artistic debates of the time and defended progressively more reactionary views.

HANS SMIDTH (1839-1917) studied under *Marstrand and Jørgen *Roed. Smidth shares his position as the foremost artist of Danish Naturalism with L.A. Ring. Smidth painted motifs in the Jutland countryside, depicting them lovingly in finely tuned light colours, which are lyrical, pure, tonal and saturated. He was a prolific artist but lived most of his life in obscurity.

MORTEN STRÆDE (born 1956) studied at the Academy of Fine Arts in Copenhagen. His sculptures deal with doubt and paradox. Construction and demolition are the same process, clarity and confusion are mutual prerequisites. Countless approaches are offered, since we have lost time and space. When the spectator realises that the interpretation is infinite, the purpose of the work has been fulfilled and it becomes superfluous.

FREDERIK SØDRING (1809-62) had J.C.*Dahl as his major early influence when he specialised in painting motifs on Zealand and Møen, turning later on to southern Sweden and Norway. In 1836 he went to Germany, where he studied for several years. He then concentrated on depictions of mediaeval castles and mountain scenery with dramatic lighting effects more reminiscent of German landscape painting than studies from nature. He became more widely esteemed after his death than during his lifetime.

ERIK TOMMESEN (born 1916) is a self-taught sculptor. His sculptures in fired clay, granite and above all, wood, are based on the human figure which is reproduced in extremely simplified rhythmic forms and monumentality.

ELISABETH TOUBRO (born 1956) studied at the Academy of Fine Arts in Copenhagen. Her slender sculptures develop as the viewer watches, as they describe the transition from one stage to the next. The picture crawls, runs, sinks, rises, is formed and dissolves. The process is dependent on the spectator.

LAURITS TUXEN (1853-1927) studied at the Academy of Fine Arts in Copenhagen under W.*Marstrand and Jørgen *Roed and in Paris under Léon Bonnat, who followed the tradition of J.L.David and hence that of *Eckersberg. Nevertheless, it was Tuxen, together with P.S.*Krøyer, who brought about the final break with the Eckersberg tradition when they introduced painting in the open air in 1880 together with the techniques an views of French Naturalism, with light, energy and simplicity in form and colour. Tuxen is overshadowed by Krøyer because he spent so much of his life as an official portraitist with long placements at various European courts.

F. VERMEHREN (1823-1910) was a respected painter and teacher at the Academy of Fine Arts for nearly 30 years. He was an early devotee of national genre painting. People were the focus of attention, but in Vermehren's work they are frequently less interesting than their surroundings, reproduced with meticulous detail and with freshness, calm and control. Vermehren had the misfortune of being labelled reactionary during the era of artistic turbulence, chiefly represented by P.S.*Krøyer.

EDVARD WEIE (1879-1943) studied under the brilliant art teacher Kristian Zahrtmann, but his great revelation came in 1911 when he became acquainted with Cézanne's theories in Paris. Weie was a very good and confident colourist demonstrating rich tonality. He applied his colours with a broad brushstroke in separate fields to obtain the maximum contrast. In the 1930s his technique changed and he coated the white canvas with large fields of pure, glazed colours like water colours.

SVEND WIIG HANSEN (born 1922) started his studies at the Academy of Fine Arts as a sculptor, but soon enlarged his mode of expression to painting, drawing and graphic art. His pictures contain a dynamic, expressive energy which explodes the picture space. They are violent depictions of the psychological layers underlying human drives. No wonder that his work has sometimes provoked storms of public indignation.

J.F. WILLUMSEN (1863-1958) was the great individualist in Danish modern art. He was a multifacetted talent, embracing painting, graphics, sculpture, ceramics and architecture. His breadth and scope as an artist were quite unique. He continued to experiment with content and form throughout his life, always seeking new directions. From 1890 he spent much of his time in France, and was profoundly influenced by the current artistic movements, especially Synthetism and Paul Gauguin. His perception of nature as the source of energy and health and destruction were the main influence at the beginning of the 20th century. After 1910 his colours became more profound and saturated, inspired by El Greco: later paintings display a new freshness and violent illumination. Willumsen was a co-founder of the artists' association *Den Frie Udstilling* (The Independent Exhibition) in 1891 together with *Rohde, *Hammershøi and *Slott-Møller.

* indicates separate entry

Danish Decorative Arts

BY JONNA DWINGER

There is an awful lot happening in the decorative arts in Denmark at the moment, with our artist-craftsmen making more of a mark and becoming more independent than has been the case for several decades, and increasingly attracting attention abroad. Anyone who really wants to gain an insight into Danish decorative arts and who visits Copenhagen, should start back at the beginning just over one hundred years ago and get a historical view by visiting the museum exhibitions, and above all, the Kunstindustrimuseet (Museum of Decorative Arts).

This is a beautiful and charming museum housed in a low building with four wings surrounding a grassy courtyard in what used to be Frederik V's old Frederik's Hospital, just a few hundred yards from Amalienborg. Here one can follow the history of modern Danish decorative art from 1888, when the pioneers, headed by the architect, ceramicist and designer Thorvald Bindesbøll and his painter friends the Skovgaard brothers, made their revolutionary break with historicism and imitation. A new era was dawning all over Europe, and the new trends in architecture, furniture design and crafts, particularly those produced by kindred spirits in Britain and Austria, were followed closely in Denmark. It was the circle around Thorvald Bindesbøll

which heralded the new era with their remarkable contribution to the Nordic Industrial, Agricultural and Art Exhibition. The name may well be ponderous, but it was this exhibition, held in a wooden building designed by Martin Nyrop, the architect of the Copenhagen Town Hall, which sparked off the development. Amongst the exhibits was an almost sculptural service, the *Hejre* service, produced by Bing and Grøndahl, which totally broke with the familiar imitations of style, and which was designed by Pietro Krohn, who shortly afterwards was appointed as the director of the proposed Museum of Decorative Arts.

The next ten to fifteen years were a highly fertile period, with many new talents emerging, but Bindesbøll remaining the key figure. He may well be renowned for his design of the fishermen's booths in Skagen, which were built shortly after the turn of the century and are still a source of inspiration for Danish architects, but he did not practise much as an architect. However, his ceramics were revolutionary. His freely formed jars and dishes had an almost rough texture, bearing signs of the hands which had worked them and with abstract decorations, inspired by clouds and plant shapes. They were provocative at the time, today they are classical collectors'

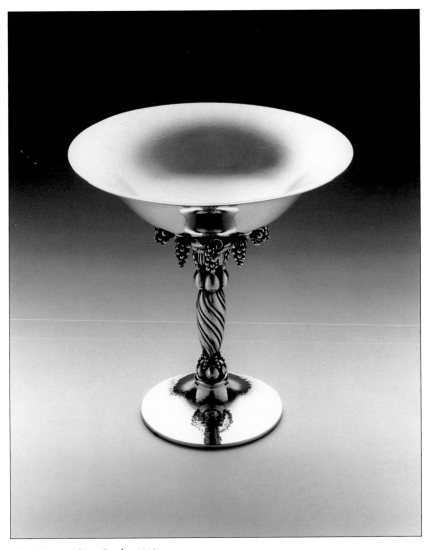

Georg Jensen **Grape Bowl** *1918*

bowls decorated with clouds and lightning for the old Copenhagen firm of A. Michelsen, the Court jeweller, with whom he worked around the turn of the century. He designed book covers, and in Skagen he even took on the task of painting the panels in Brøndum's Hotel, which was closely associated with the Skagen artists; Anna Ancher, a fine colourist, and the wife of Michael Ancher, was born Anna Brøndum.

There were other prominent figures around the turn of the century. Arnold Krog, the artistic director of the Royal Porcelain Manufactory, received instant international recognition with his Japanese-inspired vase *Bølgen* (the Wave), when it was exhibited at the Paris exhibition in 1900. It is no exaggeration to say that he, and the Royal Porcelain Manufactory, were a sensation. For it was in Paris that the world was first introduced to Arnold Krog's underglaze decorations, early examples of what we would nowadays classify as the best of Danish Art Nouveau.

Only four years later the young sculptor and goldsmith Georg Jensen set up his workshop. He was to enjoy far greater success than his contemporary, the equally creative and talented goldsmith, Mogens Ballin, who started exhibiting artistically innovative, art-nouveau jewellery from his own workshop in 1899. Eight years later he was forced to shut up shop.

Georg Jensen, whose life was not actually as easy and untroubled as one might think, is a name famous all over the world. He worked as a designer and silversmith almost right up to his death in 1935. The simple cutlery he designed in 1906, *Antik*, incidentally also his first flatware design, is so beautiful and functional that it is still considered by many to be unsurpassed, the best ever to be produced in the silver workshop. Characteristically for Georg Jensen, the surface is not smoothly polished, but retains signs of the hammer marks. His jewellery, the best of which was produced in the early 1900s, was partly

items. Clay was a material which suited Bindesbøll's temperament and there have been few others who have matched his ability to produce such intense and personalised ceramics whilst retaining the interplay between material, form and colour. He had an impulsive nature, working for several workshops, including Kähler in Næstved, which had a reputation for artistic quality and technical skill and which became so significant for Danish ceramics in the first half of the 20th century. Bindesbøll was always ready to take up a challenge and he found it stimulating to tackle new materials. He designed furniture of extreme simplicity and beauty, and silver

inspired by nature, as was so much of the Art Nouveau, but it was also highly individual. The pieces demonstrate the joy of the creative artist working with silver and amber and other semi-precious blue and green stones. It could even be postulated that these are jewels from a man in love with wonderful women.

In any discussion of Georg Jensen, Johan Rohde must also be included. He was originally a painter who joined the workshop in 1906, producing hollow ware which is the epitomy of simplicity and elegance. Since then, dozens of artists and designers have been affiliated to the Georg Jensen company, which has retail outlets all over the world and is now part of the Royal Copenhagen conglomerate. Of all the excellent artists working for Georg Jensen in our own time, the most outstanding must surely be the sculptor Henning Koppel. He, like his predecessor Bindesbøll, also successfully mastered a plastic expression. His large fish dish could be called a wonderfully beautiful sculpture, and it has found a place in the New York Museum of Modern Art. Koppel too has created a large number of very personal pieces in silver, his favourite material.

However it is now 1995, and it is possible to follow the development of the Danish arts and crafts from those early days to the very latest products, all displayed at the Museum of Decorative Arts. There is furniture, textiles, jewellery, silver, glass, and all the other forms of crafts. Anyone interested in ceramics should also visit Galleri Nørby in Vestergade, which houses a wide range of beautiful ceramics. The gallery was started three years ago by Ingrid Nørby, an enthusiastic and quality concious lady, who originally trained as a textile artist. Her gallery is now widely respected, filling a large gap left since the closure of the Den Permanente, the collective gallery, and so it has now been promised an official subsidy.

Danish ceramics have also developed radically since the turn of the century. Our contemporary ceramicists have a rich heritage, which some can identify with and others find inhibiting. Herman A.Kähler in Næstved has already been mentioned above in connection with Thorvald Bindesbøll. This was a better than average pottery founded in 1839, which for many decades concentrated on series production. Towards the end of the century, the painters Svend Hammershøj and Jens Thirslund started having a considerable impact on the production line. They were both excellent ceramicists. Hammershøj worked with simple, sometimes angular forms and developed a black and white speckled glaze, whilst Thirslund had a freer, yet still disciplined, modelling style, and he specialised in tiles. Kähler continued to produce commendable ceramics in the form of bowls, vases, plates, cups, candlesticks and ashtrays well into the 20th century whilst maintaining remarkably low prices. Of course this increased sales and meant that Kähler's ceramics became well-known all over Denmark. It gave artists who had a decoration commission the confidence to approach Kähler for collaboration on the production of major pieces, when they did not possess the technical skills or capacity themselves.

In the 1930s there was another notable development in the history of Danish ceramics – Saxbo appeared on the scene and immediately established a very strong position. Saxbo was founded by Gunnar Nylund (who soon faded into the background), and Nathalie Krebs, who was a chemical engineer and master of the most superb Chinese-inspired glazes that had ever been seen in Denmark. They possess a subtlety, depth and saturated intensity which still evoke admiration and wonder. How she conjured these up remained her secret, for she never revealed her formulae, not even to close colleagues, and she took them with her to her grave. Nathalie Krebs never touched the clay herself, she employed the outstanding ceramicists and designers Eva Stæhr-Nielsen and Edith Sonne, whose contributions were undervalued for a long time.

It is difficult to limit the list of names, but

a couple more of the excellent ceramicists since the 1930s must be mentioned. Axel Salto was a painter and graphic artist before he started making pottery, as well as designing textiles; his ceramic idiom is inspired by nature, by bulbs, fruits and plants. The extensive series of jars and bowls which he made for the Royal Porcelain Manufactory have been categorised as his "sprouting style", and they really do grow, buds and shoots and all. One of the last of the great female ceramicists of this century is the 82 year-old Gertrud Vasegaard, who also worked for a time for The Royal Porcelain Manufactory, where she was responsible for a couple of dinner services in a harmonious design, inspired by Chinese porcelain, with blue decoration, as well as one undecorated service, with strong plastic effects. Unfortunately these are no longer in production. But it is her individual pieces, made in her own workshop, which provide the strongest evidence of her exemplary ability to combine form and a stylised, sparse decoration in the most natural and simple manner. Finally, there is Gutte Eriksen, who was influenced by Japanese ceramics, and who will be discussed later in her capacity as an inspirational teacher.

All these ceramicists laid the foundations for the current generation, which is almost inconceivably rich in talent. It is not a small élite, but a large one. And this élite includes Bente Hansen, Bodil and Richard Manz, Malene Müllertz, Sten Lykke Madsen and the three Strandstræde ceramicists; Jane Reumert, Gunhild Aaberg and Beate Andersen. Unlike all the others exhibiting in Edinburgh, this last group is not based on Bornholm. Bente Hansen's grainy, salt glazed jars and bowls, often with a geometric pattern, are bold and commanding and in recent years they have acquired sculptural forms. Both Bodil and Richard Manz seem to have been blessed with artistic talent at birth. They are masters of the highest quality functional pottery, as well as of sculptural expressions, and Bodil Manz excels

in near geometric constructions of jugs and ship-shaped forms in the very finest, almost transparent porcelain. But at the exhibition in Scotland it is Jane Reumert who will represent the group. Whilst she is also capable of a more robust expression, she will be exhibiting her almost transparent "eggshells" in porcelain and one of her latest experiments, a fibreglass bowl with inlaid pattern.

Bornholm, the rocky island in the Baltic, has been sought out by artists and ceramicists since the end of the last century. The first pottery opened in 1859, when a young ceramicist by the name of Hjorth founded the L. Hjorth's Terracottafabrik in Rønne, the largest town on the island. It still exists, having acquired museum status, and his descendants (including the ceramicist Marie Hjorth who has also been selected to participate in this exhibition), run the workshop and ensure the survival of their great grandfather's beautiful old building. L. Hjorth worked in the style of his day, and became known in particular for his vases in classical forms and red clay, inspired by ancient Greece. To the Greek repertoire he added copies of old nordic urns and stones. It was not until the 20th century, however, that his successors – and there are many ceramicists amongst his descendants – produced new ideas. It is interesting to note that four of the most prominent women in contemporary Danish ceramics are direct descendants: Gertrud Vasegaard and her sister Lisbeth Munch-Petersen, both exhibiting in Scotland, and the latter's daughters, Julie Høm and Ursula Munch-Petersen, whose famous new service, *Ursula*, produced by Royal Copenhagen, is finding favour all over the world.

It is obvious that with such a collection of talents around Hjorths Terracottafabrik, this little island is quite a source of inspiration. Even in the last century Bornholm could boast a number of excellent potters. Since then pottery has spread across the whole island – almost like a bush fire – and the beautiful and

striking scenery and the favourable climate have probably also provided some of the incentive. There are some superb ceramicists here, making beautiful, simple things to use in the home, working in near obscurity and barely able to subsist. There are also ceramicists producing wares with horrible, thick glazes for the tourist market, and then there are the great talents and international names such as Gerd Hiort Pedersen and her husband Hans Munck Andersen, who has developed a unique technique of building up bowls and jars in different coloured clays, which have been acquired by some of the leading museums of the world.

Bornholm is no longer the only region in Denmark which is densely packed with ceramicists. The area around Århus, Denmark's second city, has also become a potter's mecca; even in London a very alert private gallery, the Galerie Besson in the Royal Arcade, has noticed the Århus ceramicists and exhibited their works. Some of the best are Mette Augustinus Poulsen and Clara Andersen, Dorthe Heide, Anne Flöche and Inger Rokkjær. Of course there are ceramicists all over the country, but there are a couple of specific reasons for this relatively new concentration in Jutland. Firstly, the most recent school of decorative arts is situated in Kolding. Secondly, and more importantly, Gutte Eriksen, now 76 years old, and one of Denmark's most outstanding ceramacists, who worked in Bernard Leach's workshop as a young woman and was influenced by him and her own study trips to Japan, taught at the Jutland Academy of Art for ten years. This spirited lady has had a tremendous impact.

Returning to Bornholm, this island can now also be called the glassmaker's island, which is not surprising, since many glassmakers initially train as ceramicists. Their glassworks are dotted all around the island. Some of them prefer to work alone, like Else Leth Nissen, who is an expert in *überfang* and engraving, but in the summertime in Gudhjem

and Svaneke, queues of visitors form to watch the fascinating and impressive process of glassmaking.

It is no more than 20 years ago since Finn Lynggard, the grand old man of Danish studio glass, started teaching glassmaking at the college now called Danmarks Designskole, and since 1980 he and his wife, Tchai Munch, who is also amongst the Edinburgh exhibitors, have lived and worked in Ebeltoft on the nose-tip of Jutland. What is more, this indefatigable banner bearer was the initiator of the Glass Museum in Ebeltoft, the only one of its kind in Denmark. He has drummed it up from nothing, and has persuaded the leading studio glass artists of the world to make donations or permanent loans of their works. They are exhibited side by side with the works of an ever increasing troop of Danish glassmakers. It cannot be denied that glassmaking in Denmark has been strongly influenced by experienced foreigners who have settled in Denmark for shorter or longer periods. Two of the best of those we consider as Danish are the husband and wife team Anja Kjær and Darryle Hinz, who had a large exhibition at the Glass Museum in 1994. They live on North Zealand and have a shop in Copenhagen. We have to journey further to the island of Taasinge south of Funen to find two other artists, Lena Ljunger and Jesper Södring, also exhibiting beautiful bowls and glasses in Scotland, and on to Holmegaards Glasværk for another one, Torben Jørgensen.

Holmegaard is one of the oldest Danish glassworks, established in 1825, originally near a South Zealand peatbog, where peat for firing the ovens was cheap and readily available. It was not until the 20th century that Holmegaard stopped copying other glass and employed their own designers. The first important designer was Jacob E. Bang, who started working for the glassworks in 1925. He expressed himself in an exemplary and clear manner, when he explained the new policy which he intended to introduce at

Holmegaard – to make the glass "practical, strong, cheap and beautiful". This is pure Functionalism, and proposed very early on, before the Stockholm exhibition in 1930. Much has happened since. Holmegaard, which is now part of the Royal Copenhagen conglomerate, still makes series of drinking glasses, and over the years many have been designed by Per Lütken. One of the most recent and most inspired series, shell-shaped, was designed by the goldsmith Arje Griegst, who was also responsible for a dinner service first produced by Royal Copenhagen 10 years ago. Today Holmegaard also specialises in one-off pieces and Torben Jørgensen has made many of these since starting with Holmegaard in 1977.

Glass is also stained glass, and its long tradition is evident in the great cathedrals and churches of Europe. Many artists are still attracted by glass as a material. In Denmark, Per Steen Hebsgaard is the artist with the greatest professional skill in this field, and he has even set up a studio of glass decoration in Copenhagen. He prefers to work with contemporary abstract artists, and well-known painters and sculptors. These include Arne Haugen Sørensen, Peter Brandes, Jørn Larsen, Carl-Henning Pedersen, who has made a huge, highly controversial decoration for Ribe Cathedral, and Bjørn Nørgaard, whose designs for glass paintings and a single glass sculpture are on view in Edinburgh.

Furniture design is flourishing in Denmark, but here it must be admitted that it was even stronger in the 1930s, 40s and 50s, when it was possible for relatively small cabinet-makers to hire good architects and both sell the furniture and make the books balance. The term *Danish Design* became an international catchword in the 1950s. Danish furniture is not included in the Edinburgh exhibition, since it was the subject of a separate exhibition here a couple of years ago. This also goes for jewellery, which despite hard times, boasts numerous goldsmiths bubbling with talent. Their work covers a wide spectrum, from delicate and very feminine pieces, sometimes inspired by classical Greece and Rome, to strict abstract forms in silver or polished stone; from brooches and pendants as small non-figurative sculptures in different colours to organic forms: from artistry in gold and diamonds to plastic and rubber bands and imaginative recycling of ordinary household objects. And they really have enriched the decorative arts in Denmark today.

But silver hollow ware is being exhibited in Edinburgh, and even though this is a small area, due no doubt to the limited potential market of wealthy customers, it lives up to its proud traditions. Here it is again important to mention the example set by both Georg Jensen and by Hans Hansen in Kolding. The youngest silversmith exhibiting in Scotland is Claus Bjerring, who is in his early forties, and he occupies a deservedly prominent position and has a circle of regular customers. It is probably no exaggeration to say that it is thanks to the churches and their orders of ecclesiastical silver that many of the silversmiths are able to lead a tolerable life, and Bjerring has also recently finished a commission for altar silver for the new church in Greve, south of Copenhagen. He was also the artist who made the magnificent table silver which was a silver wedding present to Her Majesty Queen Margrethe and Prince Henrik in 1992. This cutlery was inspired by the 18th century royal table silver on display in Rosenborg Castle, which is taken out and used every New Year, when the Queen entertains her cabinet and other dignitaries. Claus Bjerring is a master of both hollow ware and jewellery and he has developed a unique and sophisticated technique to exploit the interplay between various metals to make a silver and gold bracelet or a box (and he is particularly good at boxes) look as though the gold is inlaid, in the intarsia style. His work has been acquired by many museums around the world.

The silversmith Allan Scharff also has an

international reputation. He was artistic adviser and designer for Hans Hansen in Kolding for more than ten years, and he now holds the same position at Royal Copenhagen. He is being showered with prizes and medals - for instance he was awarded the World Craft Council's European Award in 1993. He is well-known in Britain not only as a frequent participant in international exhibitions, but also as a visiting lecturer of several years' standing at the Royal College of Art.

Allan Scharff works are inspired by organic forms, and more specifically, much of his hollow ware is inspired by the shapes of birds, which lends them a unusual lightness. There is often a charming gaiety in his small silver bowls and boxes. He has been charged with the difficult task of renewing and extending the range of silver at Georg Jensen/Royal Copenhagen, but the firm has also allowed him to try out his talents in other materials and his first attempts at glassmaking have been most successful. The grand old man of Danish silversmiths is the 84 year-old Mogens Bjørn Andersen, who has fashioned elegant christening ewers and dishes for many churches, but who also has the inclination to make nick-nacks like the little tipping tumbler, a small silver beaker which enhances the pleasure of a Scotch – or a Danish Snaps.

It is worth noting, and it always surprises people outside Denmark, that many Danish artist-craftsmen are members of the artists' organisations which feature so strongly on the exhibition circuit in Denmark. This indicates the status accorded to the decorative arts in Denmark. All the associations mount regular exhibitions throughout the winter season, and those artist-craftsmen who are members are nearly always textile artists and ceramicists. Which is understandable, since textile artists nowadays are creative artists and many of them have abandoned wall-hangings in favour of floor decorations. There is not a great leap from a woven tapestry to a painting or from large ceramic jars and dishes and services to

sculpture. Even before the Second World War works by a couple of the acknowledged weavers of the day, Gerda Henning and Lis Ahlmann, were being exhibited in art exhibitions. Nowadays it is weavers like Nanna Hertoft, Vibeke Klint and Jette Thyssen and a ceramicist such as Gertrud Vasegaard, who participate in the exhibitions organised by the major artists' associations.

One of the exhibitors in Edinburgh, Annette Juel, is a fine example of a weaver who has taken the plunge and step by step has experimented her way from weaving to a free artistic style. Nowadays we may wonder why it caused such a sensation when she started working with coloured metal wiring, probably telephone wires, sprawling her wonderful, sculptural compositions across the floor. She no longer considers any weaving technique when producing her compositions, which could just as well be called reliefs as textile art. But it is worth remembering that she is in fact an accomplished weaver, with an in-depth knowledge of Japanese ikat weaving, and she is still producing her popular series of neat black and white belts and bags. Another weaver who enjoys the challenge of working with non-textile materials is Randi Studsgarth, but she has not abandoned the warp and weft so emphatically as Juel.

It is most reassuring to know that Vibeke Klint, who is the most significant weaver in Denmark and who has trained and influenced more weavers than anyone else, would never so much as consider pulling wires through holes in metal plates or making felt sculptures. She herself trained under the great Gerda Henning and demonstrates a very personal and creative expression in the strict, geometric designs of her beautiful rugs. And also in her splendid silk shawls which reveal a Venetian influence. She can put life into a large carpet with just a couple of broad stripes and a small arrowhead, and her colours are confident and exciting. Technically she is of course quite perfect.

Ruth Malinowski and Puk Lippmann

(who studied under Klint) also use geometric patterns and figures in their designs, and nothing but very beautiful work has emerged from their workshops. They have both recently completed large commissions. Ruth Malinowski has made rugs for The Danish Academy in Rome, and Puk Lippmann has been working for the residence of the Bergia Trust at Nivågaard. Another fine weaver is Torill Rud Galsøe, whose bold work is inspired by natural forms. The number of excellent Danish textile artists is far greater than can be included at the exhibition in Edinburgh. Large decorative commissions are fortunately on the increase. There is for instance Berit Hjelholt's splendid wall-hanging behind the Speaker's Chair in the Danish parliament building, or Jette Gemzøe's wall hangings in the old rococo assembly hall at the Museum of Decorative Arts. This is one of the largest commissions to be awarded to a weaver for many years. Jette Gemzøe has introduced the use of handmade paper in large tapestries to Denmark and she has applied it in the most fascinating manner in a number of works where Egypt was the source of her inspiration. In Edinburgh it is Anne Vilsbøll, a pioneer in the use of handmade paper, who will be exhibiting some of her large decorative works.

It was Marie Gudme Leth, now in her nineties, who introduced textile printing to Denmark and became the first, and very successful, teacher of the subject at the School of Arts and Crafts in 1931. A selection of her printed materials are being exhibited in the summer of 1995 in the Museum of Decorative Arts along with designed furniture of the period. But block printing, actual printing on textiles, which was her speciality, has been somewhat neglected by the new generation of textile artists. *Kvadrat* the textile firm based in Ebeltoft, makes a considerable effort and must be praised for maintaining such high quality. In Edinburgh textile printing is represented by Bitten Hegelund and Naja Salto, best known as a tapestry weaver, and designer of two Gobelin tapestries produced in France which now hang in Holmens Kirke.

Bookbinding has also been alloted space at the Edinburgh exhibition. Even though the number of potential clients for a handbound version of their favourite book is rather limited, there is still a market. Her Majesty Queen Margrethe is thus a regular client of one of Denmark's best master bookbinders, Ole Olsen, who runs the gallery *Co Libri* and whose work has been exhibited widely, including exhibitions at the Metropolitan in New York and at the Victoria and Albert Museum in London. Queen Margrethe II designed the binding of her own copy of the Danish edition of Tolkien's *Lord of the Rings,* which she illustrated.

In 1868 the wood engraver F. Hendriksen, who made an energetic effort to improve the quality of book art in Denmark, travelled to Britain to learn more from the British craftsmen whom he admired so much. He was also the organiser of a Danish book exhibition at the world exhibition in Chicago in 1893. Other well-known master bookbinders of the period included Anker Kyster, who also exhibited in Chicago, and who later made the bindings designed by Thorvald Bindesbøll. Kyster maintained the same style throughout his career, and innovations were not introduced until his successor, Bent André, took over.

The bookbinders who are exhibiting in Edinburgh are all employed by the Royal Danish Library, and their daily work consists of binding journals and restoring the Library's collections. Hanna Christensen and Allan Jensen are former employees of Ole Olsen's company *Co Libri*.

Even though an exhibition like this cannot be completely comprehensive, this current overview in Edinburgh will hopefully persuade the visitor that the decorative arts are thriving in Denmark and that the country is teeming with talented artist-craftsmen.

Translated by Vivien Andersen

Lisbeth Munch-Petersen

1909	Born in Denmark
1928-30	School of Museum of Decorative Art, Copenhagen
From 1933	Own studio in Gudhjem, Bornholm

Selected Exhibitions

1951/57	Triennale, Milan
1954-57	Design in Scandinavia, USA
1958	Formes Scandinave, Louvre, Paris
1958	XX Ceramics International, Syracuse Museum of Fine Art, New York
1960	The Arts of Denmark, Metropolitan Museum, New York
1968	Two Centuries of Danish Design, Victoria & Albert Museum, London

Awards

	Davids Legat
	Tagea Brandts Legat
From 1983	Civil List Pension
1985	Bindesbøll Medal

Collections

Museum of Decorative Art, Copenhagen
Danish State Art Foundation
Bornholms Kunstmuseum
Trapholt Museum, Kolding, Denmark
National Museum, Stockholm
Rösshka Konstslöjdmuseet, Gothenburg
Museum of Modern Art, New York
Victoria & Albert Museum, London
Ceramic wall decoration, Danish Sports Hall, Flensburg
Various ceramic church decorations together with Paul Høm
Ceramic relief decoration, Nexø Town Hall

▲

Gertrud Vasegaard

1913	Born in Denmark
1930-32	School of Arts & Craft, Copenhagen
1933-48	Own studio in Bornholm
1948-59	Bing & Grøndahl, Copenhagen
From 1959	Own studio in Copenhagen

Selected Exhibitions

| 1984 | Retrospective exhibition at Museum of Decorative Art, Copenhagen |

Awards

1943	Ole Haslund's Award for Artists
1956	Tagea Brandt's Travel Award
1963	Eckersberg Medal
1981	Bindesbøll Medal
1981	Prince Eugen Medal
	Danish State Art Foundation

Collections

Museum of Decorative Art, Copenhagen
Royal Museum of Fine Arts, Copenhagen
Holstebro Museum of Art
National Museum, Stockholm
King of Sweden's Collection
Malmö Museum
Nordenfjellske Museum, Trondheim
Groninge Museum
Het Prinsessehof, Leeuwarden
Boymann van Beuningens Museum, Rotterdam
Museum of Art, Pennsylvania State University
Bornholms Museum
Trapholt Museum, Kolding
Aarhus Museum of Art
Victoria & Albert Museum, London

Gutte Eriksen

1918	Born in Denmark
	School of Arts and Craft, Copenhagen
	Studied with Bernard Leach, St. Ives, Cornwall, with Pierre Lion, St. Armand and with Vassil Ivanoff, La Borne, France
1951-53	Studied with Felix Möhl, Allerød
Since 1953	Own studio in St. Karlsminde, Hundested

Selected Exhibitions

	National Museum, Stockholm
	Faenza, Concorso Internazionale della Ceramica d'Arte
	Louvre, Paris
1968, 1978	Victoria & Albert Museum, London
1970	Kyoto Museum of Modern Art

Awards

	Tagea Brandts Legat
1972	Gold Medal, Faenza, Italy
	Ole Haslund's Award for Artists
	Thorvald Bindesbøll Medal
	Danmarks Nationalbank's Anniversary Foundation of 1968
	Civil List Pension

Collections

Museum of Decorative Art, Copenhagen
Louisiana Museum of Modern Art
Trapholt Museum, Kolding, Denmark
Museum of Art, Pennsylvania, USA
Museum of Modern Art, Tokyo
Royal Scottish Museum, Edinburgh
Victoria & Albert Museum, London
King Gustav IV Adolf's Collections, Stockholm

Astrid Anderberg

1927	Born in Tranås, Sweden
1946-51	School of Design and Craft, Gothenburg

Selected Exhibitions

1977	Röhsska Konstslöjdmuseet Museet, Gothenburg
1979	Galerie Doktor Glas, Stockholm
1982	Varbergs Museum
1984	Höganäs Museum
1986	Lidköpings Konsthall
1990	Frölunda Kulturhus
1994	National Gallery, Stockholm

Awards

1965	Göteborg-Tidningens Debut Prize
1968	Gothenburg's Culture Prize
1991	Sällskapet Gnistan

Collections

The National Museum, Stockholm
Röhsska Konstslöjdmuseet, Gothenburg
The Museums of Höganäs
Kalmar and Jönköping
Bornholms Kunstmuseum

▼

Richard Manz

1933	Born in Germany
1950	Educated as ceramist and tilemaker
1954	Emigrated to Sweden
1956	Applied Art School, Stockholm
1955-1965	Working at Porcelain Factory Gustavsberg
Since 1967	Studio together with Bodil Manz

Selected Exhibitions

1966	Mexico City
1977	Den Permanente, Copenhagen
1977	Museum of Decorative Art, Copenhagen
1980	Galerie de Proen, Amsterdam
1986	Gammel Dok, Copenhagen
1987	Maison du Danemark, Paris
1987	Museum Boymans van Beuningen, Rotterdam
1987	Seibu, Tokyo
1987-88	Design au Danemark, France Rösshka Konstslöjdmuseet, Gothenburg

Collections

Museum of Decorative Art, Copenhagen
Danish State Art Foundation, Copenhagen
Rösshka Konstslöjdmuseet, Gothenburg
Nagoya Museum, Japan
Museum Boymans van Beuningen, Rotterdam
Landesmuseum, Karlsruhe
Kunstindustrimuseet, Helsingfors, Finland
Palmer Museum of Art, Pennsylvania, USA
Carlsberg Foundation, Denmark

Sten Lykke Madsen

1937	Born in Denmark
1958	Graduated from School of Arts & Craft, Copenhagen with Bronze Medal
1958	Employed by Kähler, Næstved
1959	Own workshop
Since 1962	Employed by Bing & Grøndahl (now Royal Copenhagen)

Selected Exhibitions

Major exhibitions in Denmark, Germany, Italy, Portugal, Japan, Formosa, Russia, Belgium, Holland, Sweden, Great Britain and the USA

Awards

1969	Hofjuveler Michelsen's Jubilee Grant
1971	Paul Mikkelsen's Grant
1972	Thanning's Grant
1984	Ole Haslund's Award for Artists

Collections

Trapholt, Museum, Kolding, Denmark
Victoria & Albert Museum, London
Nordenfjellske Kunstindustrimuseum, Norway
National Museum, Stockholm
Museum of Decorative Art, Copenhagen
The Danish State Art Foundation, Copenhagen
Museum Boymans van Beuningen, Rotterdam
Museo Internazionale delle Ceramice, Faenza
Höganäs Museum, Sweden
Alka Insurance, Copenhagen
Wall decoration, Bing & Grøndahl, Copenhagen
Fountain at Holstebro (1986), Denmark
Wall decoration, Sølvgade 14, Copenhagen

▼

Gerd Hiort Petersen

1937	Born in Nexø
1961-65	School of Arts and Craft, Copenhagen
1968-73	Own studio at Royal Copenhagen Manufactory
1973	Own studio in Bornholm together with Hans Munck Andersen

Selected Exhibitions

Numerous exhibitions in Denmark, The Netherlands, Germany, Sweden, Norway, Japan, Belgium and France

Awards

1973	First prize – 2nd International Exhibition of Ceramic Arts, Gdansk
1982	The Craft Council's Annual Award
1984	First prize, International of Arts and Crafts
1991	Artist of the Year - Jyllandsposten

Collections

National Museum, Gdansk
Museum of Decorative Art, Copenhagen
Nordjyllands Kunstmuseum
Museum of Decorative Art, Oslo
National Museum, Stockholm
Kunstgewerbemuseum, Berlin
Museum Boymans van Beuningen, Rotterdam

Gunhild Aaberg

1939	Born in Denmark
1964	Graduated from School of Arts & Craft, Copenhagen
Member of the exhibition group Ceramic Ways |

Selected Exhibitions

The Museum of Decorative Art, Copenhagen
Röhsska Konstslöjdmuseet, Gothenburg
Flehite Museum, Holland
Nordenfjellske Kunstindustrimuseum, Trondheim
Museum of Art, Pennsylvania
De Danske, Kulturhuset, Stockholm
Scandinavia Today, Cooper Hewitt, New York
Tender is the North, Barbican Centre, London

Awards

Danmarks Nationalbank's Anniversary Foundation of 1968
Danish State Art Foundation – 3-year working award

▼

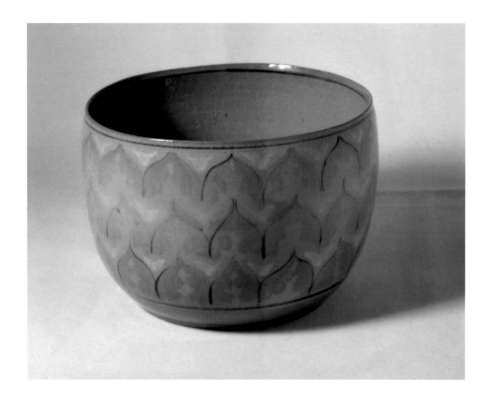

Marie Hjorth

1941	Born in Rønne, Bornholm
1964	Graduated from School of Arts & Craft, Copenhagen
Since 1965	Own workshop

Selected Exhibitions

Bornholm Kunstmuseum
Museum of Decorative Art, Copenhagen
Museum of Decorative Art, Oslo
Museum of Decorative Art, Hamburg
Nordenfjellske Kunstindustrimuseum, Trondheim
Nordens Hus, Thorshavn
Museum of Art, Pennsylvania
Schloss Gottorp, Schleswig-Holstein
Trapholt, Kolding, Denmark
Grimmerhus, Middelfart, Denmark

Awards

Danmarks Nationalbank's Anniversary
Foundation of 1968

Collections

Major mural carried out for Pakhuset in Rønne

Beate Andersen

1942	Born in Denmark
1960-64	School of Arts and Craft, Copenhagen
1964	Established the Studio Strandstræde with Gunhild Aaberg and Jane Reumert
1985	Member of Exhibition Group Ceramic Ways

Selected Exhibitions

1974	Exempla, Munich
1977	Röhsska Konstslöjdmuseet, Gothenburg
1981	Nordenfjellske Kunstindustrimuseum, Trondheim
1981	Danish Ceramic Design, Museum of Art, Pennsylvania
1982	Galerie Het Kapelhuis, The Netherlands
1983	Ceramique Danoise, The Ministry of Foreign Affairs' Travelling Exhibition, France
1992	Tender is the North, Barbican Centre, London

Awards

1969	1st Prize at the Scandinavian Competition of FDB
1969	Frederik Nielsen's Award
1968	Chr. Grauballe's Award

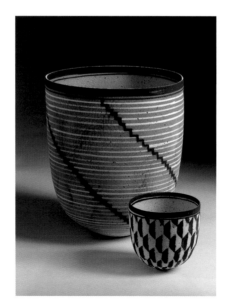

1969/72/77/80/85/89/91	Danish State Art Foundation
1970/77/89	Danmarks Nationalbank's Anniversary Foundation of 1968
1973/89	Jork Foundation

1977	Flac-Bundgaard Foundation
1977/88	Ole Haslund's Award for Artists
1988	Højesteretssagfører C.L. David's Award
1989	The Ellen and Knud Dalhoff Larsen Foundation
1989	Krøyer Foundation
1989	October Foundation
1990	Academy Council's Award Foundation
1994	Queen Margrethe and Prince Henrik's Foundation

Collections

Danish State Art Foundation, Copenhagen
Danish Museum of Decorative Art, Copenhagen
Röhsska Konstslöjdmuseet, Gothenburg
Hälsingborgs Stadsmuseum
Nordenfjellska Kunstindustrimuseum, Trondheim
Museum of Art, Pennsylvania
Swedish State Foundation of Art
Sammlung Dr. Thiemann, Hamburg
H.M. Queen Margrethe II of Denmark
H.M. Queen Sonja of Norway

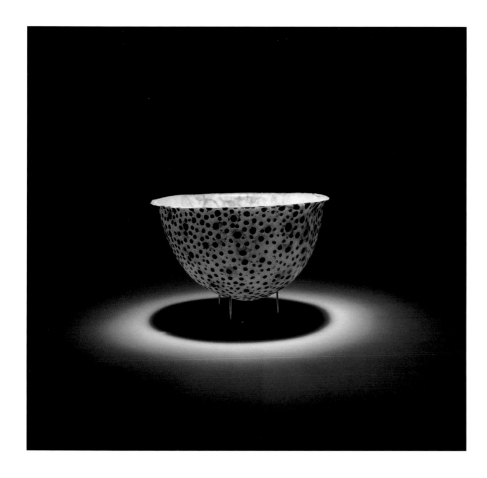

Hans Munck Andersen

1943	Born in Odense
1963-68	School of Arts & Craft, Copenhagen
1968-71	Own studio at The Royal Copenhagen Factory
1972-73	Design Department, Royal Danish Academy of Fine Arts, Copenhagen
Since 1973	Own workshop with Gerd Hjort Petersen in Bornholm

Selected Exhibitions

Major exhibitions in Denmark, Germany, The Netherlands, Italy, Sweden, Japan, USA, France

Awards

1968	Silver Medal Det Tekniske Selskabs Skoler
1980	Member of Academie Internationale de la Céramique, Geneva State Art Foundation Danmarks Nationalbank's Anniversary Foundation of 1968

Collections

Museum of Decorative Art, Copenhagen
Nordjyllands Kunstmuseum
Museum Boymans van Beuningen, Rotterdam
Kunstgewerbemuseum, Berlin
Kestner Museum, Hannover
Museum für Kunst und Gewerbe, Hamburg
Museum of Decorative Art, Oslo
National Museum, Stockholm
Herbert F. Johnson Museum of Art, Ithaca, USA
Smithsonian Institutions, National Museum of Design, New York

▼

Jane Reumert

1942	Born in Denmark
1964	Graduated from School of Arts & Craft, Copenhagen
From 1964	Own studio with Beate Andersen and Gunhild Aaberg

Awards

1969/72/77/80/86/92	The Danish State Art Foundation
1994-96	Danish State Art Foundation, 3 year Workers Stipendium
1970/72/77/85/88/92	Danmarks Nationalbank's Anniversary Foundation of 1968
1977/88	Ole Haslund's Award for Artists
1984	First prize at International Exhibitions of Arts Crafts, Bratislava
1994	Thorsten & Vanja Söderberg's Nordic Design Prize

Collections

Danish State Foundation of Art
Museum of Applied Art, Copenhagen
Rösshka Konstslöjdmuseet, Gothenburg
Nordenfjellske Kunstindustrimuseum, Trondheim
Museum Boymans-van-Beuningen, Rotterdam
Landesmuseum
Johanneum, Graz, Austria

Museum of Applied Art, Oslo
Museum of Art, The Pennsylvania State University, USA
National Museum, Stockholm
Trapholt Museum, Kolding, Denmark
Metropolitan Museum of Art, New York

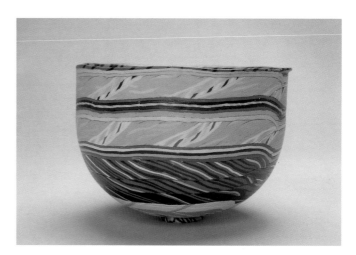

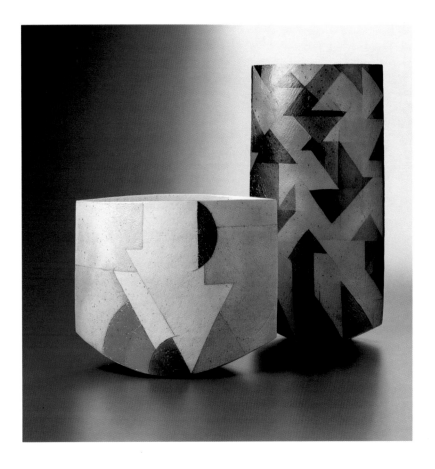

Bodil Manz

1943	Born in Denmark
1961-65	School of Arts & Craft, Copenhagen
Since 1967	Studio together with Richard Manz

Selected Exhibitions

1966	Mexico City, Mexico
1977	Den Permanente, Copenhagen
	Museum of Decorative Art, Copenhagen
1980	Galerie de Proen, Amsterdam
1985	Taipei Fine Arts Museum, Taipeh, Taiwan
1986	Gammel Dok, Copenhagen
1987	Maison du Danemark, Paris
	Museum Boymans van Beuningen, Rotterdam
	Seibu Museum of Art, Tokyo
	Design au Danemark, France
1992	Porcelain Triennale, Nyon, Switzerland
1993	Keramikmuseum Westerwald, Höhr-Grenzhausen
1994	Taipei Fine Arts Museum, Taipeh, Taiwan

Awards

| 1993 | Grand Prix World Triennale of Small Ceramics, Zagreb |
| | The Craft Council's Annual Award |

Collections

Museum of Decorative Art, Copenhagen
Danish State Art Foundation
National Museum, Stockholm
Palmer Museum of Art, Pennsylvania, USA

▼

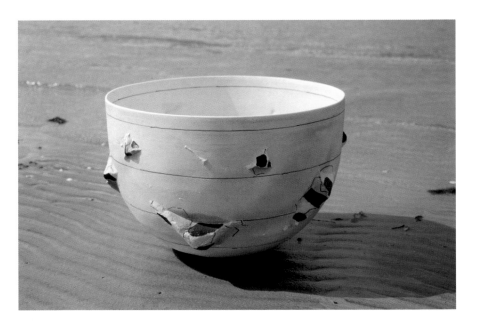

Bente Hansen

1943	Born in Copenhagen
1960-64	School of Handicrafts & Design, Copenhagen
1964-70	Artist in Residence Bing & Grøndahl
1978-82	Artist in Residence Royal Copenhagen
Since 1968	Private workshop in Copenhagen
Since 1992	Head of Ceramic and Glass Department, School of Handicrafts & Design, Copenhagen

Selected Exhibitions

1981	Royal Copenhagen
1982	Pennsylvania State Museum, USA
1984	Galerie Heidi Schneider, Zürich
1986	Gummesons Konstgalleri, Stockholm
1989	Graham Gallery, New York
1990	Gammel Dok, Copenhagen (The Craft Council's Annual Award)
1992	Hetjens Museum, Düsseldorf
1995	Museum of Decorative Art, Copenhagen

Collections

National Museum, Stockholm
Museum Boymans van Beuningen, Rotterdam
Hetjens Museum, Düsseldorf
Victoria & Albert Museum, London
Museum of Decorative Art, Copenhagen
Schleswig-Holsteinisches Landesmuseum
Nottingham Castle Museum
New Carlsberg Foundation

Ivan Weiss

1946	Born in Denmark
1962-70	Royal Copenhagen Porcelain Manufactory
1970-72	Studies in Japan
Since 1972	Employed by Royal Copenhagen Porcelain Manufactory

Selected Exhibitions

1974	Faenza, Italy
1979	Museum of Decorative Art, Copenhagen
1982	Takashimaya, Tokyo (Solo Exhibition)
1985	Craft, Spirit and Fire, Royal Copenhagen
1988	American Craft Museum, New York
1992	Trapholt Museum, Kolding, Denmark

▼

1994	Stoneware and Glass, Nikolaj Exhibition Building, Copenhagen

Awards

1978	Artist-Craftsman Prize, Technical Society Schools, Denmark

Commissions

1979	Copenhagen School of Economics and Business Administration, Denmark
1979	National Bank of Denmark
1983	Registry of Gladsaxe Court, Denmark
1990	The Dipylon Gate, Carlsberg

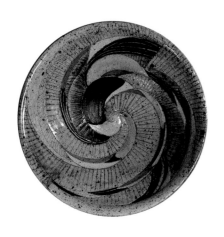

Julie Høm

1944	Born in Gudhjem, Bornholm
1962-65	School of Arts & Craft, Copenhagen

Selected Exhibitions

1969/77/81/84	Bornholms Kunstmuseum
1975	National Museum, Stockholm
1976/78/81	Museum of Decorative Art, Copenhagen
1979	Hetchens Museum, Düsseldorf Rösshka Konstslöjdmuseet, Gothenburgh
1980	Museum of Art, Pennsylvania, USA Herbert F. Jonsson, Museum of Art, New York
1994	Oberhessisches Museum, Giessen, Germany

Awards

1969/75	State Art Foundation
1977/89	Danmarks Nationalbank's Anniversary Foundation of 1968

Collections

Museum of Decorative Art, Copenhagen
Trapholt, Kolding, Denmark
Bornholms Kunstmuseum
National Museum, Stockholm
Rösshka Konstslöjdmuseet, Gothenburg
Museum of Art, Pennsylvania, USA
Themanns Sammlung, Hamburg, Germany
Oberhessisches Museum, Giessen, Germany
Schloss Gottorp, Schleswig
Wall decoration Nexø Town Hall
Wall decoration Bornholms Centralsygehus
Organ decoration of Jesuskirken, Copenhagen
Decoration Bornholms Musikskole

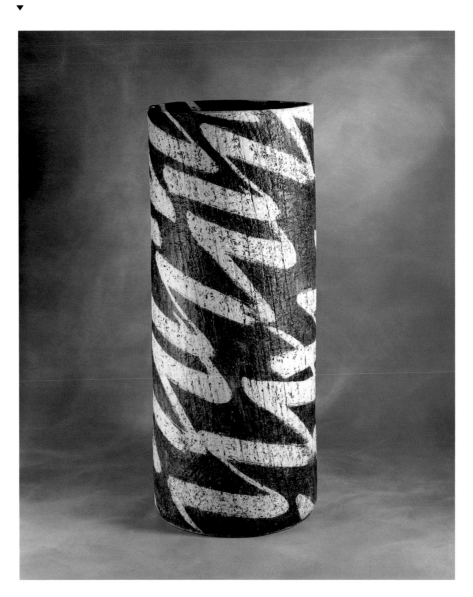

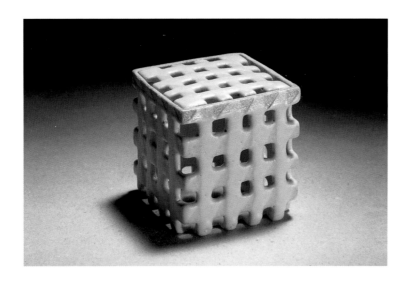

Malene
Müllertz

1949 Born in Denmark
1966-70 School of Arts & Craft, Copenhagen
1973-75 Royal Academy of Fine Art,
 Copenhagen

Selected Exhibitions

1983 Museum of Decorative Art,
 Copenhagen
1988 Esbjerg Kunstmuseum
 (with Vibeke Klint)
1988 Sorø Kunstmuseum
 Also major exhibitions in Europe,
 USA and Japan

Awards

 Danmarks Nationalbank's
 Anniversary Foundation of 1968
1988/91/93/95
 Danish State Art Foundation
1987 Danish State Art Foundation
 3-year scholarship

Collections

Museum of Decorative Art, Copenhagen
Pennsylvania State University Museum, USA
National Museum, Stockholm
Sammlung Thiemann, Hamburg
Museum Het Prinssenhof, The Netherlands
Danish State Art Foundation
Keramische Museum, Frechen, Cologne
Victoria & Albert Museum, London
Trapholt Museum, Kolding, Denmark
Schleswig-Holsteinisches Landesmuseum,
Germany
Museum Boymans van Beuningen, Rotterdam
New Carlsberg Foundation, Denmark
Parmer Museum of Art, Pennsylvania State
University, USA

Torben
Jørgensen

1945 Born in Denmark
1969-73 School of Applied Art, Copenhagen
1973-78 Head of Department of Glass,
 School of Applied Art, Copenhagen
Since 1977 Attached to Holmegårds
 Glasværker (now Royal
 Copenhagen A/S)

Selected Exhibitions

1980 Museum of Decorative Art,
 Copenhagen
1980 Contemporary Glass - Europe and
 Japan, Kyoto and Tokyo
1983 Charlottenborgs Efterårsudstillling,
 Copenhagen
1984 Danish-German Craft, Stadtisches
 Museum, Flensburg
1984 International Exhibition of Arts &
 Crafts, Bratislava
1987 Scandinavian Craft Today, Art
 Forum. Seibu, Tokyo
1988 Scandinavian Craft Today,
 American Craft Museum, New York
1990 Design – Craft or Industry, Den
 Frie, Copenhagen

Awards

1972 Second Prize Royal Copenhagen
 Jubilee Competition
1974 Administrator Krøyers Fond
1980 Hofjuveler Michelsens
 Jubilæumslegat
1989 Hvass Fondens Travel Grant

Collections

Danish State Art Foundation
Museum of Decorative Art, Copenhagen
Smålands Museum, Väjö
Museum of Decorative Art, Oslo
National Museum of Modern Art, Kyoto
Museum of Modern Art Shop, New York
Observa Instituttet, Copenhagen
Industrifagene, Metalarbejdernes Hus,
Copenhagen
Unilever House, London

Naja Salto

| 1945 | Born in Copenhagen |

Selected Exhibitions

1987	Danish Museum of Decorative Art, Copenhagen
1988	Herning Kunstmuseum, Denmark
1989	Køge Skitsesamling, Denmark
1990	AXIS MUNDI, Skissernas Museum, Lund, Sweden
1994	Maison du Danemark, Paris
1994	Aarhus Kunstbygning, Denmark

Awards

Danish State Art Foundation
Queen Margrethe and Prince Henrik's Foundation

Collections

Danish Museum of Decorative Art, Copenhagen
Trapholt Museum, Kolding, Denmark
Køge Skitsesamling, Denmark
Danish State Art Foundation
New Carlsberg Foundation, Denmark

Else Leth Nissen

1949	Born in Denmark
	Various ceramic workshops in Denmark and Sweden
	Örrefors Glassskole, Sweden
	DK and HKS Konstfackskolan, Stockholm
	Royal College of Art, London
	Guest student at Rietveld Academie, Amsterdam

Selected Exhibitions

Major exhibitions in Denmark, Sweden, Norway, Finland, Germany, France, Switzerland, Austria, Poland, Japan and Great Britain

Awards

Ole Haslund's Award for Artists
Danish State Art Foundation
Hempel's Glass Award

Collections

Bornholms Kunstmuseum
Anneberg-Samlingerne
Ebeltoft Glasmuseum
Schleswig-Holsteinisches Landesmuseum

Jesper Södring

1953 Born in Copenhagen
1973-78 School of Arts and Craft,
 Copenhagen
 Örrefors Glass School, Sweden,
 Gerrit Rietveld Academie,
 Amsterdam

Selected Exhibitions

1980 Danish Arts & Crafts Cavalcade,
 Danish Museum of Decorative Art,
 Copenhagen
1983 Nordic Glass '83 at KVADRAT,
 Ebeltoft, Denmark
1985 Kunstsammlung der Veste Coburg,
 Germany
1990 Sign in the 90s, Arts & Craftsmen of
 Funen, Brandts Klædefabrik,
 Odense
1993-94 Danish Glass '94, Glasmuseum,
 Ebeltoft, Denmark

Awards

1992 Ole Haslund's Award for Artists
1993 Hempel's Glass Prize

Collections

Danish Museum of Decorative Art, Copenhagen
Kunstsammlung der Veste Coburg, Germany
Leerdam Glasmuseum, Holland
Glasmuseum, Ebeltoft, Denmark
Anneberg Samlingerne, Denmark

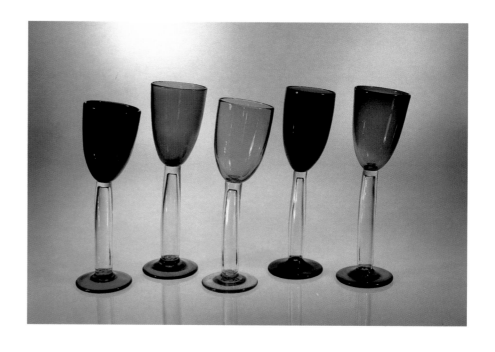

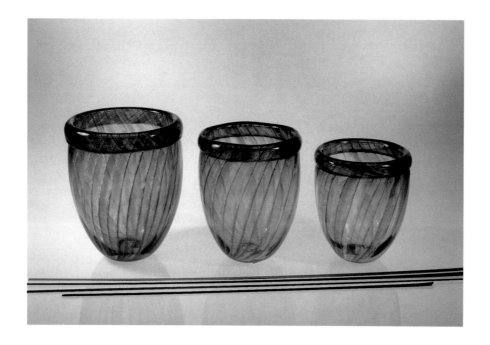

Lena Ljungar

1953 Born in Stockholm
1973-78 School of Arts & Craft, Copenhagen
 Örrefors Glass School, Sweden
 Gerrit Rietveld Academie,
 Amsterdam

Selected Exhibitions

1980 Danish Arts & Crafts Cavalcade,
 Museum of Decorative Art,
 Copenhagen
1983 Nordic Glass '83 at KVADRAT in
 Ebeltoft, Denmark
1985 Kunstsammlung der Veste Coburg,
 Germany
1990 Signs in the 90s, Arts & Craftsman
 of Funen, Brandts Klædefabrik,
 Odense
1993-94 Danish Glass '94, Glasmuseum,
 Ebeltoft

Awards

1992 Ole Haslund's Award for Artists
1993 Hempel's Glass Prize

Collections

Danish Museum of Decorative Art, Copenhagen
Kunstsammlung der Veste Coburg, Germany
Leerdam Glasmuseum, Holland
Glasmuseum, Ebeltoft, Denmark
Anneberg Samlingerne, Denmark

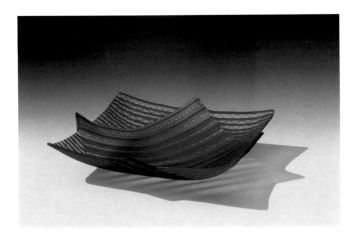

▲

Tchai Munch

1954	Born in Denmark
1975-80	School of Arts and Crafts, Copenhagen
1986	Pilchuck School of Glass, USA

Selected Exhibitions

1982	Scandinavia and Japan Craft, Kanazawa, Japan
1987-88	Scandinavian Craft Today, Japan and USA
1990	Nordform '90, Malmö, Sweden
1992	Contemporary Kilnformed Glass, Portland, USA
1994	Nordic Images, Denmark, Finland, Norway, Sweden
1994	Glasmuseet, Ebeltoft, Denmark (Solo Exhibition)
1995	Portrait der Meister, Munich
1995	Galerie L, Hamburg
1995	Dansk Design Aktuelt, Sophienholm, Denmark

Awards

1985	Coburger Glass Prize, Germany
1988	Hempel's Glass Prize
1994	Bavarian State Prize

Collections

Glasmuseum, Ebeltoft, Denmark
Danish State Art Foundation
Sønderjyllands Kunstmuseum, Denmark
Bornholms Museum, Denmark
Nordenfjeldske Kunstindustrimuseum, Trondheim
SMPK Kunstgewerbemuseum, Berlin
Kunstmuseum Düsseldorf
Danish Museum of Decorative Art, Copenhagen

Maibritt Jönsson

1956	Born in Copenhagen
1975-80	School of Arts and Crafts, Copenhagen

Pete Hunner

1954	Born in Kansas
1972-76	Whitworth College, WA, USA.
1976-79	School of Arts and Crafts Copenhagen. Diploma

Selected Exhibitions

1979	New Glass, Corning Museum of Glass, USA
	Contemporary Glass, Europe & Japan
1985	2. Coburger Glaspreis, Kunstsammlungen der Veste Coburg, Germany
1986	Studioglas aus Dänemark, Hinz, Kjær, Hunner & Jönsson. Westfälisches Museumsamt, Germany
1987-90	The Glow of Bornholm, travelling exhibition in Scandinavia
1989	Danish State Department, Copenhagen
1995	Adamson-Ericu Muuseum, Tallin, Estonia (Solo Exhibition)

Awards

1979	Danish Craftsmen Prize Project, Silver Medal, Copenhagen
1990	Danmarks Nationalbank's Anniversary Foundation of 1968
1994	C.L. David's Award for Relations & Friends, Hempel's Glass Prize

Collections

Bornholms Kunstmuseum, Rø, Denmark
Kelvingrove Museum, Glasgow
Kunstgewerb Museum, Berlin
H.M. Queen Ingrid, Queen Mother of Denmark
Art Association of 14th August, Denmark
Ebeltoft Glass Museum, Ebeltoft, Denmark

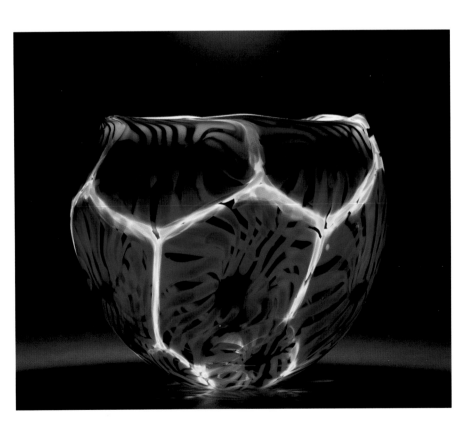

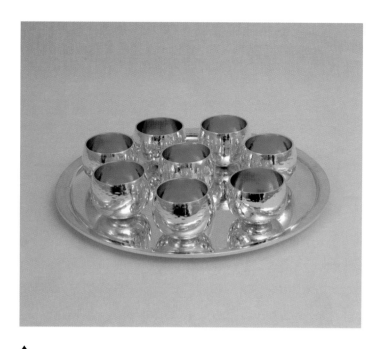

▲

Mogens Bjørn-Andersen

1911	Born in Denmark
1934	Silversmith at Georg Jensen Apprenticeship Certificate with Silver Medal
1934-35	Royal Danish Academy of Fine Arts
From 1935	Own workshop

Selected Exhibitions

Kunstnernes Efterårsudstilling
Craft Exhibitions at Danish Museum of
Decorative Art
Official Danish Exhibitions abroad
A number of Individual Exhibitions

Awards

K.A.Larssens og Hustrus Grant, Franz Ronges
Grant, Københavns Handelsbanks Grant, Knud
Højgaards Foundation, Queen Ingrids Grant, The
Augustinus Foundation, The Ellen og Knud
Dalhoff Larsens Foundation, Danmarks
Nationalbank's Anniversary Foundation of 1968,
Danish State Art Foundation, Sv. Aage
Rasmussen og Hustrus Foundation, King
Frederik and Queen Ingrid's Foundation, Queen
Margrethe II and Prince Henrik's Foundation

Collections

Danish Museum of Decorative Art
Sønderjyllands Kunstmuseum, Tønder
Varde Museum
Das Bröhan Museum, Berlin
Museum für Kunst und Gewerbe, Hamburg
Ellen og Knud Dalhoff Larsen's Foundation
Danish State Art Foundation

Jørgen Dahlerup

1930	Born in Denmark
1952	Silversmith at A. Dragsted, Copenhagen Apprenticeship Certificate with Silver Medal
1955-60	Royal Academy of Fine Arts Sculptor School
1961	Accademia di Brera, Milan
1962	Accademia di belle Arti, Rome
1962-63	Royal Academy of Fine Arts for Industrial Design
1967	Own workshop
1968-70	Product Development at Georg Jensen Silver

Selected Exhibitions

1964-65	World Exhibition, New York
1968	Autumn Exhibition Charlottenborg
1977	Solo Exhibition at the Danish Museum of Decorative Art, Copenhagen
1990	Church Art in 100 years at Runde Tårn.

Awards

Hertz Grant, The Copenhagen Polytechnic Arts
and Crafts Prize of 1879 with Bronze Medal,
Tuborg Foundation's Travel Grant, Carl Christian
Poulsen's Memorial Grant, Competition at
Goldsmith's Trade Co-oprative Council, The
Italian State Bursary, Sct. Carialdo Grant, Georg
Jensen Silver Scandinavian Competition. Viners
Sheffield The Council of Industial Design,United
Kingdom

1974	Form Prize

Collections

Bodo Glaub Collection, Germany
Danish Museum of Decorative Art
Danish Design Center
Represented in about 100 Danish Churches
Selected works at Ibesta International Exhibition,
Sheffield
Mayoral Chain, Sukkertoppen in Greenland

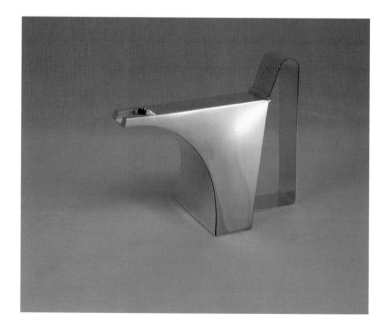

Ib Andersen

1932	Born in Denmark
1954	Silversmith
	Own workshop
1955-57	Danish Institute of Precious Metals
1954-59	Georg Jensen Silver
1958-93	Copenhagen Polytechnic Institute of Precious Metal.

Selected Exhibitions

1961 & 80	Denmark's National Museum
1963	Gesellschaft für Goldschmiede-kunst
1979	Marienlyst Castle, Scandinavian Gold and Sliver Fair
1990	Exempla Europäische Meister des Handwerks, Munich

Awards

1957	Goldsmiths Trade Co-operative Council, Competition for Contemporary Gold and Silver Design.
1959	Copenhagen Polytechnic Arts and Crafts Prize of 1879 with Silver Medal.
1972	Director Povl Frigasts Education Grant
1976	Honorary Member of The Worshipful Company of Goldsmiths
1976	Danish State Art Foundation
1981	Jewellers and Goldsmiths Council of Sweden, Eligius Prize
1993	Danish Metalworkers Union Gold and Silver Initiative Prize
1993	Danish Gold and Silver Trade

Collections

Goldsmiths Trade Co-operative Council
Gold and Silver Manufacturers Council,
Sønderjyllands Kunstmuseum
Craft Council of Copenhagen
H.M. Queen Margrethe II of Denmark
Bricklayers' Guild of Copenhagen
Copenhagen Polytechnic
Friends Foundation of Institute of Precious Metal
Danish Museum of Decorative Art
Danish Metalworkers' Union

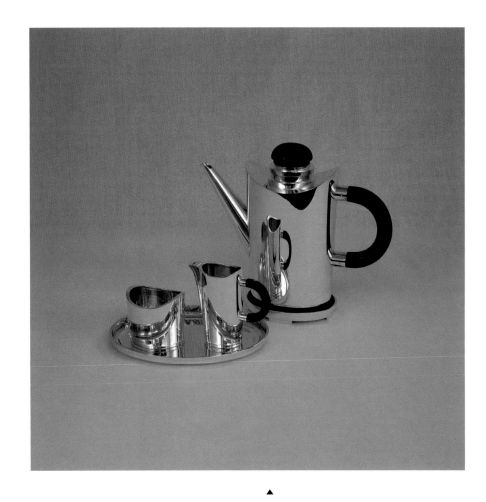

▲

Erik Sjødahl

1940	Born in Denmark
1959	Silversmith at C.C. Hermenn Silver Apprenticeship Certificate with Silver Medal
1976	Own workshop

Selected Exhibitions

All over the World

Awards

| | Member of Goldsmiths' Guild in Copenhagen |
| 1991 | Copenhagen Polytechnic Arts and Crafts Prize of 1879 with Silver Medal |

Collections

Danish State Art Foundation.
Nordenfjellske Kunstindustrimuseum, Trondheim
Rösska Konstslöjdmuseet
Sønderjyllands Kunstmuseum, Tønder
Guild Silver to Goldsmiths' Guild.
Guild Chain to Master of Guild.

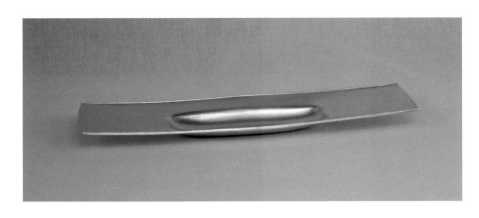

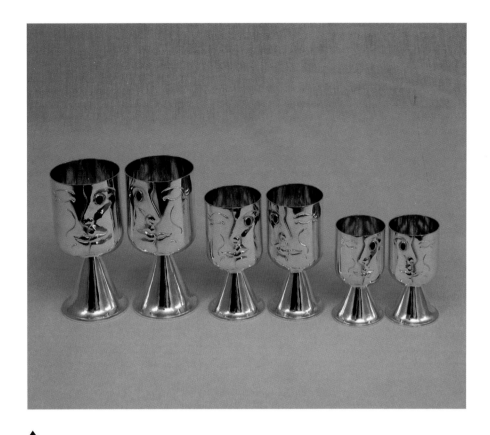

▲

Peter Vedel Tåning

1944	Born in Denmark
1963	Gold medal at Gairne-Uhomotas Idirnaisicenta, Printes-edchta, Eire
1965	Silversmith at A. Michelsen Silver Apprenticeship Certificate
1965-67	Study tour to Germany, France, Sweden
1967-69	Danish Institute of Precious Metals

Selected Exhibitions

1968-71	Gallery Exhibition in Copenhagen
1971	Exhibitions in Kolding and Århus
1971	Angelholm
1973	Sønderjyllands Kunstmuseum

Awards

1972	Copenhagen Exchange Account's Prize
	John Franz Ronges Grant
	Kurt Aulins Grant

Allan Scharff

1945	Born in Copenhagen
1963-67	Silversmith at Georg Jensen Apprenticeship Certificate with Silver Medal
1972-75	Danish Institute of Precious Metals
1975	Own workshop
1978	Herning Kunstmuseum
1978	Artistic Consultant/Designer Hans Hansen Silver
1988	Designer Georg Jensen

Selected Exhibitions

1991	Kensington Palace, London
1993	A Sparkling Party, Antwerpen
1993	Twentieth Century Silver, Crafts Council, London
1995	Gestaltende Handwerk, Munich
1995	Royal Copenhagen, Amagortou, Copenhagen

Awards

1967	National Board of Goldsmiths Trade Prize
1975 &76	Copenhagen Polytechnic Arts and Crafts Prize of 1879 with Bronze and Silver Medal
	Danmarks Nationalbank's Anniversary Foundation of 1968
1981	Danish State Arts Foundation
1981	Jens Kastrup-Olsen Memorial Foundation
1993	World Crafts Councils Europe
1995	Bayerischer Staatspreis with Gold Medal
	Honorary Member of World Crafts Council Europe

Collections

H.M. Queen Margrethe II of Denmark
Neue Samlung in Munich
Nordenfjellske Kunstindustrimuseum, Trondheim
Sønderjyllands Kunstmuseum, Tønder
Danish Museum of Decorative Art
Danish State Art Foundation

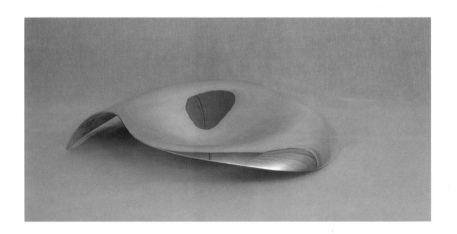

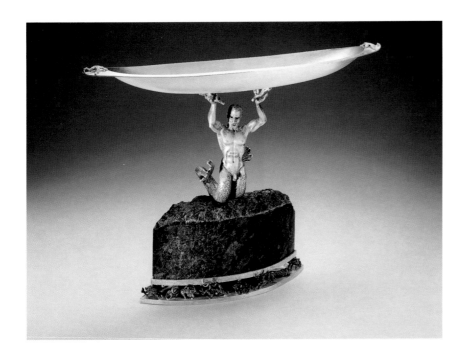

▲

Torben Hardenberg

| 1949 | Born in Copenhagen |
| 1972 | Silversmith Apprenticeship Certificate with Bronze Medal |

Selected Exhibitions

1978	Danish Museum of Decorative Art
	Art Prospect Gallery, Bruxelles
	Gallery Metal, Copenhagen
	De Danske, Kulturhuset, Stockholm
	Hotel Carlton, Cannes
	Louisiana Museum of Modern Art
	Images Nordique, Maison du Danemark, Paris
	Autumn Exhibition Charlottenborg
	Château de Brion, Dordogne
	Chr. IV Exhibition, Magasin, Copenhagen

Awards

Prince of Denmark's Grant
Danmarks Nationalbank's Anniversary
Foundation of 1968
Danish State Art Foundation

Collections

Danish Museum of Decorative Art
Craft Collection, Nationalmuseet, Stockholm
Kunstindustrimuseet, Oslo
Cooper Hewitt Museum, New York
Nordnorsk Kunstmuseum
Nordenfjellske Kunstindustrimuseum, Trondheim
Musée des Arts Decoratifs Louvre, Paris

Per Sax Møller

1950	Born in Denmark
1972	Silversmith at A. Michelsen Silver Apprenticeship Certificate with Bronze Medal
1973-75	Danish Institute of Precious Metals
1976	Own workshop
1978	Herning Kunstmuseum
1979	Bornholms Free Workshops

Selected Exhibitions

1977	Nordenfjellske Kunstindustrimuseum, Trondheim
1980	Europäische Silbertrienale, Hanau
1984	Spring Exhibition, Charlottenborg
1993	Adin, Antwerpen

Awards

| 1979 | Danish State Art Foundation |

Collections

Kunstindustrimuseet, Oslo

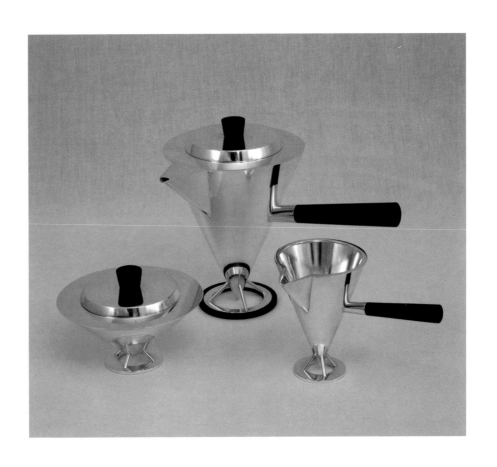

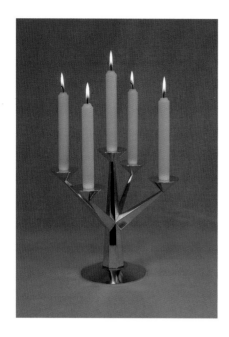

Claus Bjerring

1951	Born in Denmark
1973	Silversmith at Georg Jensen Apprenticeship Certificate with Silver Medal
1978	Own workshop
1979	Danish Institute of Precious Metals
1982-85	Royal Danish Academy of Fine Arts, Copenhagen

Selected Exhibitions

1980	Europäische Silbertrianale, Hanau
1982	Danish Museum of Decorative Art
1986	European Craft Today, Tokyo and Osaka
1987	Musée des Beaux Arts, France
1988	A number of Exhibitions in USA

Awards

1977 & 78	Copenhagen Polytechnic Arts and Crafts Prize of 1879 with Bronze and Silver Medal
1984	Design Competition, Association of Goldsmiths
1986	Danish State Art Foundation, 3 year grant
1987	Diploma Aurifex, Budapest

Collections

Danish Art Foundation
Danish Museum of Decorative Art
Nordenfjellske Kunstindustrimuseum, Trondheim
Røsska Konstslöjdmuseum, Gøteborg, Sweden
H.M. Queen Margrethe II of Denmark and H.R.H
Prince Henrik of Denmark
Victoria and Albert Museum, London

Annette Juel

1934	Born

Selected Exhibitions

1970/90	Danish Museum of Decorative Art, Copenhagen
1975-77	Danish Expression of Textile, USA
1976-77, 1979-80	
	Nordic Textile Triennale
1978	Scandinavian Crafts, Tokyo
1980-82	Danish Design, Holland, Spain, Portugal
1978/85	International Textile Triennale, Lodz, Poland
1984	Galleri Marius
1984-86	For the Floor, USA
1988	Nancy, France
1989	International Textile Competition, Kyoto
1991	Herning Kunstmuseum, Denmark
1991/92/93/94	Pro

▼

Awards

1970/75/76/78/81/86/89/90/91	
	Danish National Endowment of Art
1983, 1986	Danmarks Nationalbank's Anniversary Foundation of 1968
1984	Craft Council of Denmark
From 1995	Civil List Pension

Collections

Danish Museum of Decorative Art, Copenhagen
New Carlsberg Foundation
Danish State Art Foundation
Trapholt Museum, Kolding, Denmark

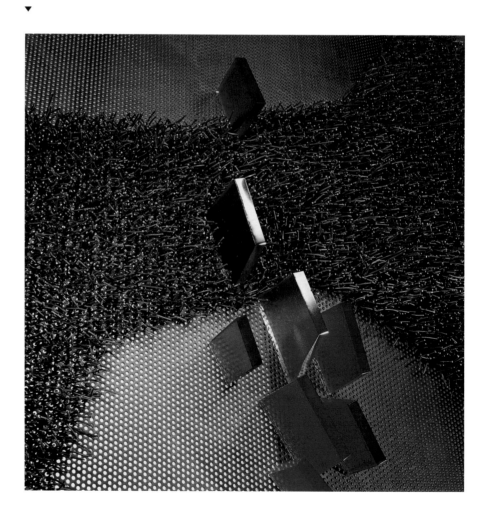

Ruth Malinowski

1928 Born in Vienna

Selected Exhibitions

1976 Nordic Textile Triennale
1977 Danish Museum of Decorative Art,
 Copenhagen
1978 National Museum, Stockholm
1979 Röhsska Konstslöjdmuseet,
 Gothenburg
1979 Danish State Art Foundation,
 Copenhagen
1982 Scandinavian Modern Design 1880-
 1980, USA
1983 Jönköpings Länsmuseum
1985 Smålands Konstarkiv, Värnamo
1985 Autumn Exhibition at
 Charlottenborg
1986 Galleri F15, Moss, Norway
1986 Kluuvin-galleriet, Helsingfors
1987-88 Scandinavian Design: A Way of
 Life, Japan
1988, 93 Galleri Gräna Paletten, Stockholm
1990 Nikolaj, Copenhagen
1991 Museum Het Princessehof,
 Leeuwarden, Holland
1991 Danish Cultural Institute, Edinburgh
1994 Nordens Hus, Reykjavik, Iceland

Awards

 Danish State Art Foundation
 Danmarks Nationalbank's
 Anniversary Foundation of 1968
 Knud Højgaard's Foundation
1985 Jönköpings Läns Landstings
 Cultural Award
1985 Hall-pressens Cultural Award
1989 Craft Council's Annual Award
1991 Thorvald Bindesbøll Medal from the
 Royal Danish Academy of Fine Arts

Vibeke Klint

1927 Born in Denmark
1949 Graduated from School of Arts and
 Crafts, Copenhagen
1949-51 Employed Gerda Henningsen's
 Studio
1951 Studied at Beaux Arts, Aubusson,
 with Jean Lurcat, Sct. Cerè and
 with Pierre Wemaëre, Bretagne,
 France

Selected Exhibitions

1952 Landsforeningen Dansk
 Kunsthåndværks Udstilling
1971 Malmø Museum
1972 Danish Museum of Decorative Art,
 Copenhagen
1979 Nikolaj Kirke, Copenhagen
1983 American-Scandinavian
 Foundation, New York
1987 Paustian, Copenhagen

Awards

1960 Lunningprisen
1972 The Eckersberg Medal
1974 Tagea Brandt's Travel Grant
1980 The Danish State Art Foundation
1989 C F Hansen's Medal

Collections

Danish Museum of Decorative Art, Copenhagen
Nordenfjellske Kunstindustrimuseum, Trondheim
Louisiana Museum of Modern Art, Denmark
Danmark's Nationalbank, Copenhagen
Vor Frue Kirke, Copenhagen
New Carlsberg Foundation

▼

▲

Randi Studsgarth

| 1938 | Born in Copenhagen |
| 1957-61 | Schools of Fine Art: Copenhagen, Gothenburg, Aubusson |

Selected Exhibitions

1972/75/83	Charlottenborg
1975	Danish Museum of Decorative Art, Copenhagen
1975-77	Danish Expression in Textile, USA
1979-81	Nordic Textile Triennale
1979-81	Danske Ægte Tæpper
1989	ITF, Kyoto
1991	Danish Museum of Decorative Art, Copenhagen

Awards

1985-91	Danmarks Nationalbank
1990	Danish State Art Foundation
1991	Queen Ingrid Foundation

Collections

Danish Museum of Decorative Art, Copenhagen
Danish State Art Foundation
Hälsingborg Museum
H.M. Queen Margrethe
H.M. Queen Ingrid
Den Danske Bank, Copenhagen, London, New York, Luxembourg
Town Hall, Hørsholm
Town Hall, Billund, Denmark
Hotel Trouville, Hornbæk, Denmark
Ali Kashoggi's villas in Ryiath, Cannes and Exenveq, France

Puk Lippmann

| 1945 | Born in Stockholm |
| 1967-70 | Apprentice handloom weaver, Vibeke Klint Studio/Workshop Member of the Danish Artists' Society |

Selected Exhibitions

1974	The Danish Museum of Decorative Art, Copenhagen
1979,80,81	Danske Ægte Tæpper, Group exhibition
1995	Dialogue with Bindesbøll, Thorvaldsen's Museum

Awards

| 1976 | Frederik Nielsen's 1st Prize in Nordic F.D.B. Competition |
| 1977 | The Craftsman's Award of 1879 |

1978/79/90/92/94/95	Danmarks Nationalbank's Anniversary Foundation of 1968
1979/90/92/94	Danish State Art Foundation
1991	Royal Danish Academy Council: the Non Nobis Award
1991	Weaver Lis Ahlmann's Award

Collections

Danish State Art Foundation
Danmarks Nationalbank
Episcopal Palace, Aalborg
Simonsen & Weel, Høje Taastrup, Denmark
Bergia Foundation, Nivaagaard Collection
Decoration - Floor of central hall of Danish Parliament, Copenhagen

Torill
Ruud Galsøe

1947	Born in Oslo
1971-76	School for Applied Arts, Copenhagen
1989-94	Head of Textile Design at the School of Handicrafts and Design, Copenhagen

Selected Exhibition

1979	Danske Ægte Tæpper, Copenhagen
1980	Danske Ægte Tæpper, Poland
1980-81	Kunstnernes Efterårsudstilling, Copenhagen
1983	Kunstnernes Forårsudstilling, Copenhagen
1985	For the Floor, USA
1986	Trapholt Museum, Kolding
1987	Scandinavia Today, Japan
1990	Efterårsudstillingen, Copenhagen
1991	Nordiske Tæpper, Gothenburg and Kalmar, Sweden
1992	Nordiske Tæpper, Athens

Awards

1981, 87	Danish State Art Foundation
1987, 90,92	Danmarks Nationalbank's Anniversary Foundation of 1968

Collections

1976	Kunstforeningen af 14 August
1980, 83	New Carlsberg Foundation
1982, 87	Danish State Art Foundation
1986	Trapholt Museum, Kolding, Denmark
1980	Ministry of Foreign Affairs, Denmark
1993	School of Handicrafts and Design, Copenhagen

▲

Bitten Hegelund

1960	Born in Denmark
1983-87	School for Applied Art, Textile
1986 & 92	Study Tour to Japan
1991	Study Tour to USA

Selected Exhibitions

1988/92	Spring Exhibition Charlottenborg
1990	Furniture and Textiles The Ministry of Culture's Exhibition Gallery
1992	ID-Forum
1992	3rd. International Textile Competition, Kyoto
1992	Interplays '92, The International Exhibition of Crafts and Applied Art, Bratislava
1994	Danish Days, The Danish Cultural Institute, Vienna
1994	The Independent Exhibition
1995	Sophienholm

Awards

1990	Thomas B. Thriges Foundation
1990	Academy Council's Award
1991	Danmarks Nationalbank's Anniversary Foundation of 1968
1991/92	Gangsted Foundation
1992	Honory Prize of "Interplay '92" jointly with the Designers Group OCTO
1993	Danish State Art Foundation
1994	Copenhagen Polytechnic Arts and Crafts Prize of 1879 with Silver Medal
1994	Hofjuveler Michelsen Award jointly with the Designers Group OCTO

Collections

Danish Museum of Decorative Art
Kunstforeningen af 14 August.

▲

A n n e V i l s b ø l l

1951	Born in Copenhagen
1970-76	University, Copenhagen and Aix-en-Provence
1980-84	College of Art, Paper and Prints, Buffalo, New York

Exhibitions

1980	Sønderjyllands Kunstmuseum, Tønder
1984-86	Spring Exhibition Charlottenborg
1985	The Artists Autumn Exhibition
1986	1st International Paper Biennale, Leopold Hoesch Museum, Düren, Germany
1988	In the Hothouse, Ordrupgaard, Copenhagen
1991	Nordenfjellske Kunstindustrimuseum, Trondheim, Norway
1994	Nordic Profiles, Travelling Exhibition, Scandinavian Museums

Awards

1986/88/91	The Danish Ministry of Foreign Affairs
1991	Queen Margrethe II of Denmark and Prince Henrik of Denmark's Foundation
1993	Foundation of Gösta Liljedahl

Collections

Danish State Art Foundation
Copenhagen Cultural Foundation
Leopold Hoecsh Museum, Düren, Germany
Vejen Kunstmuseum
Himmerlands Kunstmuseum
Dahlhoff Larsens Foundation
Royal Library
Rolex Collection, Switzerland

The Royal
Danish Library

The bindings in this section have all been made as part of the daily work of staff members working in the Binding Section of the Royal Library, Copenhagen.

> Grete Andersen
> Hans K. Biller
> Søren Carlson
> Hanna Christensen
> Allan Jensen
> Erik Løvborg
> Ole Nielsen
> Ernst Ramussen
> Neils O. Selfort
> Trine Torp

The initiative started as part of the Royal Library's 200th anniversary as a public institution. The books are either taken from the stock of the Library or purchased specially.

They represent a large variety, from small collections of poems to fully illustrated folios, Danish as well as foreign. The cover of each book is designed to reflect the character of its contents, interpreted in a contemporary design idiom.

These bindings continue the long tradition of specialist bookbinding, combining craft skills with the creativity and artistic vision of the individual binder.

The books subsequently become part of the Library's Rare Book Collection, which holds printings, older bindings from several countries, and a large collection of unique Danish bindings from the last 150 years, including these exquisite 20th century examples.

Exhibition Catalogue

Paintings and Sculpture

All dimensions are in centimetres, height preceding width.

Christoffer Wilhelm Eckersberg
1783-1853

1 View near Liselund on Møen, 1809
oil on canvas 54.4 x 41
Statens Museum for Kunst

2 Landscape with Stile, Møen, 1810
oil on canvas 58 x 74.8
Statens Museum for Kunst

3 Building in the Roman Campagna, 1815
oil on canvas 27.5 x 31.5
Statens Museum for Kunst

4 S Agnese fuori le mura. Rome, 1815
oil on canvas 32 x 50
Statens Museum for Kunst

5 Russian Fleet at Anchor in the Roads of Elsinore, 1826
oil on canvas 31.5 x 59
Statens Museum for Kunst

6 Privateer Outsailing a Pursuing Frigate, 1845
oil on canvas 55.5 x 68.5
Statens Museum for Kunst

Johan Christian Dahl
1788-1857

7 Beach Scene at Sunset, 1825
oil on canvas 26.9 x 36.3
Statens Museum for Kunst

8 View in the Park at Wörlitz, 1838
oil on canvas 47.5 x 37.5
Statens Museum for Kunst

Christian Albrecht Jensen
1792-1870

9 Portrait of Kirsten Stampe, née Kaas (1766-1842), c. 1831
oil on canvas 25 x 19.7
Statens Museum for Kunst

10 Portrait of Catherine Jensen, née Lorenzen, the Artist's Wife Wearing a Turban, c. 1842-44
oil on canvas 68 x 53
Statens Museum for Kunst

11 Portrait of Professor Andreas Christian Krog, 1854
oil on canvas 33.5 x 25
Statens Museum for Kunst

Martinus Rørbye
1803-1848

12 View of Copenhagen at Sunset, c. 1847
oil on canvas on board 28.5 x 23
Statens Museum for Kunst

Wilhelm Bendz
1804-1832

13 Portrait of Marie Raffenberg, the Artist's Fiancée, 1831
oil on canvas 16.5 x 13.5
Statens Museum for Kunst

Constantin Hansen
1804-1880

14 Piazza della Bocca della Verità in Rome, 1837
oil on canvas 75.5 x 100
Statens Museum for Kunst

15 The Arch of Titus in Rome, 1839
oil on paper on canvas 24 x 29
Statens Museum for Kunst

16 Meta Magdalene Hammerich and the Artist's Daughter Kristiane Konstantin Hansen, 1861
oil on canvas 63.5 x 53.5
Statens Museum for Kunst

Fritz Petzholdt
1805-1838

17 Mountainous Landscape. Italy, 1831/36
oil on paper on panel 22.5 x 33
Statens Museum for Kunst

Jørgen Roed
1808-1888

18 Farewell Scene at the Customs House, 1834
oil on canvas 66 x 82
Private Collection

Frederik Sødring
1809-1862

19 Summer Spire at the Cliffs of Møen, 1831
oil on canvas 30 x 41.5
Statens Museum for Kunst

Christen Købke
1810-1848

20 Frederiksborg Castle Seen from the North-West. Study, 1835
oil on paper on canvas 24 x 27
Statens Museum for Kunst

21 Susanne Cecilie Købke, née Købke, the Artist's Wife, 1836
oil on canvas 73.5 x 57.5
Statens Museum for Kunst

22 A View towards Nørrebro from Dosseringen, 1841/45
oil on paper on canvas 26 x 35
Statens Museum for Kunst

Wilhelm Marstrand
1810-1873

23 A Charlatan Selling Blacking at Piazza Barberini in Rome, 1845/48
oil on canvas 37 x 37.5
Statens Museum for Kunst

24 Landing at a Palace on the Canal Grande, in the Background the Church of S. Maria della Salute: the Woman in the Beggar's Gondola Receiving Alms, 1845
oil on board 39 x 53
Statens Museum for Kunst

Dankvart Dreyer
1816-1852

25 Landscape with Sunlit Clouds, 1840s
oil on paper on board 30 x 42.5
Statens Museum for Kunst

26 View from Mølleknap Hills towards the Little Belt, late 1840s
oil on paper on canvas 30 x 44
Statens Museum for Kunst

Peter Christian Skovgaard
1817-1875

27 The Artist's Friends and Family Seated round the Table. Vejby, 1843
oil on canvas 23 x 28.5
Statens Museum for Kunst

28 Delhoved Wood near Lake Skarre, 1847
oil on canvas 132 x 190
Statens Museum for Kunst

29 View towards Beldringe Manor, 1847
oil on board on canvas 37 x 54
Statens Museum for Kunst

30 View from the Artist's Dwelling in Copenhagen on a Winter Day, 1854
oil on canvas 35 x 36
Statens Museum for Kunst

Johan Thomas Lundbye
1818-1848

31 View of Ørkesholm. Zealand, 1841
oil on paper on canvas 14 x 32
Statens Museum for Kunst

32 View of Frederiksborg from Hestehaven, 1841
oil on paper on canvas 18.5 x 31.5
Statens Museum for Kunst

33 Marling of a Field, 1846
oil on paper on board 14 x 22
Statens Museum for Kunst

34 Study of the Cliffs at Refsnæs in North Zealand, 1847
oil on board on canvas 32.5 x 51.5
Statens Museum for Kunst

Vilhelm Kyhn
1819-1903

35 Landscape in the North of Zealand, Afternoon, 1849
oil on canvas 64.5 x 92
Statens Museum for Kunst

36 The West Coast of Jutland at Kandestederne, 1877
oil on canvas 32 x 44
Statens Museum for Kunst

37 Evening after Thaw, Taarbæk in North Zealand
oil on paper on board 27.5 x 36.5
Statens Museum for Kunst

Emanuel Larsen
1823-1859

38 View of the Harbour of Copenhagen from Langelinie towards Nyholm, 1850
oil on canvas 56 x 86.5
Statens Museum for Kunst

Frederik Vermehren
1823-1910

39 A Jutland Shepherd on the Moors, 1855
oil on canvas 59.5 x 80
Statens Museum for Kunst

Christen Dalsgaard
1824-1907

40 A Young Peasant Girl from Jutland Writing her Beloved's Name on the Misty Window Pane, 1852
oil on paper on canvas 44.5 x 31.5
Statens Museum for Kunst

Carl Bloch
1834-1890

41 Sunset, View of a Landscape at Ellekilde in North Zealand, 1889
oil on panel 36 x 52
Statens Museum for Kunst

Hans Smidth
1839-1917

42 A Storm Brewing behind Nørre Vium Church. Jutland, mid 1890s
oil on canvas 36.5 x 46.5
Statens Museum for Kunst

43 Classroom with Boy Reading, no later than 1904
oil on canvas 30.5 x 60
Statens Museum for Kunst

44 View of the Sea from a Pier
oil on board 29 x 45
Statens Museum for Kunst

Michael Ancher
1849-1927

45 Children and Young Girls Picking Flowers in a Field North of Skagen, 1887
oil on canvas 62 x 79
Skagens Museum

46 The South Beach. Skagen, 1893
oil on canvas 54 x 73.5
Skagens Museum

47 The Fisherman Hans Tversted, c. 1895
oil on canvas 32.5 x 21.5
Skagens Museum

48 A Stroll on the Beach, 1896
oil on canvas 69 x 161
Skagens Museum

49 A Fisherman, 1901
oil on panel 32 x 23.5
Skagens Museum 1377

Peder Severin Krøyer
1851-1909

50 Fishermen Hauling in their Nets, 1882
oil on canvas 84 x 94
Skagens Museum

51 The South Beach. Skagen, 1884
oil on panel 20.5 x 33
Skagens Museum

52 The Light Summer Nights at Skagen, 1885
oil on canvas 40 x 56
Skagens Museum

53 Marie Krøyer, the Artist's Wife, Painting at Stenbjerg Beach, 1889
oil on panel 24 x 33
Skagens Museum

54 Fishermen on the North Beach. Skagen. Summer Evening, 1891
oil on panel 32 x 43
Skagens Museum

Carl Locher
1851-1915

55 Stormy Weather. Højen, 1895
oil on canvas 41 x 57
Skagens Museum

56 The South Beach at Skagen. An Afternoon in November, 1905
oil on canvas 40 x 55
Skagens Museum

Viggo Johansen
1851-1935

57 Martha Johansen, the Artist's Wife, Seated near their Home in Skagen Vesterby, 1880
oil on canvas 23 x 27
Skagens Museum

58 Dividing the Catch, 1885
oil on canvas 95 x 147
Skagens Museum

59 A September Evening. Skagen, 1889
oil on canvas 63.5 x 85.5
Skagens Museum

Laurits Tuxen
1853-1927

60 Sunset over the North Sea. Højen, 1909
oil on canvas 42 x 60.5
Skagens Museum

61 Rhododendrons in the Artist's Garden, 1917
oil on canvas 92 x 124
Skagens Museum

Laurits Andersen Ring
1854-1933

62 Spring, 1895
oil on canvas 189.5 x 159
Den Hirschsprungske Samling

63 Smallholders, Enø. Zealand, 1898
oil on canvas 122.5 x 97
Statens Museum for Kunst

64 Lady at the Beach of Karrebæksminde. Zealand, 1898
oil on canvas 46 x 65
Statens Museum for Kunst

65 View of Karreæksminde, 1895
oil on canvas 23 x 42
Private Collection

Johan Rohde
1856-1936

66 A Summer's Day at the Karup River. Jutland, 1891
oil on canvas 43.5 x 49
Statens Museum for Kunst

Anna Ancher
1859-1935

67 Women Making Garlands for a Festival, 1906
oil on canvas 45 x 66
Skagens Museum

Jens Ferdinand Willumsen
1863-1958

68 Sophus Claussen Reading his Poem "Imperia", 1915
oil on canvas 147.2 x 187.2
Aarhus Kunstmuseum

69 The Green Girl Lying in the Woods, 1922
oil on canvas 192 x 142
J. F. Willumsens Museum

Vilhelm Hammershøi
1864-1916

70 Ida Ilsted, the Artist's Fiancée, 1890
oil on canvas 55 x 47
Statens Museum for Kunst

71 Self Portrait, 1890
oil on canvas 52 x 39.5
Statens Museum for Kunst

72 Interior at Strandgade with the Artist's Wife, 1902
oil on canvas 63.5 x 60
Statens Museum for Kunst

73 A Wing of Christiansborg Castle. Copenhagen, 1907
oil on canvas 58 x 45
Statens Museum for Kunst

74 Bredgade Interior with the Artist's Wife, 1911
oil on canvas 74 x 79
Aarhus Kunstmuseum 933

Harald Slott-Møller
1864-1937

75 Primavera, 1901
oil on canvas 69.2 x 119
Nordjyllands Kunstmuseum, Aalborg

76 Paolo and Francesca, Dante, The Divine Comedy, Fifth Song, 1905
oil on panel 176 x 91
Private Collection

Edvard Weie
1879-1943

77 Reflections of the Sun on the Sea, Christiansø, 1913
oil on canvas 59.6 x 77.9
Aarhus Kunstmuseum

78 Still Life, early 1920s
oil on canvas 54.6 x 60.2
Aarhus Kunstmuseum

79 Romantic Fantasy. Sketch, 1922
oil on canvas 152.5 x 151
Statens Museum for Kunst

Harald Giersing
1881-1927

80 The Artist's Father in a Fur Coat, 1907
oil on wooden fibre board 91 x 73
Statens Museum for Kunst

81 Behind "Filosofgangen", Sorø, 1915
oil on canvas 54 x 69
Statens Museum for Kunst

82 Country Road to Faaborg, 1925
oil on canvas 75 x 85.5
Aarhus Kunstmuseum

Vilhelm Lundstrøm
1893-1950

83 Still Life with Jars, Sauce Boat and Bottle, 1920
oil on canvas 94 x 124
Statens Museum for Kunst

84 Still Life with Jugs and Pots c. 1929
oil on canvas 89.5 x 116.4
Nordjyllands Kunstmuseum, Aalborg

85 Female Model, 1930
oil on canvas 131 x 97
Statens Museum for Kunst

Wilhelm Freddie
b. 1909

86 Solitude, 1947
oil on masonite 73 x 60
Aarhus Kunstmuseum

Ejler Bille
b. 1910

87 Composition. Mask Figure, 1944
oil on canvas 67.5 x 91.5
Nordjyllands Kunstmuseum, Aalborg

88 Ornamental Figures, 1955
oil on canvas 68.2 x 63.2
Nordjyllands Kunstmuseum, Aalborg

Egill Jacobsen
b. 1910

89 Carnival, 1944
oil and pencil on canvas
113.3 x 88.5
Aarhus Kunstmuseum

90 Spring, 1948
oil on canvas 100.5 x 76.7
Nordjyllands Kunstmuseum, Aalborg

Richard Mortensen
1910-1993

91 Botanical Portrait, 1937
oil on canvas 125.9 x 162.5
Aarhus Kunstmuseum

92 Stresa, 1951-52
oil on canvas 65 x 54.5
Nordjyllands Kunstmuseum, Aalborg

93 Bolléne, 1954
oil on canvas 92 x 72.6
Nordjyllands Kunstmuseum, Aalborg

Sonja Ferlov Mancoba
1911-1984

94 Concentration, 1962-63
bronze h. 38
Galerie Mikael Andersen

95 Confiance, 1963
bronze h. 175
Galerie Mikael Andersen

96 Courage, 1968
bronze h. 160
Galerie Mikael Andersen

97 Sculpture, 1970
bronze h. 120
Galerie Mikael Andersen

98 Mask, 1977
bronze h. 93
Bornholms Kunstmuseum

99 Mask and Figure, 1977
bronze h. 90
Galerie Mikael Andersen

Robert Jacobsen
1912-1993

100 Reste fidèle, 1953
iron 41.5 x 25 x 20.5
Aarhus Kunstmuseum

101 Statique II. Construction, 1959
iron h. 90.5
Aarhus Kunstmuseum

Carl-Henning Pedersen
b. 1913

102 The Golden Tree and Bird, 1947
oil on canvas 122 x 198.8
Aarhus Kunstmuseum

103 People and Yellow Star, 1950
oil on canvas 118.5 x 101
Nordjyllands Kunstmuseum, Aalborg

104 Tower, Trees and Fantastic
Animals, 1951-52
oil on canvas 69.1 x 79.2
Aarhus Kunstmuseum

Asger Jorn
1914-1973

105 Spanish Drama, 1952-53
oil on canvas 100 x 89.6
Aarhus Kunstmuseum

106 La grande Fatigue, 1964
oil on canvas 116 x 89
Galerie Jerome

107 Décollage, 1968
oil on paper 110 x 74
Galerie Jerome

Erik Thommesen
b. 1916

108 Self Portrait, 1940
wood h. 32.5
Statens Museum for Kunst

109 Head of a Woman, 1949
wood h. 83
Holstebro Kunstmuseum

110 Woman, 1962
wood h. 52
Private Collection

111 Caryatid, 1991
wood h. 52
Galerie Mikael Andersen

Svend Wiig Hansen
b. 1922

112 The Fire, 1955
oil on canvas 135.5 x 102.9
Aarhus Kunstmuseum

113 Standing Woman, 1958
bronze h. 50
The Artist

114 Sitting Woman, 1959
bronze 27 x 27 x 27
The Artist

115 Sitting Figure, 1965
oil on canvas 100 x 80
Aarhus Kunstmuseum

116 Meeting with Judas. 1979
oil on canvas 80 x 107
The Artist

117 Fertility, 1983
bronze 27 x 27 x 27
The Artist

118 The Cathedral, 1983
bronze 34 x 31 x 14
The Artist

119 The Stranger, 1992
bronze 60 x 125
The Artist

120 Vision, 1992/3
oil on canvas 205 x 155
The Artist

Per Kirkeby
b. 1938

121 Untitled, 1981
oil on canvas 200 x 130
Louisiana Museum of Modern Art

122 Untitled, 1981
oil on canvas 200 x 130
Louisiana Museum of Modern Art

123 Untitled, 1981
oil on canvas 200 x 130
Louisiana Museum of Modern Art

124 Gate, 1981
bronze 35.5 x 23 x 15
Louisiana Museum of Modern Art

125 Small Head and Arm, 1981
bronze 35 x 14 x 22
Louisiana Museum of Modern Art

126 Model: Two Arms I, 1981
bronze 28 x 38 x 19
Louisiana Museum of Modern Art

Michael Kvium
b. 1955

127 Blind Eggs, 1995
oil on canvas 200 x 200
Galerie Faurschou

128 Future Jam, 1995
oil on canvas 200 x 200
Galerie Faurschou

Morten Stræde
b. 1956

129 Winterreise/Torum, 1992
polyester h. 160
Galerie Mikael Andersen

130 Love Corridor, 1992
polyester h. 116
Galerie Mikael Andersen

Elisabeth Toubro
b. 1956

131 A Construction of Spaces in
Between, 1995
photograph 100 x 140
Galerie Mikael Andersen

132 Disguised Construction, 1995
photograph 100 x 140
Galerie Mikael Andersen

133 Construction with Transposed
Contours, 1995
photograph 100 x 140
Galerie Mikael Andersen

134 Transparent Construction –
punktiformed, 1995
photograph 100 x 140
Galerie Mikael Andersen

135 Transparent Construction with
Dotted Contour, 1995
photograph 100 x 140
Galerie Mikael Andersen

Claus Carstensen
b. 1957

136 Cancellation Proof VI, 1994
acrylic on canvas 250 x 195
Galerie Mikael Andersen

137 Cancellation Proof IX, 1994
acrylic on canvas 250 x 195
Galerie Mikael Andersen

Erik A. Frandsen
b. 1957

138 Jalta Series IX, 1989
oil on canvas with rubber ring
200 x 180
Aarhus Kunstmuseum

Søren Jensen
b. 1957

139 Gold Light I, 1992
bronze 22 x 38 x 85
Galerie Mikael Andersen

140 Gold Light II, 1992
bronze 23 x 37 x 86
Galerie Mikael Andersen

141 Silver Light I, 1992
bronze 23 x 36 x 85
Galerie Mikael Andersen

142 Silver Light II, 1992
bronze 23 x 36 x 85
Galerie Mikael Andersen

Peter Bonde
b. 1958

143 Hell, 1990
oil on canvas with PVC cloth
280 x 180
Aarhus Kunstmuseum

Hebsgaard Glass Studio

Carl-Henning Pedersen
b. 1913

144 Glass Painting, 1994
h. 132, w. 98.5
Hebsgaard Glass Studio

Jørn Larsen
b. 1926

145 Concrete Glass, 1993
d. 120
Hebsgaard Glass Studio

Arne Haugen Sørensen
b. 1932

146 Angel's Wings, 1991
glass h. 165, w. 130
Hebsgaard Glass Studio

Peter Brandes
b. 1944

147 Glass Painting and Collage
h. 200, w.100
Hebsgaard Glass Studio

Bjørn Nørgaard
b. 1947

148 Sculpture in Glass and Copper
app. 110 x 110
Hebsgaard Glass Studio

Ceramics

Thorvald Bindesbøll
1846-1908

149 Vase, 1892
earthenware h. 46, d. 35
Museum of Decorative Art

150 Dish, 1893
earthenware d. 43.5
Museum of Decorative Art

151 Vase, 1893
h. 45
Skagens Museum

152 Vase, 1896
h. 45.5
Skagens Museum

153 Dish, 1896
d. 44
Skagens Museum

Harald Slott-Møller
1864-1937

154 Part Dinner Service:
earthenware
Tureen, h. 24, l. 40
Oil/vinegar set
Plate, d. 21
Soup Plate, d. 22
Royal Copenhagen

Axel Salto
1889-1961

155 Vase with Grain Pattern, 1945
stoneware, "budding style", solfatara glaze h. 30
Royal Copenhagen

156 Vase with Spikes, 1948/49
stoneware, "sprouting style", Sung glaze h. 39
Royal Copenhagen

157 Vase: Bundle of Muscles, 1952
stoneware, cobalt blue glaze h. 92
Royal Copenhagen

158 Tear-Shaped Vase, 1945
stoneware, "fluted style", tenmoku glaze h. 26
Royal Copenhagen

Lisbeth Munch-Petersen
b. 1909

159 Bowl, 1994
earthenware
tin-glaze painted with iron-oxide and cobalt h. 14, w. 19

160 Jug, 1995
earthenware
tin-glaze painted with iron-oxide and cobalt h. 19, w. 14

161 Bowl, 1995
earthenware, tin-glaze painted with iron-oxide and cobalt h. 13, w. 8

162 Relief, 1995
earthenware, mosaic technique
134 x 55.5

163 Relief, 1995
earthenware, mosaic technique
53 x 43

Gertrud Vasegaard
b. 1913

164 Round Bowl
h. 18, d 19
Museum of Decorative Art

165 Oval Bowl
h. 12, w. 24, l. 31
Museum of Decorative Art

166 Round bowl
h. 20.5, d. 23
Museum of Decorative Art

Gutte Eriksen
b. 1918

167 Square Jar, c.1990
high-fired earthenware, ash and raw borax glaze h. 46.5, w. 25

168 Square Jar, c.1990
high-fired earthenware, ash and raw borax glaze h. 48, w. 22

Astrid Anderberg
b.1927

169 Square Jar, 1995
stoneware, scraffito decoration
h. 20, w.19, l. 38

170 Owl, 1995
stoneware, engobe glaze h. 48

171 Relief, 1995
stoneware 70 x 70

Richard Manz
b. 1933

172 Bowl Form "Tromsø", 1991/2
stoneware, hand-thrown, light-blue glaze h. 23, d. 53

173 Lying Form, 1991/2
stoneware, hand-thrown, matt white glaze h. 14, w. 58, l. 69

174 Rhombic Form,1991/2
stoneware, hand-thrown, matt white glaze h. 12, w. 60, l. 102

Sten Lykke Madsen
b.1937

175 Dog-Fish-Bird
stoneware, hand-built, reduction-fired glazes h. 27, w. 20, l. 38

176 Vase with Raised Shoulder
stoneware, hand-built, reduction-fired glazes h. 56.5, d. 29

177 Vase with Fable and Fish
stoneware, hand-built, reduction-fired glazes h. 40, w. 20, l. 47

178 Boot with Fish
stoneware, hand-built, reduction-fired glazes h. 125, w. 38, l. 50

179 Two Fables are Riding on the Mountain
stoneware, hand-built, reduction-fired glazes h. 73, w. 30, l. 65

Gerd Hiort Petersen
b. 1937

180 Sea Urchin, 1994
stoneware, slab-built, feldspathic and ash glazes h. 30, d. 44

181 Rock bowl (large), 1994
stoneware, slab-built, feldspathic and ash glazes w. 56, l. 62

182 Rock bowl (small), 1994
stoneware, slab-built, feldspathic and ash glazes w. 43, l. 44

183 Square dish, 1994
stoneware, slab-built, feldspathic and ash glazes w. 55, l. 60

Gunhild Aaberg

184 Landmark
h. 62, w. 64

185 Landmark
d. 68

186 4 small ceramic pictures
15 x 22

187 Flat jar
h. 45

188 Boat
h. 20, l. 90

Marie Hjorth
b. 1941

189 Jar with lid, 1995
stoneware, hand-built with black glaze and slip decoration
h. 16, d. 24

190 Bowl, 1995
porcelain, painted decoration, clear glaze h. 8, d. 26

191 Bowl, 1995
porcelain, painted decoration, clear glaze h. 11, d. 21

Beate Andersen
b.1942

192 Vase
h. 40, d. 32

193 Bowl
h. 21, d. 26

194 Cupola
h. 17, d. 12

195 Cupola
h. 17, d. 12

Jane Reumert
b. 1942

196 7 Shells, 1995
porcelain h. 12, w. 8 each

197 Bowl, 1993
fibreglass, gold leaf and mixed media
h. 25, w. 75

Hans Munck Andersen
b. 1943

198 Bowl. 1994
coloured porcelain, coil-built
h. 16, d. 21

199 Bowl, 1994
coloured porcelain, coil-buitl
h. 16, d. 21

200 Bowl, 1994
coloured porcelain, coil-built
h. 12, d. 16

Bente Hansen
b. 1943

201 Oval Jar
h. app. 60, w. app. 26

202 Sharp Vase
h. app. 20, w. app.20

203 Sharp Vase
h. app.12, w. app.18

Bodil Manz
b. 1943

204 Bowl, 1986
porcelain, sandcast, matt white glaze
h. 35, d. 53

205 Bowl, 1986
porcelain, sandcast, matt white glaze
h. 35, d. 53

Julie Høm
b. 1944

206 Dish, 1992
stoneware, scraffito decorated with
coloured clay h. 6, d. 38

207 Bowl, 1994
stoneware, scraffito decorated with
coloured clay h. 16, d. 30

208 Bowl with lid, 1995
stoneware, scraffito decorated with
coloured clay h. 20, d. 17

209 Relief, 1995
stoneware, mosaic decoration
h. 55, w. 80

Ivan Weiss
b. 1946

210 Jar, 1992
stoneware, hand-thrown
h. 130, w. 56

211 Jar, 1992
stoneware, hand-thrown
h. 130, w. 56

212 Jar, 1992
stoneware, hand-thrown
h. 130, w. 56

Malene Müllertz
b. 1949

213 Jar with Lid The Caliph's Hat
stoneware

214 Lying Pyramid

215 Dish
agate technique

216 Perforated box
yellow glaze, wooden peg fastening

217 Perforated box
white glaze, wooden peg fastening

218 Perforated box
grey glaze, wooden peg fastening

Glass

Torben Jørgensen
b. 1945

219 2 Spires
glass h. 200, w. 40, d. 40 each

Naja Salto
b.1945

220 Dish, 1994
glass, moulded with applied and fired
decoration d. 42

221 Dish, 1994
glass, moulded with applied and fired
decoration d. 42

222 Dish, 1994
glass, moulded with applied and fired
decoration d. 42

Else Leth Nissen
b. 1949

223 Vase, 1994
glass, free-blown
h. 32, d. app. 9

224 Vase, 1994
glass, free-blown
h. 37, d. app. 10

225 Dish, 1995
glass, fused and slumped
h. 5, d. 50

Lena Ljunger
b. 1953

226 Striped Bowl, 1995
glass, free-blown
h. 15-20, d. 15-20

227 Striped Bowl, 1995
glass, free-blown
h. 15-20, d. 15-20,

228 Striped Bowl, 1995
glass, free-blown
h. 15-20, d. 15-20

Jesper Södring
b. 1954

229 Dish, 1995
glass, free-blown dia. 45

230 3 "Lopsided" Glasses, 1995
glass, free-blown

231 Cylindrical Vase, 1995
glass, free-blown
h. 25-30, d. 15-20

Tchai Munch
b.1954

232 Oval Form, 1994
glass, fused and slumped
71 x 40

233 Square Form, 1994
glass, fused and slumped
47 x 47

234 Double Square Form, 1994
glass, fused and slumped
38 x 38

Maibritt Jönsson & Pete Hunner
b. 1956 **b. 1954**

235 Dish, 1995
glass, free-blown d. app. 50cm

236 Bowl, 1995
glass, free-blown d. app. 35cm

237 Vase, 1995
glass, free-blown h. app. 37

Metalwork

Georg Jensen Silver Workshop
Designs by Georg Jensen
1866 - 1935

238 Bowl, 1912
silver d. 20, h. 16.5
Georg Jensen Silver Museum

239 Tray, 1919
silver d. 36
Georg Jensen Silver Museum

240 Grape Bowl, 1918
Silver d. 18.2, h. 19
Georg Jensen Silver Museum

241 Bracelet, 1912
silver and moonstones
Georg Jensen Silver Museum

242 Pendant, 1912
silver with labradorite
Georg Jensen Silver Museum

243 Pair of Earrings, 1920
silver with silverbead
Georg Jensen Silver Museum

244 Armring, 1915
silver
Georg Jensen Silver Museum

245 Armring, 1915
silver
Georg Jensen Silver Museum

246 Brooch, 1905
silver
Georg Jensen Silver Museum

247 Brooch, 1905
silver with green agate & carnelian
Georg Jensen Silver Museum

248 Brooch, 1904-6
silver with amber
Georg Jensen Silver Museum,

249 Brooch, 1914
silver with green agate & carnelian
Georg Jensen Silver Museum

250 Brooch, 1914
silver with moonstones
Georg Jensen Silver Museum

251 Brooch, 1913
silver with green agates
Georg Jensen Silver Museum

Design by Thorvald Bindesbøll
1846-1908

252 Bowl, 1900
silver h. 9, d. 15
Georg Jensen Silver Museum

Designs by Sigvard Bernadotte

253 Serving Bowl, 1942
silver, ebony handle and knob,
Lidded version d. 16.5, l. 27
Georg Jensen Silver Museum

254 Pair of Candlesticks,1939
silver h. 25
Georg Jensen Silver Museum

Design by Henning Koppel

255 Jug, 1952
silver h. 29
Georg Jensen Silver Museum

Design by Søren Georg Jensen

256 Candelabrum, 1959
silver h.18
Georg Jensen Silver Museum

Mogens Bjørn-Andersen
b. 1911

257 Round Tray with 8 Tumbler
Goblets, 1994
silver and silver gilt
tray d. 32
goblet d. 7

258 Jug, 1994
silver and pockenholtz 11 x 16

Jørgen Dahlerup
b.1930

259 Teapot with Milk and Sugar Set,
1995
silver and silver gilt
teapot 20 x 25
sugar bowl 5 x 10
milk jug 8 x 8

Ib Andersen
b. 1932

260 Schnapps Jar, 1986
silver and titanium

261 Tray, 1995
silver 13 x 50

Erik Sjødahl
b.1940

262 Coffee Pot on Tray, 1995
silver and ebony 25 x 12

263 Milk and Sugar Set on Tray,
1995
silver, silver gilt and ebony
sugar bowl 5 x 7
milk jug 9 x 6

Peter Vedel Tåning
b.1944

264 6 Goblets
silver, silver gilt and lapis lazuli
h. 11, 9 & 6

265 Jug
silver, bronze and haematite
18 x 12

Allan Scharff
b.1945

266 Bowl, 1993
silver 60 x 40, h. 12

Torben Hardenberg
b.1949

267 Object, 1994
silver, silver gilt and opal granite
30 x 20 x 20

Per Sax Møller
b.1950

268 Coffee Pot, 1993
silver and ebony 24 x 12

269 Milk and Sugar Set, 1993
silver and ebony
sugar bowl 5 x 7
milk jug 9 x 6

Claus Bjerring
b.1951

270 Five-armed Candlestick
silver h. 28, w. 25cm

271 Box
silver

Annette Juel
b.1934

272 Opus 7, 1993
iron perforated plate with red copper,
thread and blue glass 100 x 200

273 Opus 7777, 1993
iron perforated plate with brown
copper thread and yellow glass
70 x 200

Textiles

Vibeke Klint
b. 1927

274 Carpet, 1988
wool and goat hair 154 x 280

275 Carpet, 1994
mohair and horse hair 290 x 330

276 Carpet, 1994
wool 200 x 300

Ruth Malinowski
b.1928

277 Behind the Walls
tapestry 171 x 161

278 Light
tapestry 161 x 152

279 April-92
tapestry 176 x 126

Randi Studsgarth
b.1938

280 Weather Report, 1990
tapestry, silk 135 x 265

281 Form & Movement
tapestry, 2 parts, silk with gold and
silver thread 135 x 200 each

Puk Lippmann
b.1945

282 Rug, 1995
wool and cotton, hand-tufted
270 x 270

Naja Salto
b.1945

283 Sample Design, theatre curtain
for National Museum of Copenhagen,
1992
printed velour 300 x 180

Torill Ruud Galsøe
b.1947

284 Rug
120 x 480

285 Rug
120 x 240

Bitten Hegelund
b. 1960

286 Length of Material
printed h. 400, w. 150

287 Length of Material
printed h. 400, w. 150

288 Length of Material
printed h. 400, w. 150

Paper

Anne Vilsbøll
b.1951

289 Intervals, 1995
mobile, 3 parts, hand-made paper
and plexiglass 200 x 150 each

Bookbinding

*All works have been lent by the Royal
Danish Library*

Grete Andersen

290 Maja Lisa Engelhardt, Anders
Brasch & Johannes Larsen: Efter
Naturen: Sophienholm, Lyngby
Taarbæk Kommune, 1991

Hans K. Biller

291 Photographs by Bill Brandt:
Nudes: New York Graphic Society,
Boston, 1980

292 Thorkild Hansen: Sidste
Sommer i Angmagssalik:
Københavns Bogtrykkerforening,
1978

Søren Carlsen

293 Jens Birkemose: Peters nat i
Valby: Hostrup-Pedersen &
Johansen, Copenhagen, 1983

Hans Cristensen

294 Henrik Nordbrandt:
Glemmesteder: Brøndum 1991

295 B. Traven: Broen i junglen:
Skjern 1965

296 Om Wegerknapfs liv og levned:
Anders Nyborg a/s: Internationalt
forlag, u.å.

Allan Jensen

297 Asger Jorn Druckgrafik:
Lagerkatalog VI: Galerie van de Loo,
München, 1989

298 H. Justesen Ranch: Karrig
Niding: Foreningen for boghaand-
værk, 1962

Erik Løvborg

299 Henrik Nordbrandt: Håndens
skælven i november: Brøndum 1986

300 Federico Garcia Lorca:
Klagesang over Ignacio Sánchez
Mejías: Brøndum, u.å.

Erik Ramussen

301 Sølv og Salte: Fotografi og
Forskning: Rhodos, 1990

302 Robert Service: Pale Port of
Amber: Pavillon Neuf, Copenhagen/
Toronto, 1991

Niels O. Selfort

303 Kalus Høeck: Salme: Brøndum,
1991

304 Karel Appel: Works on Paper:
New York, 1980

Trine Torp

305 Henrik Nordbrandt: Forsvar for
vinden under døren: Brøndum, 1986

Photographic Credits

Hans Petersen 2, 3, 4, 6, 8, 9, 12, 13, 14, 15, 19, 20, 21, 22, 24, 26, 28, 32, 34, 35, 39, 40, 42, 62, 63, 64, 66, 73, 79, 85, p. 56 (Giersing)

Erik Jeppesen 18

Thomas Pedersen & Poul Pedersen 68, 74, 77, 86, 89, 91, 101, 104, 105, 115, 138, 143, p. 72 (Køpke), p.73 (Kirkeby), p. 74 (Nørgaard), p. 76 (Lemmerz)

Kit Weiss 69

Esben H. Thorning 88, 93

Planet/Bentryberg 98, 111, 131, p. 98 (Madsen)

Simon Lautrop 144

Vigo Rivad 146, p. 83 (Brandes)

Hviid Aps 240

Leif Tuxen p. 97 (Eriksen)

Ole Haupt p. 99 (Aaberg)

B. Itsted Bech p. 100 (Hjorth)

Ole Alhøj p. 104 (Mullertz)

Anita Corpas p. 111 (Hardenberg)

Fotografen APS p. 113 (Klimt)

Schnakenburg & Brahl p. 115 (Ruud)

Leif Bolding p. 116 (Visbøll)

Contributors

Kasper Monrad is a Curator at the Statens Museum for Kunst, Copenhagen.

Bente Scavenius is an art historican, critic and freelance writer.

Ane Hejlskov Larsen is a Curator at Aarhus Kunstmuseum.

Jonna Dwinger is the crafts critic for the Danish daily newspaper, Politiken.

Duncan Macmillan is Professor of the History of Scottish Art at the University of Edinburgh.

Copenhagen the Cultural Capital of Europe 1996

Copenhagen will be able to boast the title *European Capital of Culture 1996*. A title which it receives from Luxembourg. A title which was bestowed on Athens as the first city in 1984 and followed by Florence, Amsterdam, Berlin, Glasgow, Dublin, Madrid, Antwerp and Lisbon.

Being bestowed with a title is naturally an honour but also a burden. On the one hand an obvious occasion for celebration, for promoting the city, honouring the cultural traditions of Denmark, supporting new artistic endeavours and securing a better infrastructure for the arts. Having had the opportunity to learn from our predecessors we should be able to come up with a programme which fulfils our own ambitions and satisfies expectations – which are incredibly high.

With some 40 specially commissioned exhibitions, more than 45 festivals and with more than 200 new artistic works, and a programme covering all aspects of music, theatre, dance, opera, literature, media projects, youth projects and also environmental projects and initiatives, there will be a massive programme throughout the year. A large handful of renovations and restorations plus the inauguration of a series of *houses for culture* secures better conditions for 1997 and onwards.

On the other hand, the burden of responsibility is more difficult to resolve. Can Copenhagen really claim to be *European City of Culture 1996* and what will it contribute in the long run in the local but also in the even more crucial European context?

In our *culture circus* which is more and more taking over and dominating, what can Copenhagen do which seems to be both fitting and necessary?

In our *post* condition (i.e. post-modern, post-industrial, post Berlin Wall, post left-wing and right-wing) the condition of artistic, moral, political and ultimately human sense of vacuum seems to be our common plight in Europe. While the scientists and technologists are already bounding into the 21st century, artists, writers and humanists are still concerned with the aftermath of the 20th century which is constantly providing evidence of its debris and refuse – in all senses of the word.

Sarajevo – perhaps the true *European capital of culture* – still haunts our consciousness for the third year. Environmental catastrophes escalate. Cities are thwarted with uproar and hopelessness where the *no future* generation seems to have accepted its plight. Racism is becoming politically legitimate and more openly threatening. Our *national cultures* risk becoming shields rather than emblems, while subcultures proliferate, offering cultural freedom and identity for millions, but also functioning totally outside the public cultural arena. Central and Eastern Europe's *adjustment* to Western Europe and the free market is leaving an aftermath of cultural debris while practical possibilities to build up alternatives are still needed.

In the face of these rather daunting and sober questions, Copenhagen cannot offer any solutions but it can offer a platform for dialogue. A European platform for dialogue, where practising artists, cultural workers, city officials, youth groups, environmentalists, philosophers, architects and planners, media personalities and even citizens are invited to participate in seminars, workshops, co-productions, media-links, Summer Universities, conferences, meetings, exchange programmes on all imaginable levels.

There are more than 50 European conferences being planned for Copenhagen '96, more than 20 workshops, a 266 day *World Diary* will be written, local radio link-ups, weekly *on-line* telecommunication projects with other cities, European youth newspapers will be published, a huge manifestation of exiled artists in Europe, a series of *3rd Culture seminars for European specialists*, many European networks will use this platform for their conferences, and a direct Sarajevo culture-link is being planned – and much more. Some 20,000 people are expected to take part in the biggest think tank of the year and many more will naturally have access to the results and the public/media projects involved.

The thinking city would be quite an appropriate title for our city's Year of Culture – not to neglect the many outstanding art events. On the contrary, many of these events will themselves relate to questions and relate to conditions which will be central in this on-going debate – whether historical exhibitions, new works created by European *land artists* or video artists, choreographers, authors and composers.

Looking at this *choice* in a historical context, one could say that this actually suits Copenhagen quite well, having a strong tradition for public debate and involvement in public affairs, an exceptional popular educational tradition and a unusual openness towards new ideas and a tolerance and tradition for freedom of expression which is worth protecting.

I hope this short(ened) essay says something more than and something different than our brochures and programmes which you will hopefully come across in Edinburgh and which have the sole aim of attracting you to a city which in many ways has the charm of Edinburgh while still retaining the gutsiness of Glasgow.

I am sure you are going to be enthralled by Copenhagen '96 – and maybe you could also take part in some way in mapping out our routes into the 21st Century.

Have a great Edinburgh '95

Trevor Davies
Copenhagen, July '95

COPENHAGEN 96
CULTURAL CAPITAL OF EUROPE

If you want to go cheaper, swim.

You won't find a cheaper, or more agreeable way direct to Scandinavia, Germany or Holland than cruising across with Scandinavian Seaways.

Every one of our sleek TravelLiners boasts excellent on-board facilities including lively bars with entertainment, a cinema showing the latest releases, disco, restaurants, even a casino on some ships.

For further details post the coupon, no stamp needed, or call our 24 hour brochure line on 0117 944 7733 (quote ref 95/PN1211). Book through your travel agent or call 01255 240 240.

SCANDINAVIAN SEAWAYS

Copenhagen It's your kind of culture

In 1996 'wonderful' Copenhagen, as Cultural Capital of Europe, is hosting a magnificent programme of special events.

In fact the city has always been a particularly attractive place for the British. It's a city where so many speak your language and where you'll find everything you'd expect from a major capital – the finest of restaurants, museums, shops, art galleries, opera and theatre venues, jazz festivals and a wide variety of exhilarating night life.

Contact the Danish Tourist Board on 0171 259 5959 for full details.

You won't find a foreign city where you feel more at home.

DENMARK
SMALL COUNTRY · BIG HOLIDAYS

State of the Art.

NIMMOS

colour PRINTERS

NIMMOS

PRE-PRESS

TENNANT HOUSE, 21 TENNANT STREET, LEITH, EDINBURGH, EH6 5NA

TEL: 0131 554 2431 FAX: 0131 553 6292